PHOTOGRAPHERS
ON LOCATION WITH

CHARLIE WAITE

PHOTOGRAPHERS ON LOCATION WITH

CHARLIE WAITE

GUILD OF MASTER CRAFTSMAN PUBLICATIONS

First published 2003 by
Guild of Master Craftsman Publications Ltd,
166 High Street, Lewes,
East Sussex, BN7 1XN

ISBN 1 86108 365 3

A catalogue record of this book is available from the British Library.

Publisher: Paul Richardson
Art Director: Ian Smith
Production Manager: Matt Weyland
Managing Editor: April McCroskie
Cover design and additional design: Phil Wellington
Additional text and photography: Keith Wilson,
Ailsa McWhinnie, Elizabeth Roberts, Tracy Hallett
Additional editing: Clare Miller
Editorial Assistant: Gail Barrett
Maps: Tony Ashton

Typeface: Berkeley Book

Colour origination by Eray Scan Pte Ltd, Singapore
Printed in Singapore by Kyodo Printing, under the supervision of MRM Graphics, Winslow UK.

CONTENTS

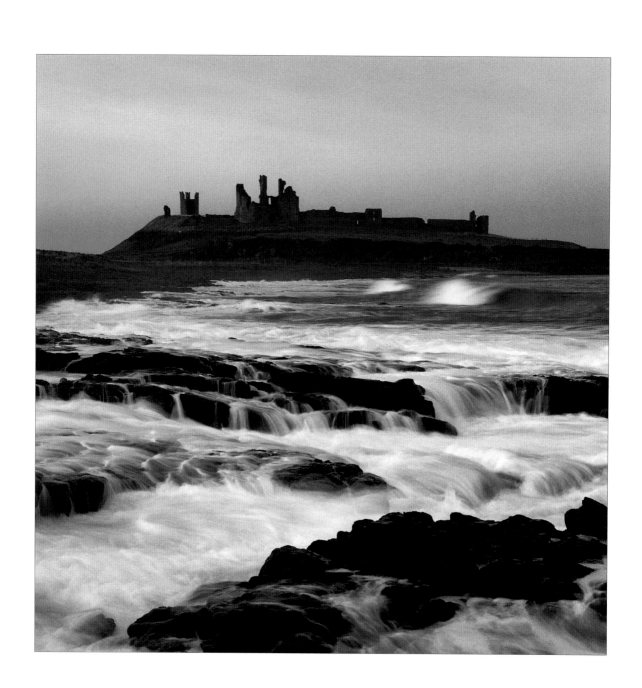

INTRODUCTION

Landscape photography can be tantalizing. It is often the case that having established a passion for the craft and selected the camera and lens, there is still hesitation when it comes to the crucial moment of pressing the shutter release.

During the 'On Location' series for *Outdoor Photography*, we have spent many an hour observing the scene that lay before us. Evaluating the component parts and asking ourselves if collectively they would make a pleasing image. All too often it has been the brutal weather that has been our undoing. Where we have wished for light, albeit for the briefest of moments, we have been denied it. Where we have longed for a more impressive sky to complement the land beneath, we have not been granted it. But our noble lovers of landscape photography have never been deflected by inclement weather. Often returning more than once to a location to secure that elusive image that they have felt compelled to achieve. This collection of landscape photographs across the length and breadth of Britain bears testament to the much admired determination of our participants.

I have fond memories of dynamic discussions about the art of photography with many of the teams that have joined me for 'On Location'. These very often take place whilst waiting for the right moment of light, or at least for the rain to pass. Inevitably there have been numerous times in our conversation when the word 'digital' has arisen. Little wonder, as all of us who are involved with the visual image are only too aware of this most phenomenal revolution that has taken place in the last few years. We have usually concluded that as landscape photographers we can take this remarkable technology and use it as desired, but that a well executed image remains the main objective.

Many an individual who is not conversant with what takes place prior to the image being made may view a photograph and make the incorrect assumption that the photograph that they admire was a chance occurrence. All our friends who have joined us for the 'On Location' series will agree that it is actually the preparation, commitment and ultimately the real devotion to the work in hand that lies behind the making of a good image.

What has been evident was a wonderful camaraderie that has always quickly materialised amongst all of the photographers who have joined us. A common knowledge that we shared the same sense of purpose, the same joy from our photography and, despite the often brutal weather, that we were pursuing our passion in the most wonderful outdoor surroundings.

I feel privileged to have met so many folk from so many varying backgrounds through the 'On Location' series, and I am happy that with the publishing of this collection we have been reunited once again.

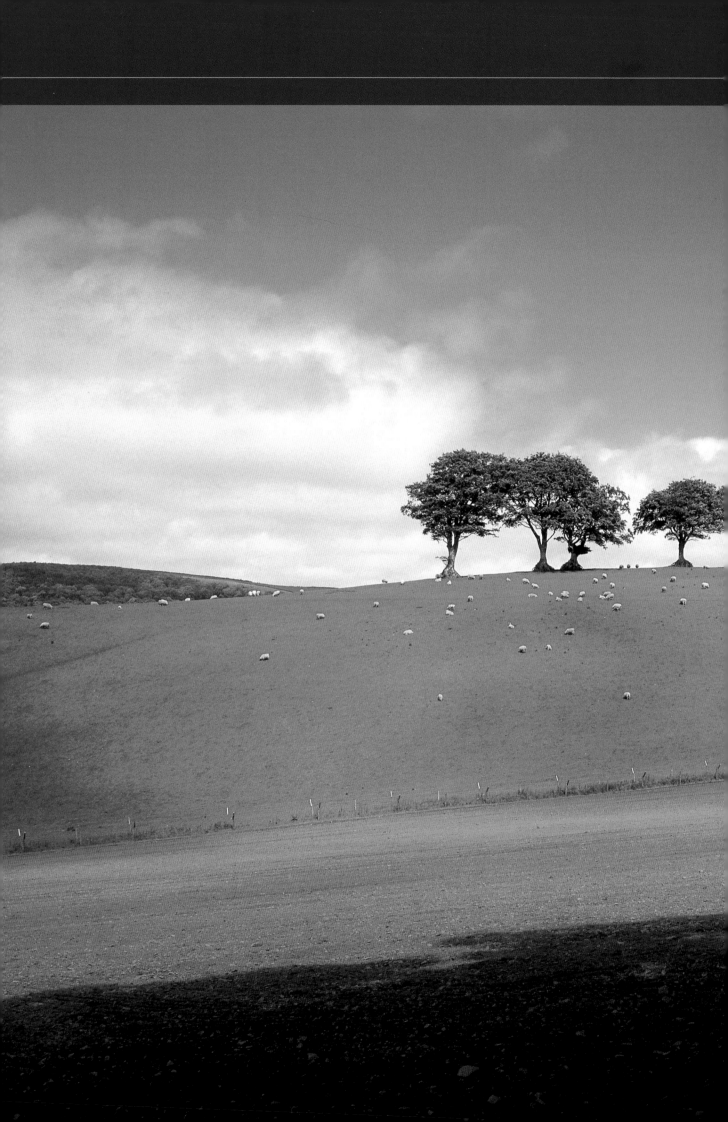

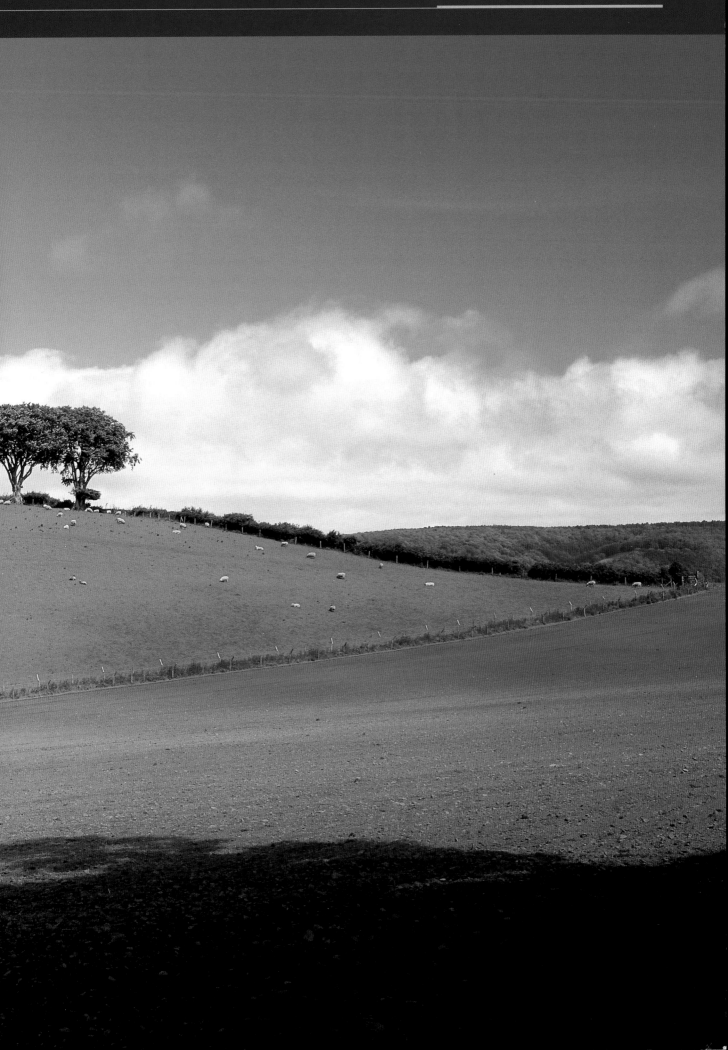

Legends of the fog

The Manger in Oxfordshire offers some spectacular photographic opportunities, though sometimes adverse conditions can stand in the way...

Right This late afternoon shot of The Manger, near Uffington, Oxfordshire, was taken on my very first visit to this part of the Ridge Way, more years ago than I, or the nearby White Horse, would care to remember. It was after the harvest, early September, and I had waited for five hours before firing the shutter in earnest *Hasselblad 500CM with 50mm wideangle, Kodak Ektachrome 64, 1/4sec at f/22*

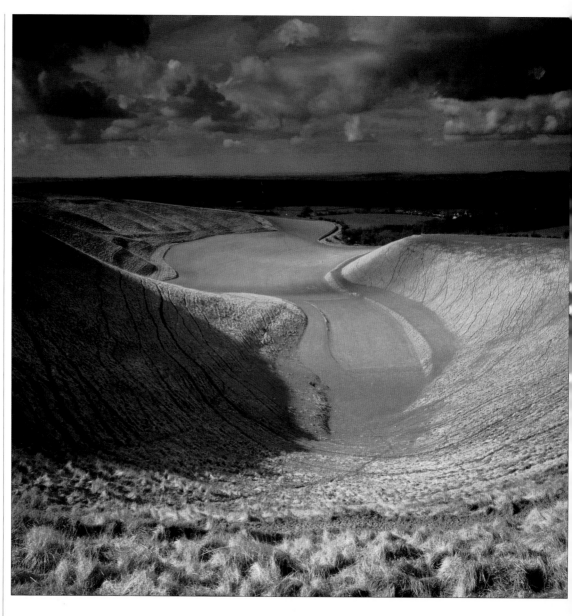

IT IS ALWAYS a joy for me to visit The Manger. This great scoop of land has intrigued many an archaeologist for years and to stand by the edge above the hollow never fails to stir the imagination. The base often reminds me of a giant footprint. Above and to the right is the famous White Horse Hill but it is The Manger that intrigues and fascinates me more.

It may sound like a cliché but this area really is steeped in mystery and legend. The White Horse of Uffington is Britain's most ancient hill figure and was recently dated at 3,000 years old by the Oxford Archaeological Unit. It is the best known of several ancient landmarks on the Ridge Way path.

GLENN WILGROVE

Occupation *semi-retired* **Photographic experience** *18 years seriously. Last six months has been 98% digital. Member of Wantage Camera Club for 17 years*

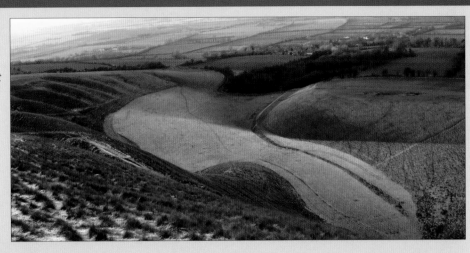

'Talking to Charlie and Keith with the other photographers over a cup of coffee was very enlightening, and went towards making a good day out of a bad one. Due to the heavy fog that refused to clear, it became impossible to make any shots of the area.

I went back a couple of days later but during the short time the sun was out the light was in the wrong place! I did manage to go back yet again just as the sun was setting and this was the best of a few I managed to take.

The frost was a bonus, but again in the wrong place, so I decided to include the distant landscape where the sun did shine.' *Fuji FinePix 6900 digital camera, 6Mb Fine setting, 1/125sec at f/11, tripod*

CHARLIE'S VERDICT

In Glenn's image it is wonderful to see the way in which the rays of the morning sun have warmed the land. With a precise line, the edge of the shadow is defined and from this image we can see that at no other time during the day was the sun able to enter the basin. Despite this very common occurrence, it always strikes me as the most wonderful phenomenon.

Away to the north west, we can see the distant farm land being lit as a brilliant orange. This is, in fact, quite an unusual arrangement. More often than not, one is wishing for light to be distributed within the immediate foreground area and it is rare and quite refreshing to see the light at the back of the image. It would seem that there has been a little cropping here, perhaps from the foreground and, in order to give The Manger a feel of being level, Glenn seems to have tipped the camera, creating a slope to the distant fields. This is no bad thing and I think his decision to omit the sky was the right one.

I have always had a fondness for the ripples of land on the western bank. Perhaps if Glenn is passing again, it may be that this spot will be lit in a way that offers him an alternative composition. The nature of the landscape may change with the movement of sheep and crops but it will always be light that lends atmosphere and drama to the scene.

There's a rather appealing tale that The Manger is the supernatural feeding place for the White Horse when it would venture down from its vantage point on moonlit nights! What a wonderful idea. However the geologists would prefer us to believe that this strangely shaped valley exists because of melting ice during the last Ice Age.

More recently (say, 700 years ago), the ripple-like terracing on the western side – known as the 'giants' steps' – is a remnant of medieval farming when a larger population cultivated all suitable land in the area. When the Black Death decimated nearby settlements, considerably less land needed to be ploughed. For the landscape photographer of the 21st century, the symmetric stripes of light and shade created by these terraces when the sun is in a certain position is one of the more identifiable features of this location.

Left 'I know it's over here somewhere!' Looking for The Manger during a freezing fog is not easy. In fact, it proved impossible

When I first visited The Manger, I was somewhat more fortunate than our small fog-bound party this time around. Admittedly, it was a warmer time of year, post-harvest, with the grass yellowing in the September sun. But when I arrived I was met with an uninteresting sky, no cloud and fairly flat lighting. Contrary to the popular saying, 'Hurry up, I haven't got all day', I have learnt that it pays to wait – all day if necessary! In landscape

Left An historic moment – Charlie takes his first look through a digital camera!

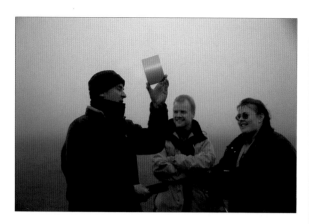

Above Adrian and Tara can't quite believe that Charlie actually uses this filter. It was the most colourful thing we saw all day!

photography success so often comes to those who wait. It's a bit like angling, returning to the same spot and watching for the subtlest changes that indicate the onset of more favourable conditions. In this case, I waited five hours and by late afternoon, things began to change: the light became warmer, the shadows longer, the clouds more defined. So the picture was made, and I count myself fortunate to have

Planning

Location The Manger is situated on the Ridge Way in the southernmost part of Oxfordshire near the boundary with Berkshire.

How to get there Swindon is the nearest mainline rail station. By car take the A419 from Junction 15 of the M4, then follow the A420 to Oxford for around four miles, turning off at the B4000, sign posted for Lambourn. At Ashbury, take the B4507 for Uffington and follow the signposts to White Horse Hill

What to Shoot As well as The Manger, there is the White Horse, Dragon Hill, and the ancient hill fort of Uffington Castle. There can be few other areas of Britain that have such a concentration of historic landmarks.

What to take Tripod and wideangle lenses are essential, especially for The Manger. Longer lenses to pick out graphic details on western terracing. Polarising and neutral density filters are also advisable.

Other times of year Spring and summer are best for The Manger, but watch out for fog in the cooler months

Nearest pub The White Horse Inn, Woolstone. Real ale and a nice selection of malt whiskies. During the winter months they even have hot mulled wine on tap! Food is impressive – the steak and kidney pudding is done in a suet pastry.

Ordnance Survey map Landranger 174

Further information This is National Trust property, with designated car parks. Open all year, free admission and disabled parking close by. Visit www.mysteriousbritain.co.uk for some fascinating legends and folklore.

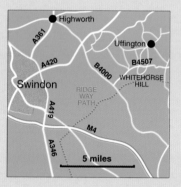

ADRIAN BEASLEY

Occupation *Development Manager* **Photographic experience** *About six years, the last four of which have been almost fanatical, spurred on by the local City & Guilds courses*

'Having taken the day off I decided to start early in the hope of a nice sunrise, but it wasn't to be. The fog was so thick all day I didn't even load up any film. However, that did mean we spent a very pleasant day

with Charlie discussing our backgrounds and photographic interests. We abandoned the day, which left us little time to complete the assignment.

This was a bad time to discover the local lab had just gone bust! I realised the only way to get the images sent in time was to abandon my trusty Mamiya 7 in favour of a digital camera and e-mail.

Sunrise on my last day was beautiful, no clouds in sight but at least the fog had gone. The classic shot of the manger required the sun to be higher but this wasn't going to happen in winter. I decided to try some telephoto shots of the rippled hillside taken from Dragon Hill, cutting out the plain sky. I chose this one based on the lovely saturated early light, shadows and the tree that gives the image scale.'

Fuji FinePix 6900 at 210mm zoom setting, 17Mb Fine setting, 81C warm-up filter, 1/32sec at f/11, tripod

CHARLIE'S VERDICT

Here is a very effective detail of those fingers of land that I care for so much. The russet colour of winter lends itself very well to this kind of image. There are many abstracts to be made from the landscape and I am particularly fond of the various patterns and shapes to be found within the countryside.

There is always some ambiguity as to 'what is it' and there are times when an abstract is so abstract that it frustrates the viewer. I wonder if this is the case here. Those who are familiar with The Manger would know from where in the scene these fingers come from but if the area is unfamiliar they may not know

what it is or how big. This is not necessarily crucial to abstract work, but images that are both abstract and informative as to the substance of the image, seem to work rather better. It is a subtle thing but let your imagination get to work and maybe that is the key to unlock this image.

TARA TAYLOR

Occupation *Typesetter* **Photographic experience** *Two years, spurred by receiving an SLR as a Christmas present. Now a very active member of Whitchurch Hill camera club and studying a City & Guilds photography course while raising two small children*

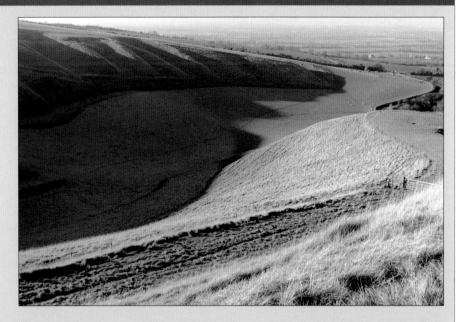

'Charlie and Keith entertained us throughout the day in the hope that the weather would improve but, alas, White Horse Hill remained smothered in thick fog. I would have to return later in the week and try to get a shot in time for the magazine deadline and, more importantly, without Charlie's advice.

After several phone calls to Michael at the White Horse Inn, Woolstone, for weather reports I returned. It was bright, hazy, and frosty and the sky was cloudless. Also, due to the only available time I had The Manger was in deep shadow – a real challenge!

I took this shot from the top of Dragon Hill. I like the way the path leads you into the S-shape ridge, which takes you through the picture and the different textures and colours of the grass. I would have preferred to include more of The Manger itself but the sun's position would not allow this.'

Canon EOS 3 with 28-135mm f/5.6-3.5 IS USM zoom lens, Kodak Royal Gold 200, 1/125sec at f/11, tripod

CHARLIE'S VERDICT

Interestingly, here we have an image taken from the east with the afternoon sun slicing and creating the same light and shadow area as Glen's image. It is sheer chance that we are able to see from this viewpoint the way in which the sun will have melted the frost.

It is just possible to see the light raking across the 'fingers' to the west and in Tara's image she has chosen to keep The Manger looking as it does to the eye, thereby allowing the distant farmland to look horizontal. We all wrestle with our horizons and obeying the spirit level often results in confusion with the eye contesting what the humble level insists on being the case. Fortunately, except when one is by the seaside photographing a river (there can be nothing more offensive than a river flowing uphill – I have done it too!), there is always some latitude when it comes to horizons looking horizontal.

It would seem that Tara has used a slightly shorter lens than Glen and whereas Glen chose not to include any foreground Tara has included some tufts of grass.

Often a foreground serves a greater purpose than merely 'foreground interest'. A foreground should try and help inform the viewer as to the nature (texture and substance) of the distant land. In this case, the foreground has done the job. The Manger offers lots of opportunities and I would urge our three photographers to keep returning. There is a magical atmosphere to this remarkable place that I feel has not been revealed in these images. But whoever said that landscape photography was easy? Persistence!

achieved this result on my very first outing to this location.

I have been back many times since, but this latest excursion will remain long in the memory for the most impenetrable and freezing fog that the Ridge Way could muster. We all expected the fog to lift at some stage but it refused to move. In fact, the higher up we went the thicker and colder it got – the very opposite of what it should have done. Honestly, the longer I live in this country the more confused I become about the way that the weather behaves here.

Despite this meteorological mash, this latest *On Location* shoot gave me the chance to take my first peek through a digital camera.

Glenn Wilgrove says he has been nearly 100% digital for some time and so I was able to look at one of his pictures on the LCD monitor of his Fuji FinePix.

What a time photography is living through! There is not even a hint of demise for traditional photographic processes and yet digital has affected us greatly; more than we may know. All images for reproduction are now scanned digitally and digital files are made prior to printing. This has been the case for some years.

Now we have digital cameras available and many of us have taken the often unsteady step toward investing in one. There are many comments being tossed about in favour and against, but there is surely one overriding factor that must (or should) be the chief governing factor. Resolution! Looking through a digital camera for the first time was strange. Not so different, it must be said, from a traditional SLR, and it would be impossible to pass judgment from merely looking through the viewfinder.

For the time being, I will stick to the cameras I have, but there can be no doubt that soon, perhaps very soon, the silver halide crystal will meet the pixel head on.

I do not believe it will be a fight to the death, though. Silver halide is far too noble and enduring to be unseated so easily!

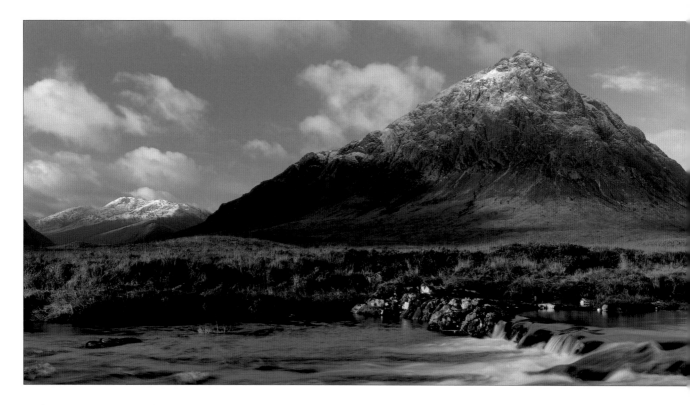

The Glencoe masochists

A wet, misty autumn morning wasn't enough to deter three keen photographers from setting up their tripods in the imposing landscape of Glencoe

Below And Joe came too... From left to right: Charlie Waite, Ron McIlhenny, Ann Sloane, David Miller, OP deputy editor Ailsa McWhinnie, and Joe Cornish

'AAH, YOU SHOULD have been here yesterday.' These are not words you want to hear the moment you stumble off the overnight sleeper from London to Fort William. Why is it that some people seem to take such a sadistic delight in imparting such unwelcome news, especially when they hear you are in the area to take photographs? But our stalwart three amateur photographers who met up in Glencoe were not to be put off. And this time we had an added bonus. Regular contributor to *Outdoor Photography*, Joe Cornish, also happened to be in Scotland that weekend, so very kindly joined us for a morning's photography.

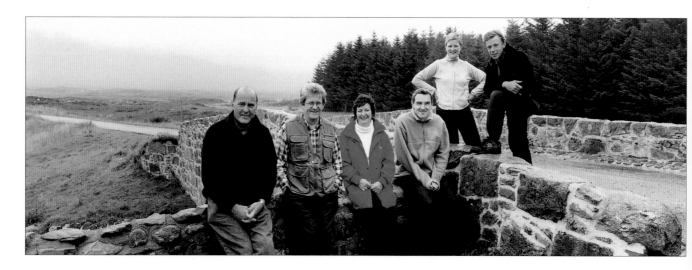

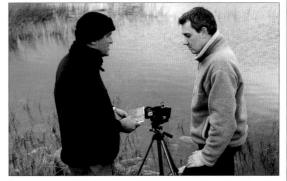

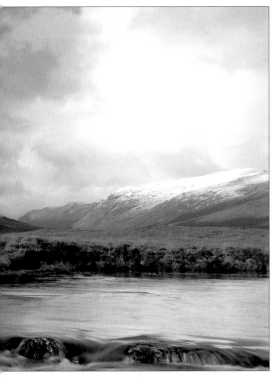

Above This is Buachaille Etive Mor, a mile or so further north from Lochan na h-Achlaise. When the light and weather is more favourable, it would be quite possible to photograph both of these locations on the same day. Often, when taking a picture, the photographer has to tolerate certain compromises. In the case of my picture, it's the sky, which I would have preferred a little moodier. Of course, digital enhancement could sort this out, but I find photography is most satisfying when everything can be achieved in the field. Here, I waited for the dull expanse of white cloud in the top right corner to be replaced by blue or a darker grey. A soft 0.3ND grad at an angle of course may have done it, had I not dropped it into a pool of brackish water! Never infallible!

Remote, threatening, and full of visual menace, Glencoe and Rannoch Moor are known to landscape photographers the world over for providing the best the Highlands have to offer. The Three Sisters, at the head of Glencoe, and the towering Buachaille Etive one are the most widely known. The early autumn

sun skims obliquely across the face of Buachaille Etive, making the corrugated clefts fill up with darkness and the serrated ridges glisten coal-black silver. Top it off with a brooding sky, for gravitas, and there is often a photograph to be made there.

Further south, off the A82, past the River Ba, there is a lovely stretch of water known as

Planning

Location Glencoe is in the Scottish Highlands, around 16 miles south of Fort William.

How to get there The A82 is the only way! It starts in the heart of Glasgow and takes you through this fantastic part of the world, all the way to Inverness. Lochan na h-Achlaise is on the left of the A82 as you travel north from Bridge of Orchy. Buachaille Etive Mor is a mile or so further north, but on a clear day can be seen from quite a distance.

What to shoot Glencoe features some of the most dramatic scenery you could ever hope to see. The problem lies in isolating those elements in order to make a successful image. Once you have photographed the all-encompassing scene of Buachaille Etive Mor, or Lochan na h-Achlaise, take time to study in close-up the shapes and colours of the scenery.

What to take Neutral density, polarising and warm-up filters will all enhance the mood your image, when used with subtlety. A wideangle lens is inevitably

the most useful, but also consider a telephoto to pick out distant details, or a macro to study the mosses and lichens in close-up. And, as it's Scotland, don't forget the waterproofs and the insect repellant!

Ordnance survey map Outdoor Leisure 38, grid ref NN3148.

Essential reading To explore the area fully, try *Hill Walks: Glencoe and Lochaber*, by Ruaridh Pringle, £9.99, The Mercat Press, ISBN 0 1149 5806 8; for a taste of the area's history, read *The Massacre of Glencoe*, by John Buchan, £9.99, Spellmount Publishers, ISBN 1 8622 7062 7.

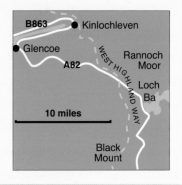

HILL AND DALE

RON McILHENNY LRPS

Occupation *Business development director, IT recruitment*
Photographic experience *About 15 years – street photography, landscapes and still life*

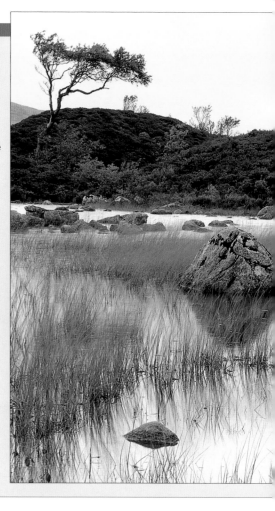

'It was a pleasure to meet both Charlie and Joe and have the benefit of their expertise on the shoot. I decided to shoot across the small bay, trying to include rocks and reeds, but I was undecided about the trees, especially those at the rear, which looked untidy. Joe came to the rescue and suggested the shot be anchored around the rocks in the frame – one bottom left, the other middle right – and additionally we should attempt to include all of the trees in the frame. I changed the position of the tripod and got down very low, setting up a tight shot which includes all the elements and gives depth to the scene. In good light, and perhaps with a warm-up filter, I feel this would be an interesting shot.'
Nikon F4s with 24-120mm Nikkor zoom, Kodak E100VS, tripod

CHARLIE'S VERDICT

This picture could almost have been taken in Japan! The large rock looks like a mini Mount Fuji, while the tree resembles an oversized bonsai. Ron has created a triangle between the small foreground rock, the large middle rock and the tree silhouette, which leads the eye through the frame. It is good that he has left space at the top and left of the tree for it to breathe, otherwise it would have looked cramped. But, to be really picky, perhaps it could have done with a tiny bit more? Raising his tripod slightly would help, and at the same time create a space between the large rock and the smaller mid-ground rocks. There is good contrast between textures and shapes, and he was bold to go for the portrait format in a scene which attracts the landscape aspect. Ron has created a very successful image, which would have tremendous potential in some of that stunning Scottish light.

Lochan na h-Achlaise. Here, the yellow reeds lean with the wind, reminiscent of oriental minimalist photography, and dwarfish trees cling steadfastly to the rocks. Macro photography of the lichen remind one of photographs of vast tracts of the African landscape taken through a NASA camera in space.

Here in this breathtaking landscape, hours can be spent on countless photographic opportunities. As photographers, we should always try to explore as many viewpoints as possible, to be sure of obtaining the most successful composition. However, the best views of this scene are found a mere few yards from the roadside, and Joe should know! On a previous visit he walked around the entire perimeter of the loch – which amounts to a good few miles – and didn't see anything to better the view we chose to photograph this day. OK, so its serenity is somewhat marred by the cars, motorbikes and vans which hurtle along the A82 at such a tremendous lick, but it's relatively easy to switch off from these once you start concentrating on your photography. And there was certainly a great deal to catch our attention, and be the subject of debate as to whether or not to include it in the frames we were exposing.

The colours we found by the loch side were exquisite. The greens of summer were starting to darken and fade, while yellows, browns and oranges were strengthening, and were highlighted by the remnants of the purple heather. The grey skies didn't bring out the colours to their best, but there was still a certain amount of brightness in the sky, which reflected in the loch, allowing the reflections of rocks and reeds to be included effectively in our compositions. There were still a few midges making their presence known, too! Lucky that Scotland looks its best in autumn and winter, when these infuriating creatures aren't at their peak.

Glencoe's majesty is a photographer's dream. The light can be among the best found anywhere in the world. Just not on this day, unfortunately!

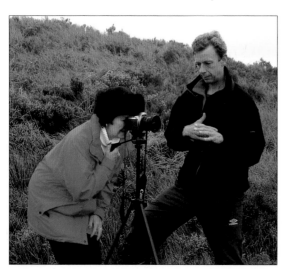

Below left Ann has chosen to use a wideangle zoom for her shot, for added drama and foreground interest

ANN SLOANE

Occupation *Library assistant*
Photographic experience *Five years – mainly outdoors and is a member of Inverclyde Camera Club*

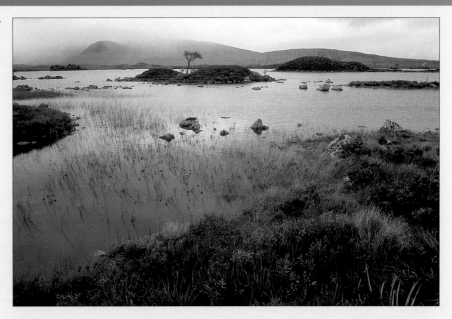

'During the drive to Glencoe I was living in hope that the weather conditions would improve, and the occasional bright spell did raise my hopes. After some discussion with Charlie and Joe, I was pleased that Lochan na h-Achlaise was the chosen spot for our photography. I decided at once that I wanted to include as many as possible of its varied elements within my photograph. I did also try to isolate some of the rocks and reeds in the foreground for a different type of shot, but with less success. This image conveys best to me the mood of this lovely place, and will be a reminder of a very enjoyable and rewarding day.'
Canon EOS 500N with Sigma 18-35mm lens, Velvia, tripod

CHARLIE'S VERDICT

Ann has included a lot of the foreground heather in her picture, and I can see why this appealed to her – the lovely fading purples contrast beautifully with the greens, and she has created a strong diagonal line across the frame. However, perhaps there is just a little too much foreground? I feel it might detract slightly from the skeletal shape of the distant tree. Having said that, she has chosen a composition which makes the tree stand out strongly against the misty backdrop. If the weather is going to be poor, you should still try to exploit it to your advantage, and Ann has achieved that.

DAVID MILLER

Occupation *Medicinal chemist*
Photographic experience *Three years – with a passion for the British landscape*

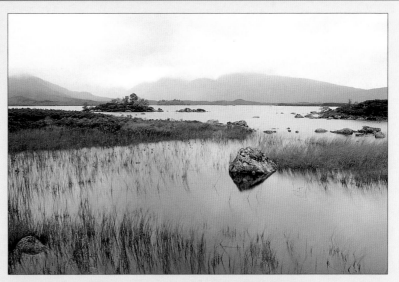

'My shot clearly shows the weather we experienced! Even in the short time before it started raining things were difficult. However, with Charlie's help, I think I achieved a good composition at a fantastic location. Initially, we considered the 'classic' scene, with the single tree on the island as a focal point, but my attention was drawn to a lichen-covered boulder surrounded by clumps of grass in the water. These grasses were swaying, so I looked to enhance that movement by slowing the exposure with a polarising filter in non-polarising mode. It's not a bad shot, all things considered, but oh for some of that wonderful Scottish light!'
Contax 139QD with Zeiss 28mm lens, Kodak Elite Chrome Extra Colour ISO 100, one second at f/22, grey grad and polarising filters

CHARLIE'S VERDICT

There is a sense of movement in this picture, as David has created a composition which leads your eye in a kind of zig-zag through the water and around the rocks. And while he has tried not to make too much of the sky, I feel that if he had brought the camera down just a touch, he would have cut out more of the sky and created a stronger diagonal with the foreground reeds. Or perhaps there weren't any more reeds to use in his picture! Also, the rock in the bottom left looks a little squashed, and would benefit from being given more space around it. Part of this image's success is the way the rocky outcrop in the top left third of the frame slots neatly between the dip in the distant hills.

Swell dale

Yorkshire doesn't come better than this – sunshine, blue skies and the rural charm of Gunnerside in Swaledale

Right Obviously taken in a contrasting season – in midwinter after a heavy snowfall – the barns and walls of Swaledale take on a more sombre mood in black & white. The snow has rendered the fields a blank white expanse, thereby adding emphasis to the shape and diagonal patterns of the walls *Hasselblad 500CM with 250mm telephoto lens, Konica Infrared, red 25 filter, 1/2sec at f/45*

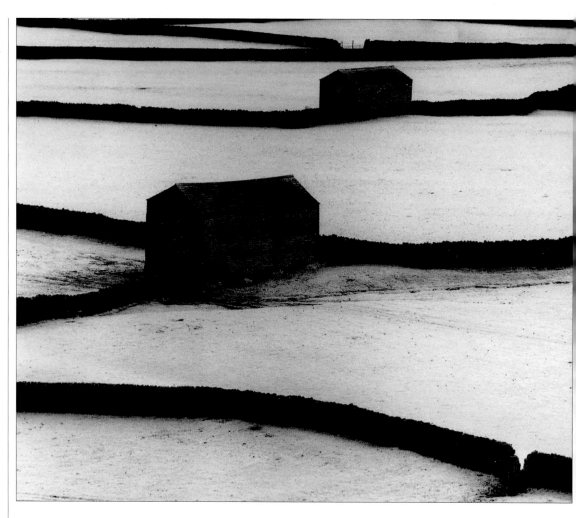

FOR BETTER OR FOR WORSE, the Yorkshire Dales are known the world over for a scenery that has been immortalised on screen by television favourites *All Creatures Great and Small* and, dare I say it, *Last of the Summer Wine*. Indeed, it could be argued that the success of these programmes owes as much to the splendour of their setting as to the script or characterisation. It certainly draws the tourists, who were much in evidence when we met at Hawes in the middle of Wensleydale.

sought out the crumbly white cheese that bears the name of this particular dale, we headed north, over the steep and winding gradient of the splendidly named Butter Tubs, to the village of Thwaite in upper Swaledale. From here the signposts direct you to a series of eccentrically named hamlets such as Muker, Ivelet, Feetham and, yes, Crackpot!

Our destination was a little less questionable – Gunnerside – on the northern bank of the River Swale. We drove through the

village and pulled up less than a hundred yards from outside its eastern approach where the view south across the dale affords one of the most English of summer views. It was the first week of May, and all the Herriot-like ingredients were there: spring lambs frolicking on pastures green, dry-stone walls and barns seemingly impervious to the elements, and glowing sunshine providing a wondrous respite from the five or six days of constant rain that had just swept across the land.

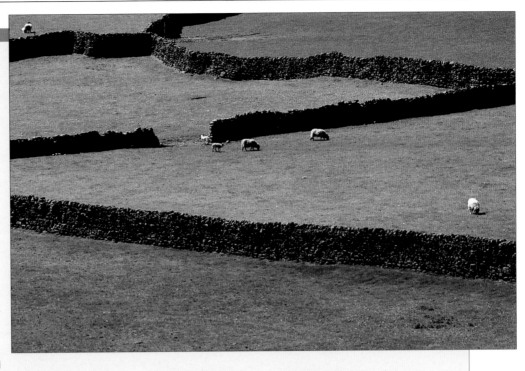

DOROTHY BURROWS

Occupation *Retired pharmacist* **Photographic experience** *Member of local camera club and enjoys wandering around with her camera – whatever the weather! 'I enjoy visiting other camera clubs and showing them my results.'*

'As I drove up from Shipley to Hawes I wondered just what had I let myself in for, but as the mist cleared from the fields revealing interesting light, I thought some good photography would be possible, enhanced by Charlie's expertise. It proved a fascinating experience helped by meeting kindred spirits and the light which held throughout the day. We met at Hawes and travelled farther north to Gunnerside in Swaledale and set up an elevated roadside location with extensive views up and down the valley.

Charlie reminded us of basic rules and demonstrated the use of black framing card to train the eye by avoiding distractions outside the proposed picture area. He also emphasised the importance of creative use of shadow for the elimination of unwanted detail and for the production of a more interesting image, particularly in early and late light. Although our photographs had to be taken around midday, this disadvantage was compensated for by the lower spring sun elevation. For my picture I tried to make a simple pattern showing wall textures and a good number of sheep!'

Minolta Dynax 700si with 300mm lens, Astia, tripod and Charlie's cable release, exposure not recorded

CHARLIE'S VERDICT

What strikes one immediately about Dorothy's picture is the absence of any barns. There is nothing wrong with this, as she has chosen to concentrate on the obvious geometrical patterns created by the drystone walls running diagonally across the frame. Dorothy could have further emphasised these diagonals if the foreground wall was running from the bottom right-hand corner of the picture. As it stands, there is too great an expanse of green in front, which lessens the impact of this geometry. I also feel that if she had moved a little to the left she could have included the conjunction of two walls to create a zig zag. When you have such distinct patterns or shapes in the landscape, cropping and framing take on even greater importance to the effect of a composition. Dorothy has come close, so close...

It was a perfect setting and, although the sun was high, the lighting was fairly even, its intensity interrupted by passing clouds. My companions for this photographic feast were Mo and Mark Newman, *On Location's* first married couple, and Dorothy Burrows who rose to the occasion by bringing her husband along for the ride too. We pulled up by the roadside and set up our tripods, lenses all pointing at the sweep of verdant valley with its zigzag array of intersecting walls and two storey barns running the length of the River Swale.

Upon first glance of such a well-lit scene, it may not seem like a difficult picture to expose, but time for careful observation must be taken to consider the subtle differences that are there, if not obviously so. For instance, there was a difference in the shading on the pasture looking down the dale compared with the more vibrant green directly in front of us. This was simply to do with the changing position of the sun and our own viewpoint.

Next, we had to consider the shadow areas in front of the barns and walls. Although narrow, these bands of shadow are dense and a strong contrast to the well-lit grass. Even though grass is one of the best midtones you can find in nature, the amount of contrast created by strong overhead lighting meant this was far from a simple greyscale scene.

We therefore had to decide what we wanted to represent in these pictures. The dominant diagonal lines of these intersecting walls and the resulting patchwork of elongated shapes meant there was more geometry in this small piece of Yorkshire than in all the works of Euclid. I advised the team to consider rendering these shadows as dark as possible in order to accentuate the obvious graphic patterns of this landscape. The simple means for this is through

Below Charlie uses his hand to shield direct sunlight from the front lens element of Dorothy's camera as she prepares to shoot

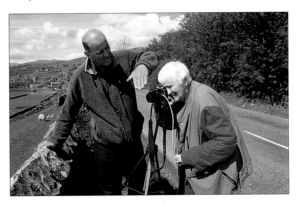

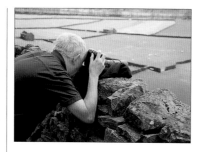

Right No tripod required – Mark uses a wall to prop up his camera as he takes another frame. A jumper proves a suitable substitute for a beanbag

the addition of a polarising filter. Many photographers use polarisers to accentuate clouds and darken pale blue skies.

In this instance, the filter's effectiveness depends on the position of the sun in relation to the plane of the front lens element. However, a polariser can be just as effective on a scene where no sky is included within the frame, as was the case here. Telephoto lenses and zooms were used to make tight compositions and I demonstrated how rotating a polarising filter can

Planning

Location Gunnerside is one of several small villages in the heart of Swaledale, the northernmost dale in Yorkshire Dales National Park.
How to get there From the A1, travelling north, take the turn-off for Richmond, just before Scotch Corner. From Richmond follow the B6270 west through Swaledale. The stone barns and walls are visible on your left just before you enter Gunnerside. Alternatively, from the M6 turn-off for Kirkby Stephen at Junction 38 on the A685. At Kirkby Stephen, follow the signs for Thwaite to the B6270.
What to shoot Apart from the stone barns and walls, the scenery around Swaledale is among the best in the dales. Rivers, heather covered hills and buttercup meadows abound.
What to take Telephoto lenses come into their own here, while a tripod is also a necessity. Polarising filters, lens hood, remote release are also vital accessories. Wear stout boots,

and have a tow rope in the boot in case you get stuck in the mud!
Other times of year As Charlie's picture shows, this scene takes on an even greater graphic emphasis when covered in snow – tailor-made for B&W.
Nearest pub The King's Head in Gunnerside fed us well and served a good pint.
Ordnance Survey map Landranger 98
Further information www.swaledale.net or www.yorkshire.co.uk. For accommodation contact Richmond tourist information on 01748 850252.

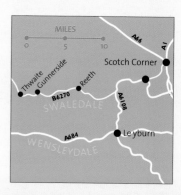

MARK NEWMAN

Occupation *Retired primary headteacher*
Photographic experience *Started taking photographs a long time ago but with more so over the past 10 years*

'I couldn't believe the weather that Charlie brought with him as the previous four or five days of that week had been very dull and grey. The midmorning light at Gunnerside was delightful but posed problems as the valley was strongly side-lit and clouds created frequent shadows. Charlie was an enormous help and encouraged us to see the possibilities for a wide variety of images within a fairly limited area of the valley floor.

The Swaledale fields and barns are very photogenic and I decided to focus on one particular barn and the dry-stone walls surrounding it. I'm quite pleased with this image but try as hard as I might I couldn't get the walls at the right-hand side to link the corners of the frame. I think, however, that the image shows the relationship between the barns, walls and the valley bottom to some effect, although the fragment of drinking trough

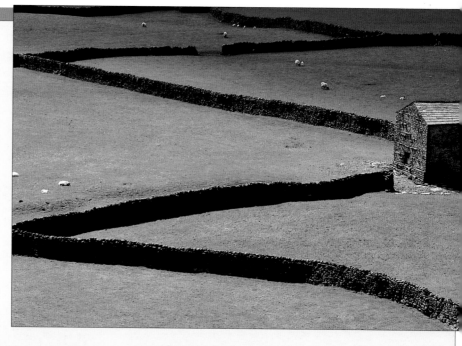

on the right-hand side is distracting – I will crop this out when the slide is printed.' (We've done it for you Mark! – Ed)
Nikon F90X with 80-200mm f/2.8 AF-D zoom at around 180mm, Fuji Sensia 100, tripod and remote release, exposure not recorded

CHARLIE'S VERDICT

Mark gets full marks here for boldness. Few photographers would have chosen to crop the barn in half, but the decision is the right one because he has sought to align the two points of converging walls with the left-hand edge of the frame. The result is a distinct zig zag line starting in the bottom right-hand corner that 'bounces' off the edges of the picture. I can suggest two small improvements. Firstly, a polariser would have made the walls darker and further emphasised the geometry of the picture; secondly, cropping out the wall running parallel to the top of the frame would have left an unfinished line leading out of the picture. Such a device makes the depth of the scene inconclusive and tantalises the viewer into wondering about the overall distance of the scene. An excellent result nonetheless.

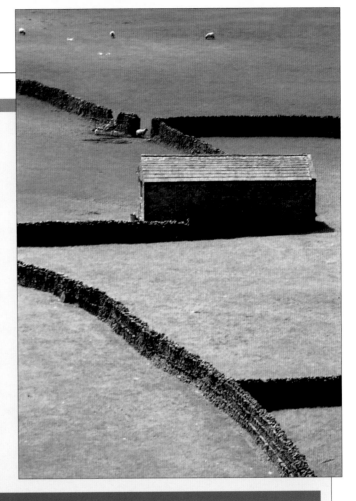

MO NEWMAN

Occupation *Retired headteacher*
Photographic experience *Started with a Box Brownie at Buckfast Abbey when she was nine and continued snapping ever since. Uses photography primarily for capturing textural and graphic images for weaving and painting, so usually uses print film*

'This was a superb location for me – full of very graphic images of the fields, walls and barns. The light on the grass was very challenging, particularly as we were shooting almost full contre-jour, and I don't have a lens hood for my Vivitar. Fortunately, Charlie's hand made a good substitute. I took several of this particular scene, both with and without the polarising filter. After much deliberation, I chose this shot (half polarised) because of the graphic structure, the contrasting light and the obliging sheep using the gateway!

There was an annoyingly distracting bath and slanting wall to the bottom right, which I excluded but found I had to compromise by including the riverbank shrubs across the top. When I got the prints back, I disliked the untidiness of these shrubs. Although they were parallel to the horizontal walls, the line was too weighty for the top of the picture, so I cropped it, and for me this maintains the graphic quality that I wanted to achieve.'

Nikon EM with Vivitar Series 1 70-210mm zoom, Kodak Royal 100, polarising filter, 1/4sec at f/22, tripod and remote release

CHARLIE'S VERDICT

Mo has all the elements for a good composition but I think she has been let down by her choice of print film. I'm assuming this has been machine printed in which case the machine has tried to render the shadow detail and overexposed the rest of the scene as a result. The roof of the barn is too pale and the grass has lost its verdant colour. Blasted machines! What remains within her control, however, is the composition and here I feel things may have been improved if Mo had taken the picture in landscape format, thereby aligning the converging walls on the left to the edge of the frame – much as her husband has done. But Mark, please don't say, 'I told you so!'

help fill in the shadow areas, blocking out detail and reducing the tiny but numerous highlighted areas of grass. In such a situation it's worth taking shots both with and without the polariser, and also bracketing either side of correct exposure by 1/3 to 1/2 a stop. Some purists may decry the use of bracketing exposures for being a lazy technique, but I freely advocate its use as it will improve your chances, providing, of course, that you're factoring in all the considerations that will affect the achievement of your desired result.

Lunchtime provided the natural and necessary break we were looking for. The sun's height was far from an ideal position, so we packed up and returned to our cars for what should have been the short drive back to the village pub. What was that I said about factoring in all the considerations? My driver, who allegedly doubles up as a magazine editor, hadn't factored in the days of rain that had soaked the roadside verge where he had parked.

Upon selecting reverse gear, releasing the clutch and applying the accelerator, one of the front wheels spun like a Ferris wheel on speed. We were stuck.

We pushed, heaved and shoved, we put down mats to try and get the tyres to grip – all to no avail. Those much-desired pints of bitter seemed an age away – should we retire to the pub and leave him to sort it out himself? Not necessary, for within minutes a passing Samaritan in a four wheel drive pulled over, got out his tow rope, tied the two vehicles together and rescued my driver and the Vauxhall from the mire.

I really do hope he doesn't give up his day job!

Below I knew we should have taken the four wheel drive! Cast and crew struggle to push the Vauxhall out of the mire

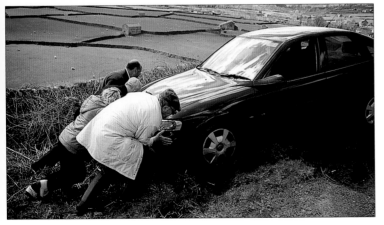

Tree treat

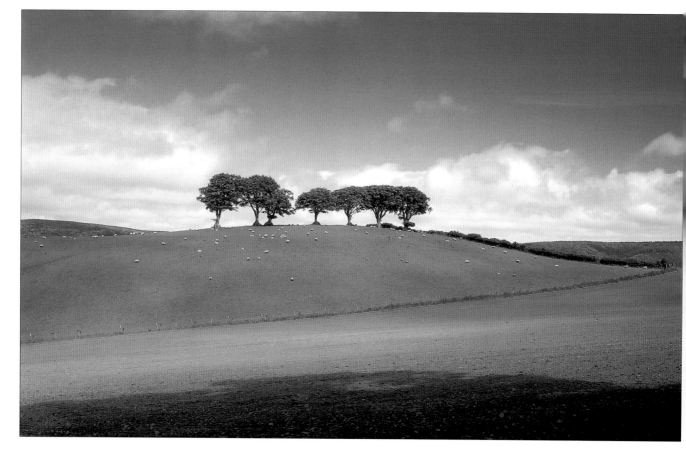

Sometimes there is a photo to be had in the simplest of landscapes. This line of hilltop trees in Exmoor is a perfect example

LONGER AGO than I care to remember, one of the first books of my photographs was published. In it was a picture of a line of trees which can be found in northern Exmoor. A decade or two later, I was in the area again, when Peter Hendrie, a friend of mine, showed me some rather lovely trees. I thought how

Above If it is perfect symmetry you are after, then these trees are not for you. However, for a lovely tree line standing proudly on the ridge I find them delightful. However, at the time of day we were there, the light was flat and there was very little sense of dimension.

Peter Hendrie and I had visited these trees a few days earlier, when I was fortunate enough to have some shadow. Unless you are after patterns or graphic shapes, a landscape – especially a large expanse – should always have depth. An image has to work hard on a two-dimensional piece of paper.

I shall return to these trees in the hope that, one day, I shall be able to achieve the picture which exists in my mind's eye. Looking at my list of UK 'return trips', I am rather alarmed to see that they are growing in numbers! Could this be something to do with our weather?

Above Just to prove he was there 20 years before everyone else, Charlie shows his rather elderly picture of 'Peter's trees'

SUE DURANT

Occupation *Art technician*
Photographic experience
10 years – she obtained her LRPS last year

Sue says 'Although I very much enjoyed the afternoon and found it informative, I struggled with the location in the brilliant mid-afternoon sunshine. In different conditions the trees would have been magnificent – perhaps with mist hovering in the valley, or late evening shadows – but on such a bright day the sun bleached much of the colour from the scene. I chose this monochrome image because I felt it had more atmosphere from this viewpoint and led the viewer into the scene. I was also intrigued by the gnarled tree roots themselves and might, on another occasion, concentrate in close-up solely on their shape, texture and pattern.'
Olympus OM10 with 50mm lens, Kodak T-Max Pro 100, 1/60sec at f/8, printed on Ilford Multigrade IV at grade 3

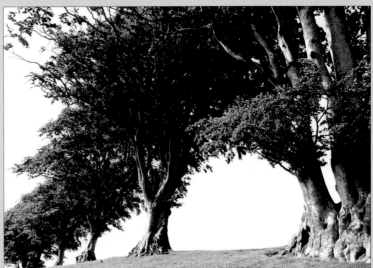

CHARLIE'S VERDICT

I could not agree more with Sue when she imagines the ideal for this scene. 'Mist hovering in the valley or streaking shadows.' Oh yes, Sue, I can see that alright! Our day was not ideal. I have always had an obsession about not cutting elements of the landscape in half if there is no need to. I would be the first to say that perhaps I need therapy about this! It is such a personal thing. However, I do feel that Sue's image would have benefited if there had been just a sliver of light appearing between trees and the right hand edge of the frame. There would have been a greater sense of separation if this had been the case. Sue's idea of working tightly with the gnarled roots would work very well and I would urge her to try it.

appealing they were and made a picture of them. But it took someone else to see the picture and remind me about it, before I remembered I'd photographed them already, all those years before! I was so grateful to Peter for re-introducing me to them, that to my mind they will always remain 'Peter's trees.'

The seven beech trees are splendid in their isolation, forming a line along the ridge of a hilltop. Their roots have grown over the remains of a now disused drystone wall, so it appears from a distance as if they are simply clinging onto the hillside!

There are a couple of different points from which Peter's trees can be photographed. One reveals the

Left Between them, our On Location participants used a variety of focal length lenses as this was a scene which lent itself to several different approaches

Above Ian buries himself among the profusion of nettles in order to shoot from his selected viewpoint

Planning

How to get there The road from which the pictures here were taken is too small to have a number, but it runs between Wootton Courtenay and Porlock. Use the OS map reference below to find the specific spot.
Time of day Early morning would be perfect as the shadows thrown down the hillside would give depth to the picture. Winter could potentially be a lovely time, because the skeletons of the trees would be isolated against the sky.
What to take A wideangle lens to make the most of the changing colours and textures in the foreground; polariser and ND grads, or red, orange or yellow filters if shooting black and white; tripod
Nearest pub The Exmoor White Horse

Inn, Exford (01643 831229)
Ordnance Survey map Outdoor Leisure 9, Eastern region, map ref SS 9045.
Recommended reading Exmoor and Beyond by Michael Milton, £12.99, Creative Monochrome, ISBN 1-8733-1924-X
Website www.exmoorattractions.com

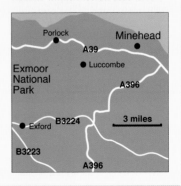

HILL AND DALE

PAUL MITCHELL

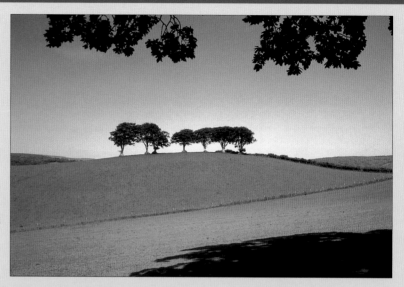

Occupation *Environmental scientist*
Photographic experience *18 years – landscape and nature, as well as a few family portraits*

Paul says 'To be honest, I'm not particularly happy with this picture – or any of the other results of the afternoon's photography, despite the fact it was so enjoyable and educational! This was virtually the first shot of the session. The afternoon was very warm, with a cloudless, hazy blue sky – ideal for sunbathing, but not landscape photography. I am reasonably happy with the framing, though the slide mount has just cut out the meeting of the hedge lines on the right – something I tried to include in the shot. I'd also have preferred a 'proper' hedge to the hedge/fence combination across the centre of the frame. I included the overhanging branch to break up the featureless sky and to match the shadow the same tree was throwing across the field in the foreground. The beech trees are smaller in the frame than I'd have liked, but at least their isolated position along the ridge of the hill is apparent.'
Olympus OM4 with Zuiko 35mm f/2.8 lens, Velvia, 1/60sec at f/11, polariser

CHARLIE'S VERDICT

Clearly Paul placed the overhanging trees along the top edge of the frame to break the monotony of the blue. Much landscape photography from the 1950s and 1960s used trees and foliage to frame an image, regardless of the prevailing sky. Some might feel that my image, without this 'support', is a little stark. It looks as if Paul has used a polariser in fully polarised mode. As a result, the precious shadow area (many photographers are obsessed with shadow detail – me included) has been rendered almost black. A little twist away from full polarisation would have saved it. The polariser is a wonderful tool, but although it does great things to our sky – when we have one – we should beware the effect it has on the land beneath!

IAN ROOKER

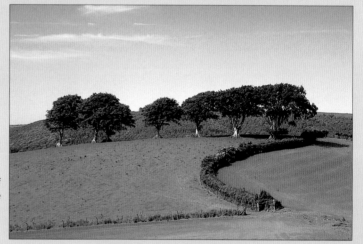

Occupation *Self-employed painter and decorator*
Photographic experience *10 years – mainly B&W for the past two years, shooting landscapes and portraits*

Ian says 'When I was invited to go on the shoot I was over the moon, especially as the location was Exmoor! When we arrived, the sun was quite high and the sky bare of clouds (the landscape photographer's friend). I tried a couple of vantage points, but the reason I opted for this composition was because of the curve of the hedgerow. It's pleasing to the eye, and the way the light hits the tree trunks manages to separate them from the background hills. I was going to shoot this scene in black and white, but changed my mind and decided to use Velvia instead to bring out the red of the soil, and to make the trees and sky as punchy as possible. I would certainly have liked more cloud (whinge whinge), and I'm not too sure about the green pathway in the right hand corner. I'll certainly return to give his another shot, either early morning or late evening, and have a go in black and white.'
Canon EOS 5 with 35-80mm USM lens, Velvia, 1/90sec at f/11, polariser and 81B warmup filters, Benbo Trekker tripod

CHARLIE'S VERDICT

We all bemoaned the lack of sky and there was no doubt that if we had had one in conjunction with more oblique light we would have been in business. Like Wendy and me, Ian was taken with sweep of hedge and I like the light coming from the semi-bleached feel of the trunks. I think he made the right choice by using colour for this image as black and white may have failed to separate the trees from the background. Greens are notorious for blocking up in B&W, especially when their light is absorbed by an orange or red filter. My feeling is that Ian could crop a portion of the sky (just above the two cloud streaks) from his image and possibly a sliver from the bottom. This would tighten up the photograph a bit.

WENDY NEWING

Occupation *Housing assistant with Sanctuary Housing*
Photographic experience *About 18 years - says she's still learning, with a long way to go!*

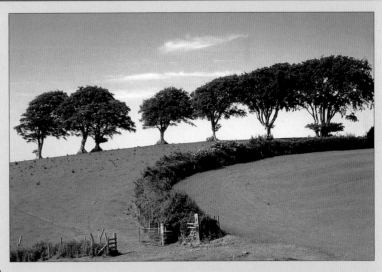

Wendy says 'I think we all found this location very challenging. If I had encountered the trees alone, I would probably have dismissed the scene as something that would not work. Otherwise, the keen macro photographer in me would have suggested I approach the subject really close. However, when I did go close and got the whole line filling my 28mm lens, the trunks were hidden by the slope of the ground and my idea was unworkable - although a 40ft ladder would have done the trick! I learned from Charlie that if your first instinct is that there is a picture in the scene, don't give up when you find the elements do not come together immediately. With his guidance I tried various viewpoints, some of which I would never have considered normally. The picture I have chosen is one of my attempts to get 'up close and personal' to the subject. I like the way you see more detail of the trees and the way they are isolated against a clear blue sky, with the colourful foreground - but I don't feel it conveys the magic of the scene to which Charlie introduced us.'
Minolta 9000 with 28-135mm lens, Velvia, f/22, polarising filter

CHARLIE'S VERDICT

I was very taken with this sweeping arc of wall and I could see what Wendy was trying to do here. To a degree, it has worked out. As with Sue's image, though, I feel that the edges of the frame could have been revealed against the sky a little more.

Wendy had a little tone in the sky and I am sure she was thankful for that.

The wall and hedge do lend themselves to the image, but Wendy's hypothetical ladder could have been put to good use here. The top portion of the wall merges with the base of the trees as it bends round to the right and seems to confuse.

Photography is a deeply personal artistic endeavour and comments such as these arise from my deep-seated way of seeing things – you don't have to agree with me!

rhythm of the land – in particular the hedges – while the other isolates the beeches against the sky. A potential problem with this scene is a white church, which sits on a hillside in the distance. While it is very pretty and has potential as a photograph in its own right, in this case it is not part of the 'story'. So efforts have to be made to crop it out of the frame.

While some cloud would have been preferable, to echo the shape of the ridge and trees, on this afternoon it was not to be. As a result, each photographer had to decide just how much of the clear blue sky to include in the frame, so the question of how to crop as a whole came under a lot of scrutiny. For me, to frame the trees too tightly seems a little mean – I feel they need to be allowed to breathe. Also, the big expanse of green in the foreground has the potential to make the picture rather two-dimensional. To overcome this, it would be ideal to photograph the trees at dawn, when the rising sun would cast long shadows, which would rake down the hillside. The idea of photographing this scene using the panoramic format is also very appealing. Again, the sky would have to be better, so the picture could be cropped quite tightly at the bottom, allowing the sky to make a statement above.

On our afternoon, the large oak tree next to us cast an extremely big shadow. It was then a question for our On Location participants of whether to include this shadow in the frame, and if so, how much?

There is a grandeur about trees seen in isolation from a wood and, some weeks earlier, when I photographed Peter's trees, a farmer stopped to talk to me. On hearing that I had photographed them – both many years before and on this occasion – he said: 'Oh well, I'm glad my Dad didn't cut them down then!' Any photographer passing this way should be glad too!

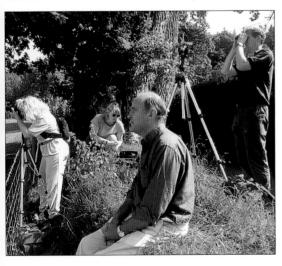

Above Charlie tries to imagine the trees crowned by a perfect sky, while our readers make the most of what they have

Imperfect day

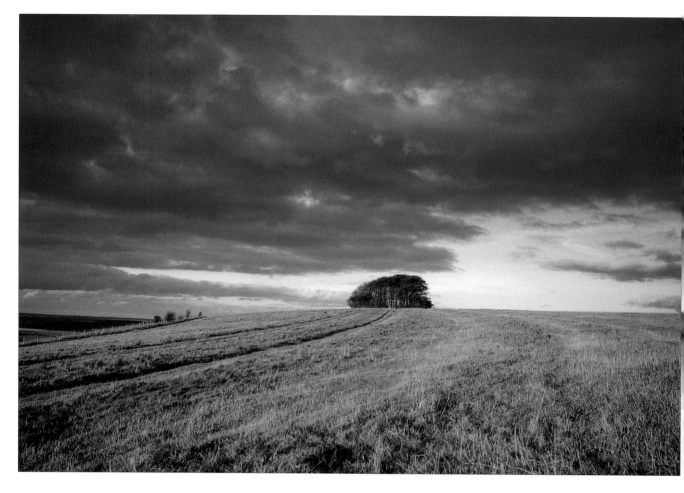

Above I was very lucky when I took this picture, as I had the kind of sky the others were after. The area of bright sky above the top of the trees was fortunate as it meant they didn't become lost in the dark cloud which covers the rest of the area. However, I do feel that I overdid an already dark sky by using a 0.3 grad. If I was to take this picture again, I wouldn't bother using one, as I don't believe filtration should ever be conspicuous

When you shoot a very simple landscape, you need the weather to be on your side. However, disappointing conditions need not prevent a productive day

THERE IS no greater challenge when photographing on location in the United Kingdom, than that presented by the weather. On this particular day our three participants – Murray Pearson, David McLean and Phil Taylor (all members of Gillingham Camera Club) – were challenged more than usual!

We had decided to meet at Win Green Hill, which is a location with a tremendous amount of potential – when the conditions are right. Of course, when we met in the car park at the top of Win Green, thick mist and a blank, grey sky greeted us. There was absolutely no chance of creating anything remotely dramatic that afternoon, so we used the time to really explore the location, with each member of the group

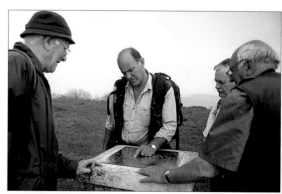

Above The On Location team check out the milestone at the top of Win Green to get their bearings

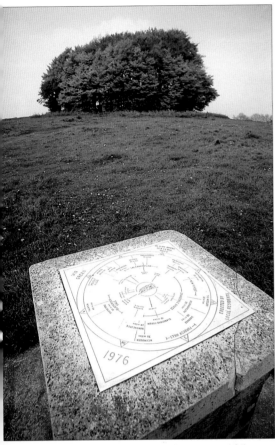

Above On a clear day you could expect to see many of the places indicated on the plaque. But this wasn't a clear day

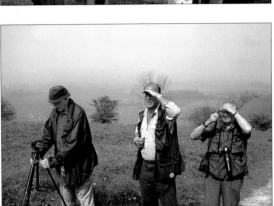

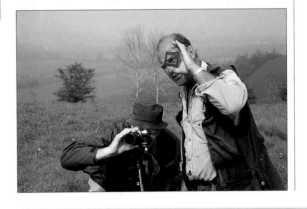

Left It wouldn't be On Location without Charlie's masking frames to help with composition. The nearer it is held to the eye, the more wideangle the aspect, while the further away, the more telephoto – and you don't even need to get out a camera or lens until you've decided!

deciding which angle they would shoot from when the conditions came right.

Win Green Hill is what I call a 'single element' landscape. It has just one strong focal point, so relies on outstanding light and skies in order to make an effective photograph. I was fortunate enough to have had wonderfully atmospheric conditions when I took my photograph shown here, but no such luck was to be had on the day of our shoot.

Above Refusing to be thwarted by the mist, Murray, Phil, David and Charlie decide to check out potential vantage points

Planning

How to get there Win Green Hill can be reached off the B3081 between Shaftesbury and Tollard Royal. There is a car park.

Time of day The later the better

What to shoot There is only the clump of trees on top of the hill, so wait until the light is perfect before making the journey. There are spectacular views across Wiltshire and Dorset from the top, too.

What to take Polarising filter and neutral density grads to make the most of the sky; a saturated film such as Velvia enhances the greens in the summer months; a wideangle lens will allow you to make the most of both foreground and sky.

Nearest pub The Half Moon, Salisbury Road, Shaftesbury; The Crown, Alvediston

Ordnance Survey map Landranger 184 or Explorer 118N; grid ref ST9 220

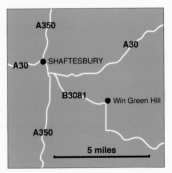

HILL AND DALE

MURRAY PEARSON

Occupation *Retired bank official*
Photographic experience *Rather longer than he would like to say!*

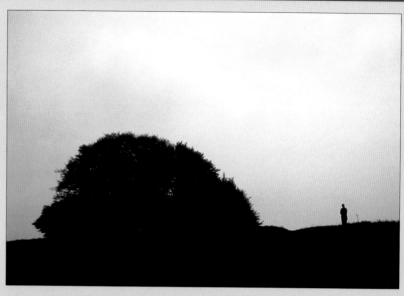

Murray says 'Win Green Hill is a great location for photography – when the light is right! I had been there on several occasions prior to this shoot, with better luck and much more promising results. And because the day of the shoot with Charlie was so misty, I re-visited Win Green five more times – including one early morning and two late evenings – and the sky remained pretty lifeless each time. Of course, on the day I sent my picture to the OP office, it was fantastic! For this picture, I tried to make the best of the conditions I had, and attempted a silhouette which, I discovered, would need good evening light in order to be successful. I don't feel this shot has quite worked, but it's now a target for me, so I'll keep trying.'
Pentax MZ-5 with 35-135mm zoom, Kodak Select Elite Chrome 100, exposure not recorded!

CHARLIE'S VERDICT

The concept of a silhouette was a very good one, but unfortunately I feel the clump of trees gets lost in the solid black band along the bottom of the frame. With silhouettes, you have to be able to identify what they are, which isn't so easy in this case. Next time I suggest he goes in very close with an ultra-wideangle lens like a 17mm, in order to see the light coming through between the bases of the trees. This would then have made the distinction between the trees and the ground. Also, the person looks rather static, so perhaps they could be walking next time? Despite this, it does have quite an interesting, science-fictional feel to it, and I definitely think Murray should have another go as he's halfway there already.

PHIL TAYLOR

Occupation *Retired civil servant*
Photographic experience *Dabbled since age 10, but with more enthusiasm and better equipment in the past five years*

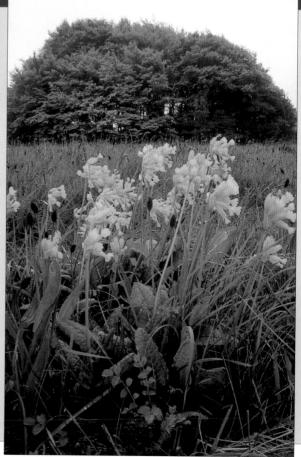

Phil says 'I had not been to Win Green before and was impressed by its potential, despite the heavy mist. The copse of trees dominated the hilltop and demanded a dramatic sky to crown it. On the day, however, I was more interested in the display of cowslips growing on the eastern side which cried out to play a part. Later in the day I selected a group that approximated the shape of the copse and chose a low viewpoint to give them the dominant say in the composition. Further emphasis was provided by an off-camera flash. But I wish I hadn't overlooked the dead grass in the bottom right of the frame!'
Canon EOS 5 with Tokina 20-35mm lens, Sensia 100, 1/2sec at f/22, polariser and Canon 300EZ flash

CHARLIE'S VERDICT

Given the dreadful conditions, Phil was clever to cut out as much of the sky as possible, and this is a well observed composition. It was also rather smart of him to use flash to brighten up the cowslips. However, I would like to have seen the mound of trees in their entirety, whereas Phil has cut them off at the sides. If he had pulled back just a little, he would also have included the cowslip to the left of the frame which has been cropped, too. A mild ND grad – about 0.3 – would have darkened the sky and trees and thus emphasised the yellow flowers even more. I agree that the straw is a distraction, but unfortunately post natal classes are no good – you have to be pre-natal!

DAVID MCLEAN

Occupation *Retired contractor*
Photographic experience *Around 16 years - an interest which really took off on joining Gillingham Camera Club*

David says 'Although I enjoy all kinds of photography, landscape is the one area that I don't feel comfortable with. Fortunately, Charlie has a very relaxed approach and passed on many useful tips in a very short space of time. As soon as I saw Win Green, I knew I wanted to shoot it from a low viewpoint with a wideangle lens to emphasise the path which leads towards the clump of trees on the hilltop. I thoroughly enjoyed the challenge and look forward – with some trepidation, I have to say – to hearing his comments on the end result!'
Pentax Z10 with 28-80mm lens, Fuji Superia 200, 1/250sec at f/11

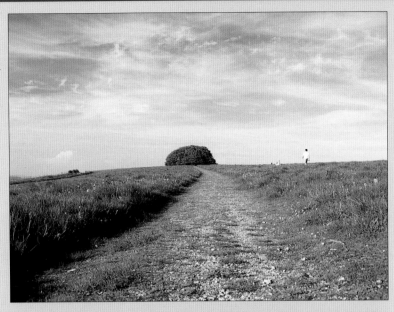

CHARLIE'S VERDICT

Although David feels the sky isn't up to much, he has in fact got some lovely delicate chiffon-like cirrus clouds. In fact, I would have been bolder and allocated even more of the frame to the sky in this case. As with Phil, fitting a grad like a 0.3 ND would have helped emphasise the sky further. The person gives a nice sense of perspective, but – although I know David couldn't help it – it would have been better if they had been wearing dark clothes. Next time I'd advise taking a friend up (making sure they're dressed in dark colours), and getting them to stand in different places – on the path, in the right hand corner, that sort of thing. I like the confident composition, with the clump of trees slap in the middle of the frame.

Murray decided there was potential in showing the clump of trees as a silhouette but, after trekking down the hill to find a suitable vantage point, the trees alone did not provide sufficient interest. Enter Phil, one of our other participants, who temporarily abandoned his camera to become a model. Silhouetted against the sky, he provided not only a sense of scale, but also enough interest to break up what would otherwise be a featureless gap in the frame. The lovely thing about silhouettes is that they are so easy to meter – either

Above There's nothing like getting your knees dirty to feel you've done a good day's work. Charlie and David get down to ground level in order to emphasise the lead-in line of the pathway which takes you towards the clump of trees

just set the aperture you want and go with the automatic shutter speed which the camera selects, or take a meter reading from the brightest area of the sky and set that manually on your camera. Either way, you'll have a perfect silhouette.

For David, a more traditional view of Win Green appealed. He selected a strong composition, in which the viewer's eye is led up the path towards the trees. To make the most of this graphic lead-in line, a tripod which goes down very low, and a wide-angle lens are essential. David had both, so set his zoom lens at the 28mm end before taking the reference shot which he would then use to re-compose when (fingers crossed) the weather improved.

As Murray had taken his shot from the back, and David from the front, Phil was left with a sideview, and he took a very innovative approach indeed. There were dozens of beautiful cowslips scattered across the fields which surround Win Green Hill, and Phil saw fit to include them in his composition, using the very wide 20mm end of his zoom to emphasise them in the foreground.

Unfortunately, despite numerous further visits to the scene – they did nothing if not persevere! – luck was not on the side of our three photographers. The weather was unremittingly dull and refused to create any kind of interest in the sky. Tenacity is always the key to landscape photography, however, and I have no doubt that Murray, Phil and David will soon achieve a winning image of Win Green Hill.

Weighing up history

Sometimes the disappointment of bad weather conditions can be a blessing in disguise, as three eager amateur photographers found on a trip to the historic site of Avebury

Right Three well separated components make for a good composition in Charlie's photograph. The relationship between the solidity of the rocks and the delicacy of the tree add to this pleasing quality *Hasselblad with 50mm lens, Konica infrared, 1/15sec at f/22*

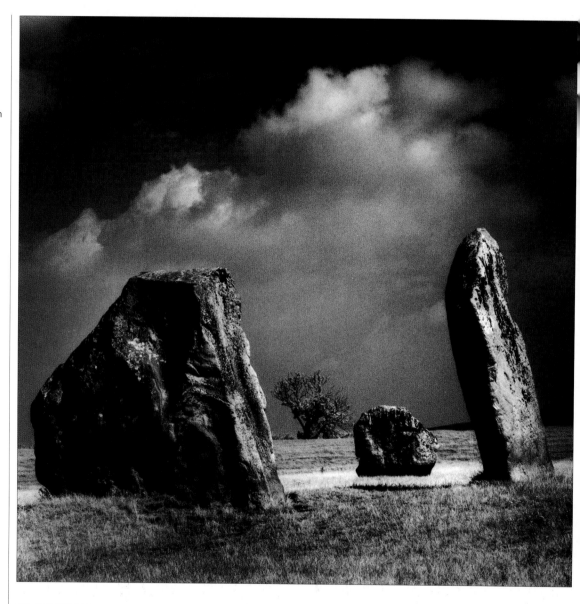

SO, WHAT DID we expect? It was January in the south of England and, having lived through a glorious phase of early winter, when the sun shone and a crisp, sharp cold brought frost to the mornings, we were bound to be disappointed. Sure enough, the greyest day in the history of meteorology descended upon us.

Now, this wasn't a bad thing. Instead of succumbing to the temptation of hurling ourselves out of our cars, desperate to catch the magnificent light, and snapping away, we had the opportunity to research the site of Avebury, and come to understand what we wanted from it.

Avebury is an extraordinary place, full of mystique, and you really need to immerse yourself in its atmosphere. In winter it becomes a stark scene that enhances

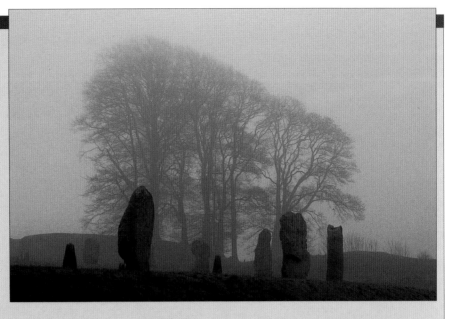

PAUL RAYNOR

Occupation *Quantity surveyor*
Photographic experience *Started in his teens to record motor racing, but photography soon became the main interest. An active member of camera clubs for 25 years*

'I enjoyed the day immensely, despite the lifeless lighting. Charlie's enthusiasm was infectious and led me to consider the different aspects of taking a picture, although it was not possible to exploit these to the full at the time because of the poor light. I returned a few days later, but the weather was no different even though I had travelled through some brilliant sunshine on my way there. It would have been nice to have some sunshine or thick fog, but I had to make do with an overcast sky and a constant mist.

I concentrated mainly on detail shots of the stones, trees and lichen, but these failed to give me the 'feel' of Avebury. The picture I have selected was taken from within the ditch surrounding the outer stone circle, so as to set the stones against the distant trees which in themselves serve to break up the bland sky. A short telephoto lens has helped the atmosphere of the picture by enhancing the effects of the mist.'
Canon AE1 with 70-210mm zoom lens at approx 135mm setting, Kodak Elitechrome Extra Colour 100, 1/15sec at f/11, tripod

CHARLIE'S VERDICT

This is an image that has an excellent atmosphere and Paul has shown a skilful attention to the design.

This image conveys both mystery and a sense of foreboding which results in the viewer thinking that perhaps there may be a ritualistic ceremony about to take place, filling the still air with the sound of howls and chants.

If that was my response, which it genuinely was, then the image has affected me, which means it is successful in that it produced an emotional response.

I like the fact that the camera angle was set below the stones, lending them a sense of dominance and power. Not one stone masks another, allowing each to make itself known. This is a truly admirable achievement, and it is evident that this image has been lovingly attended to.

this sense of history and magic. The stones themselves are quite magnificent – many of them have a pale coating of lichen – and in the background there are lime trees that, at this time of year, have a skeletal look about them. This kind of scene often lends itself rather well to black & white and, with a little judicious filtration, you can get a lot out of it.

The shapes of the stones are very interesting in that they change shape considerably when you move just a few feet to the left or the right, so you need to spend some time finding out what the best vantage point is.

A close-up shot could also prove to be a promising idea – the surface of the stones is very mottled and they are covered in lichen which is delicately coloured because of its age. To get the best from this you would need good light so that the modelling of the stone would be accentuated. Some time ago I was out with a group and came across a photographer called Ian Fairgreave, who used to be the harbour master at Inverness, on his knees in the process of photographing some lichen. He had a medium format camera and all the extension tubes and such, and I asked him if I could have a look. 'I'd rather you didn't,' he replied, 'because I have an idea.'

A couple of months went by and then eventually this wonderful print arrived, 20x20in, showing a little bit of lichen the size of my thumbnail – and it looked just like

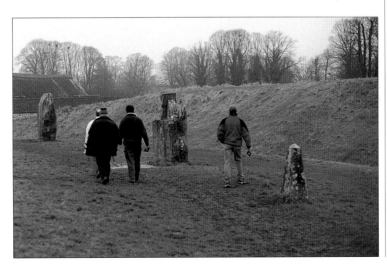

Left A walk around the stones, looking for the best viewpoints, proved a productive way of using the time when photography was impossible because of the poor light

Right Charlie, Mal and Paul study the texture of the stone with close-up shots in mind

a NASA spacecraft looking down on the planet earth. It was the most sublimely beautiful picture full of rocky mountains and rivers, streams and valleys – and yet it was just this tiny piece of lichen.

Planning

Location Avebury is situated in Wiltshire, between Devizes and Swindon, and just to the west of Marlborough.

How to get there Take the A361 from Devizes to Swindon (or vice versa) and you will come to Avebury about half way along the road. Alternatively, take the A4 from Marlborough to Chippenham (or vice versa) and turn off to Avebury at the signpost. The nearest train station is at Swindon.

What to shoot The Neolithic stone circle at Avebury is more than 4,000 years old and is one of the largest prehistoric henges in Britain. It has been designated a World Heritage Site.

What to take A range of lenses from wideangle to macro. Suitable clothing and footwear depending on the time of year – it can get pretty muddy when wet.

Other times of year All year round is good but bear in mind that it is a popular tourist location so if you don't want people in your photographs, dawn is the best time to get there.

Nearest pub The Red Lion in the centre of Avebury offers both food and accommodation and we hear rumours that it has its own resident ghost. Tel: 01672 539266.

Ordnance Survey map Landranger 173 Swindon & Devizes, Marlborough & Trowbridge.

Further information www.tourist-information-uk.com or Avebury Tourist Information Centre 01672 539425.

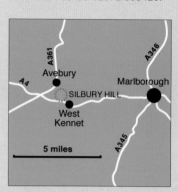

STEVE ROBERTS

Occupation *Software engineer*
Photographic experience *Started at school and began to take it more seriously when he joined his local camera club almost eight years ago*

'Our initial discussion with Charlie was very useful – he suggested that we set ourselves projects and aim at publishing, even in a small way, or exhibiting our work. This, he explained, was a great way of re-creating the enthusiasm for photography that can sometimes get lost in everyday life.

The best part of the day, for me, was the walk around Avebury discussing with Charlie what we saw, making use of framing cards – without the added weight of cameras and tripods to distract us! I will definitely consider taking this approach more in future.

This picture was taken a few days later. I like the lines formed between the trees and the stones – I tried cropping out the right hand tree but didn't like the result as much – and I love the sky!

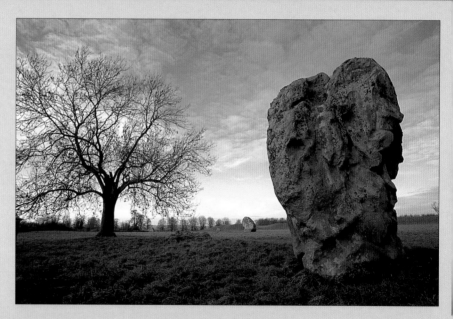

It's a shame the nearest stone is a bit underexposed but a small sunset glow around the top of the stone helps offset it just a little.

The next step is to re-take the scene and get some more light into the foreground – some ground frost may well help.'

CHARLIE'S VERDICT

This photograph has a wonderful 'dawn of time' atmosphere – and atmosphere is one of the most crucial elements of any successful landscape photograph. The craggy stone, with its wonderful sense of permanence, so decisively placed, acts as an excellent foil to the filigree nature of the silhouetted tree to the left. The distant line of trees beyond, diminutive though they may be, read very coherently and help to lend further order to the image.

The sky is perfect for the mood and the transition from the ice blue light just above the line of trees to a deep blue canopy higher above is lovely. I am puzzled by one thing; the cropping of the wonderfully fan shaped tree. I am sure there was a reason. Despite that niggle, it is clear that great care and precision has gone into this image. It has been nurtured the whole way and it shows.

MAL ASTON

Occupation *Retired marketing and promotions manager* **Photographic experience** *20 years with the last five years being devoted to landscape photography*

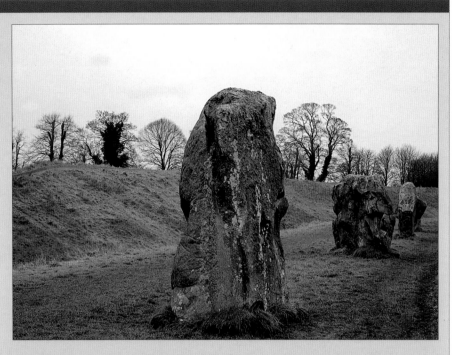

'I found that to take a photograph which says 'Avebury' was extremely difficult from ground level, because you are faced with the large stone circles and earthworks, in the centre of which the village has been built. To add to the problem the village is divided by the main Swindon to Devizes road.

The day of the shoot presented us with a bland grey sky and no hope of the magical cross lighting necessary to show the texture and relief of the stones at their best.

The fact that taking photographs on the day was not worthwhile, proved beneficial in that we were able to research the location fully and discuss details with Charlie before considering taking our cameras out of their bags. A valuable lesson was learned – research the location.

I revisited the site three more times, just after dawn, in the hope of finding some magical light. This was not to be and, to meet the deadline, I had to accept the existing conditions – grey light, grey sky.

I chose to shoot a very small section of the stone circle with one large lichen-covered stone in the foreground and earthworks, topped with beautifully shaped skeletal trees, in the background. I have tried to place the top of the stones between the trees so the tree shape is not lost.'
Hasselblad 503W with 80mm lens, Velvia, two seconds at f/22, 81B warm-up filter

CHARLIE'S VERDICT

It is often so hard to judge from one's home what the weather may be like 40 miles away. Very rarely does listening to the weather forecast provide confidence.

I know that landscape photography demands an enormous investment of time and commitment and sometimes, despite that dedication, the light is simply not good enough.

This is a bold composition that, with good shadows and some tone in the sky, would have been very successful.

It has not failed, though. I like the way the mighty central stone has been carefully slotted in between the two distant trees and, although the lower branches had to be cropped by the upper part of the stone, they still contrast well with the

stone and its markings. Diagonals are often fascinating to work with in the landscape and this image, with early morning light perhaps giving long shadows across and possibly even travelling up the bank to the left, will, I am sure, work well.

This will, of course, mean that Mal has to take a yet another trip back to the stones!

Composition

There were times, early in my photography, when I didn't consider all the components of a photograph – I would think: 'There's a standing stone – I'll photograph it.' But then, over the years I started thinking about all the other parts of the picture that are so crucial. In Avebury, the main feature is, obviously, the standing stones, but everything else in the photograph must add something to the overall effect. Deciding where you are going to place the stones within the frame is the first step – would you rather the stones stood alone, or are they masking one another? I always think with landscape photography,

what we are trying to convey is a sense of depth – all sorts of things have to be thought of here – dimensions, scale, shape, distance. So when you mask one thing with another it denies the viewer this, whereas if you can create various planes it helps to convey it.

You might want to establish a relationship between the stones and the trees in the background. You need to decide what you find acceptable and what you do not – do you mind not being able to see the base of that tree? Should you move to higher ground to get it in, or even bring a stepladder?

You might decide that you want to bring in a sense of scale to emphasise the grandeur of the

stones, in which case you could introduce a human figure into the picture. When we first arrived there was a young woman with long purple hair walking around the stones – she might have added a little drama to the scene.

Take your eye around the perimeter of the viewfinder and decide whether what exists around the outside edges supports what exists in the body of the image – it is too easy to become preoccupied with the centre. Of course, you can crop but there is an awful lot of satisfaction to be had from composing in the field.

Don't rush what you do, allow yourself time to do it well. Don't panic, just relax about it.

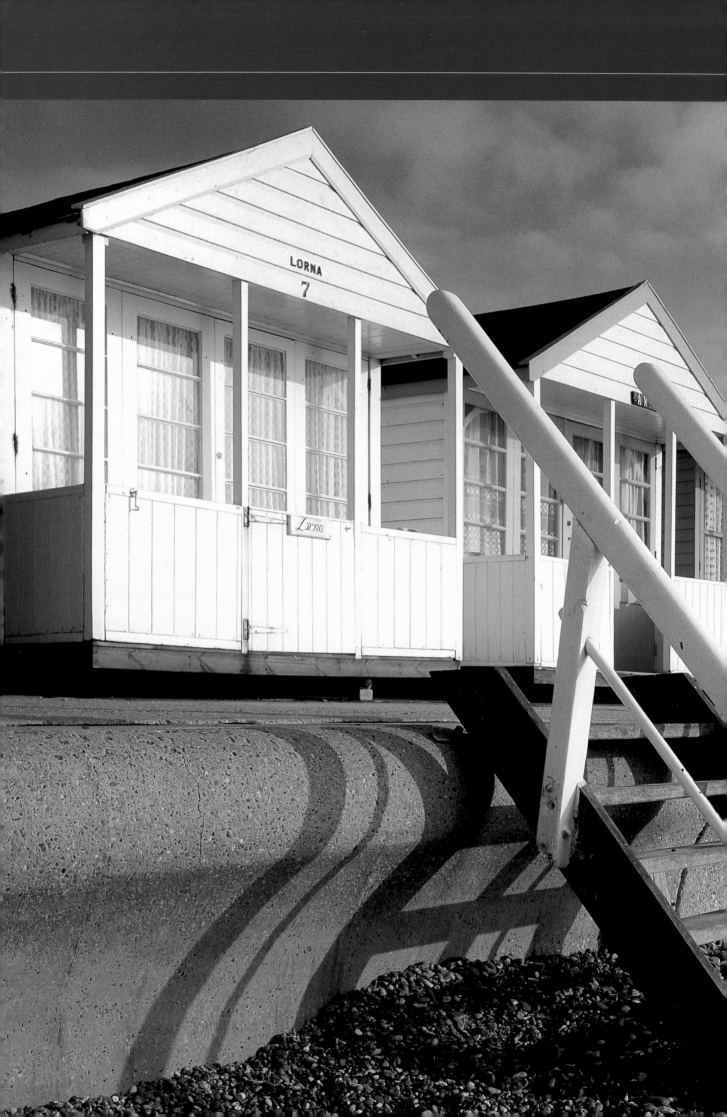

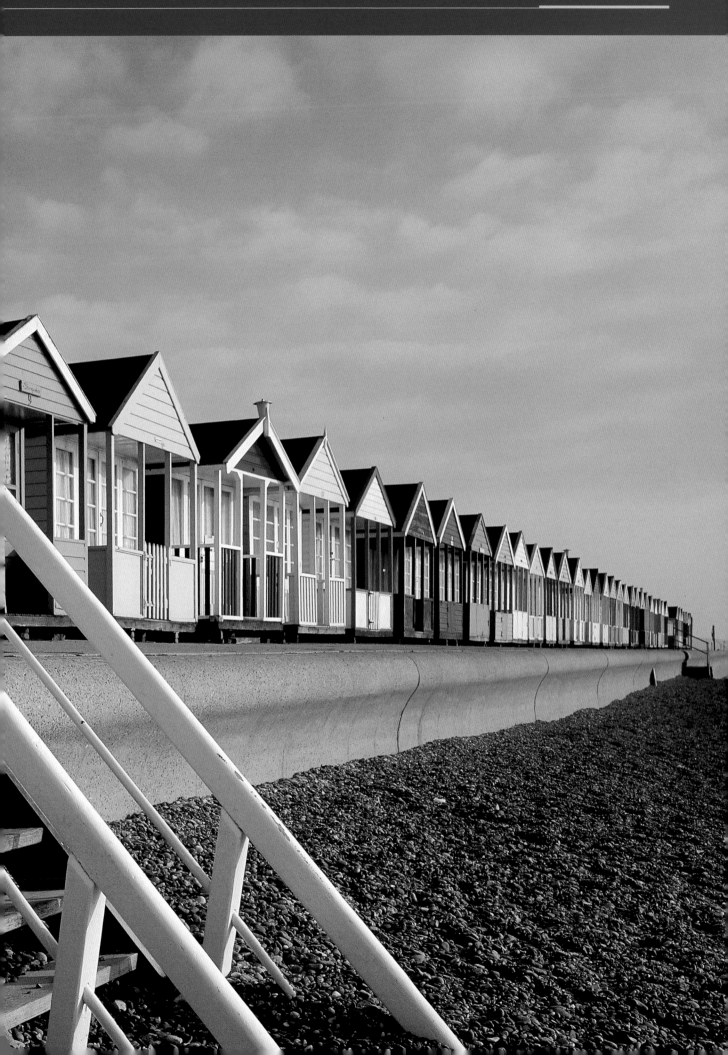

Not to be mist

For some dramatic scenery head to Barmouth on the west coast of Wales where the Mawddach estuary and mountains of Cadair Idris provide a stunning spectacle – when not shrouded in mist, that is...

Right Hard to believe this picture is nearly 20 years old, but I can't deny the advancing years! I'm rather pleased that while I am more experienced now, this early black and white doesn't cause me to cover my eyes in embarrassment like so many of my earlier efforts
Hasselblad 500CM with 150mm lens, Kodak Plus-X Pan, exposure note recorded, 1982

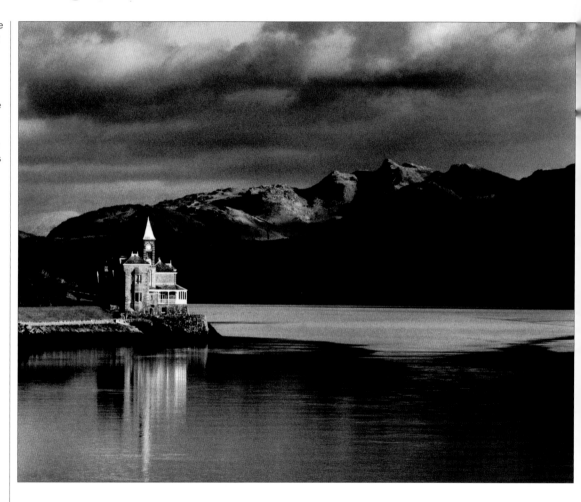

IT WAS AN early August Sunday and the weather was perfect for driving through the Cambrian Mountains to the coastal town of Barmouth. The sun was out, the hills and valleys as green as baize and there was even enough cloud in the sky to keep me happy for the prospect of the next morning's photography!

Alas, in Wales it's not just a woman's perogative to change her mind - here, the weather is even more fickle. I awoke in the early hours of Monday morning to the sound of torrential rain. The view from my window, which the previous evening had framed the estuary, mountains and a mirror-calm Irish Sea washed in the golden light of sunset, was now a grey blanket of impenetrable mist. From the floor above I'm sure I could hear the editor wailing like some condemned animal as he was struck by the prospect of no photography and three readers having taken time off work expecting just that.

Then, another change of heart - our mistress decided to stop raining. The mist lifted to around 500ft which blocked out the mountains but restored the estuary to view. At least we would be dry, and meter readings would be fairly straightforward.

We met at the tourist information centre, had a coffee and then drove up to the appropriately named and steeply inclined Panorama Road on the north side of Barmouth to take in the view of the upper reaches of

ALEN JONES

Occupation *forklift driver*
Photographic experience *More than 20 years, landscapes are my favourite subject.*

What a privilege it was to meet Charlie Waite. His easy going manner put us all at ease right from the start. It was really interesting, listening to him talk about different aspects of filtration and pointing out features in the landscape. It was just a pity the weather was so poor. I decided to return a few days later and I was lucky enough to get much better weather.

In the picture that I chose, I tried to use the drystone wall, to lead the eye across to the estuary on the right, which in turn draws you into the main body of the picture and onto the Cambrian mountains in the distance.
Bronica ETRS with 75mm lens, Velvia, polarising and 81B warm-up filters, 1/2sec at f/22, tripod

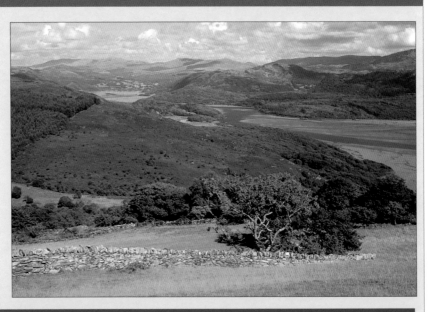

CHARLIE'S VERDICT

This image is what I often call the 'Grand Vista' normally hard to grapple with. Alen has fitted everything together very well and I know that it was the product of returning a long way to get it. Landscape photography is rarely gifted to us (sometimes it is), and the effort that Alen has put into his picture has been well rewarded.

The drystone wall is the anchor to the image and its diagonal nature lends a sense of order to the foreground, the band of pale grass almost echoing it as they both sweep across the image. I like the way the tree has been lit, setting off against the dark, light-absorbing hill cover beyond. To have seen a little more water might have been nice but at that time, the evening light just refused to coincide with high water. The image is not diminished by this however. I wish I could have been there with Alen, not to interfere but just to nudge him into using a neutral density graduated filter. If the landscape photographer has nothing else, the ND grad is crucial. It seems to me that here a 0.45 or thereabouts might have done the trick. Skies are just so important and if we are blessed with a good one as Alen had here, it is so agonising to see it go to waste through over-exposure.

Of course, if a print were to be made then the sky could be salvaged, but to get it all right on the day is ultimately more rewarding. The river seems about right but we all get perplexed when to our eye rivers appear to look 'not quite right, seemingly flowing uphill or at too much of an angle downhill. The horizontal mountain ridges inform us that all is well however.

A fine majestic photograph.

the Mawddach estuary. We were now facing east with the Cambrian Mountains on the horizon and the slopes of Cadair Idris immediately to our right. Because of the heavy veil of mist that hung above the valley, the position of the sun was an irrelevance, but I remained hopeful that with the westerly wind the mist would blow over and shafts of sunlight would break through.

Despite the flat lighting and obscured mountains, the foreground of our composition could still be addressed. The first things we noticed were the sheep, not an uncommon sight in this part of Wales, but blue sheep were not what we expected! Such was the farmer's heavy use of blue dye to mark the fleece, that we clearly had to consider expunging these woolly jumpers all together from our picture. Entirely possible with Photoshop, of course, but the purist within me dictates that one should wait for the sheep to move or reframe to avoid these blue blots on the landscape. The other consideration was a distinctive five-bar gate, obvious enough to be noticed in the frame, but not big enough to be a focal point. Do we hide it in the foliage of the trees or move to include its lines clearly in

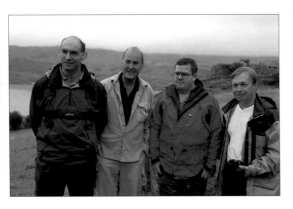

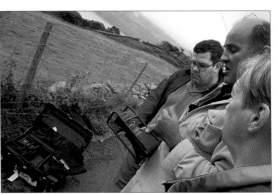

Far left Stephen, Charlie, Alen and John take in the view from Panorama Road

Left Charlie gives Alen and John a privileged peek at one of the lenses for his Fuji 6x17 panorama camera

Planning

Location Barmouth is situated on the west coast of Wales at the north end of Cardigan Bay. It is surrounded by the Snowdonia National Park at the foot Cadair Idris

How to get there Follow the A470 for half a mile north out of Dolgellau then turn left onto the A496. Barmouth is 10 miles along, you can't miss it!

What to shoot There are plenty of vantage points for shooting the estuary with its fishing boats and pleasure craft. Both the harbour wall and Barmouth Bridge give excellent viewpoints, but the Bridge is also an obvious focal point. Panorama Road rises steeply above Barmouth and gives a wonderful view up the valley to Cadair Idris and beyond.

What to take Waterproof boots or Wellingtons, tripods, and a range of lenses from wideangle to long telephoto. A selection of polariser, ND grads and warm-up filters and consider hiring a panorama camera for a weekend.

Other times of year Autumn for the colours and winter when the air is clear and the mountains are covered in freshly fallen snow.

Nearest pub The pubs were all extremely busy when OP visited Barmouth. The Crown did good food, steaks being a speciality. Tea shops and cafes were also in abundance

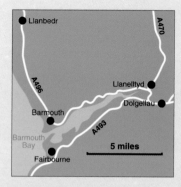

Ordnance Survey map Landranger 124

Further information Visit www.barmouth.org.uk for general information about the area.

the scene? It provided our readers with a dilemma that was more a niggle than an irritant. By contrast a dry stone wall running from left to right, made for an excellent lead-in line to the middle of the composition, and as the tide receded we began to notice a lovely s-shaped rivulet forming in the sand of the estuary. Although small, it became a focal point that added balance to the scene.

STEPHEN GILES

Occupation *Trainee orthopaedic surgeon*
Photographic experience *Since 1990 when I bought a secondhand Nikon FE2 for a college trip abroad. Self-taught by reading books and magazines*

The rain lashed down, the clouds hung low
Up on a hill, five men in a row
Cameras in hand, shutters at the ready
Tripods set up to keep it all steady
The Ed' was determined, it's not much of a scene,
But pictures I must have for the next magazine!
Viewfinders were blurred, few details to show,
But all the light's gone wailed the pro!

Don't get the wrong idea from the above! This day was one of the most useful and informative days I have had in understanding photography. Charlie Waite's enthusiasm is infectious and he clearly and simply explained his approach to each particular shot. For my picture I used the grass as a lighter foreground and allowed the wall to lead the eye into the scene. The white gate was a point of

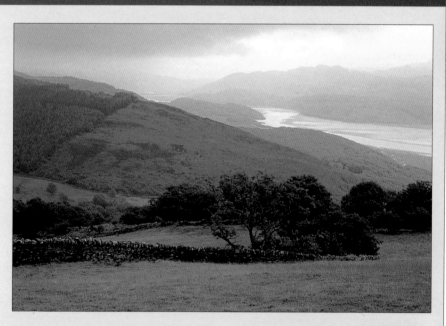

discussion. Show it or hide it? In the end I tried to frame it in the tree branches rather than partially hide it. For the mid distance interest I used the hill on the left and the heather, with the line of trees to lead into the far distance. The sky was dull grey so I cropped it out from the shot in camera and darkened it further with a neutral graduated filter. The scene was warmed generally with an 81B filter. The scene had great potential and I fully intend to return, it's just a shame it rained so much on the day!

Nikon FE2 with 50mm lens, Ektachrome 100VS, graduated ND 0.6 and 81B warm-up filters, 1/4sec at f/16, tripod

CHARLIE'S VERDICT

It is so good to have this image for us to be reminded of how weather changes everything. An almost identical vantage point to the one that Alen chose. Stephen, however, decided to photograph on the day we met at almost high water. There was a little tone in the sky to the top left which has been of enormous help. Had there not been, the photograph would have 'fallen out of itself' through the easiest route, the burnt out sky. Although a graduated filter has been tried here, I am still not convinced that there was sufficient light in the first place. In Stephen's image, the drystone wall acts as a dark delineating line giving some strength to the photograph but, I am sure Stephen will be giving this glorious location a second chance. I do hope so, it deserves it and so does he!

JOHN WILKS

Occupation *Support worker*
Photographic experience
Three years, mainly taking landscapes

Dreadful weather and poor light sums up the day, but it was very interesting and enjoyable nevertheless. In spite of Charlie's incessant optimism the weather failed to clear up before it was time to leave. I stopped near this wall for a coffee before commencing the 130 miles home, deciding, in place of any light, that I would use the wall to try and create some interest. As you can see the cloud above the Mawddach estuary is very low, and the sand banks contrast a great deal with the greenery, wall and derelict building in the foreground.
Centon DF300 with 50mm lens, Velvia, 1/8sec at f/11, tripod

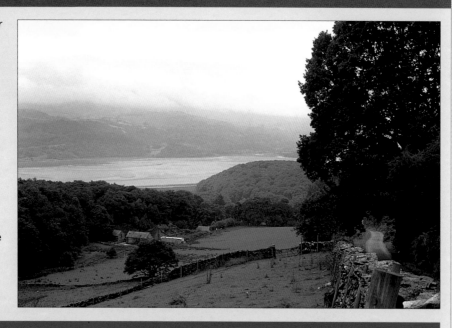

CHARLIE'S VERDICT

We were not blessed with good weather on the day we met and I am sure that had John been able to have another go, he would have been infinitely more satisfied. Photography can not always be the priority. However, he made an image and that's the important thing. Photography in bad weather is difficult. It is usually only successful if it is 'good' bad weather! Here the bad weather for John was decidedly bad!

Light, as always, is the key and here, the absolute flatness and the white-out, rain-laden clouds were of no help. This is what I call the landscape photographer's 'sigh weather'. For the sky, even a graduated filter could not have rescued him sadly. It's not usually possible to use an ND graduated filter when there is no sky worthwhile graduating as seen here. It is rather like a polarising filter being used for a sky when there is no blue.

Of course, bad weather does not mean composition cannot be considered and here I think John did well with the road but the big mass of tree is I think too overwhelming.

The link between the near drystone wall and the wall running across the fields is made clear, but as I am sure John will agree, a return trip for better light and better weather would give him greater satisfaction.

Altering details

It's only when you give yourself time to observe a vantage point that you start noticing how changeable a landscape is, even though in geological terms we were looking at something that has remained unmoved for thousands of years. The play of light, changing tides, the movement (and colour!) of livestock, a lifting mist and a forceful breeze all combine to alter key details in a composition.

Below Stephen tells Charlie and John about the picture that got away, while Alen takes in the view through Charlie's panorama camera

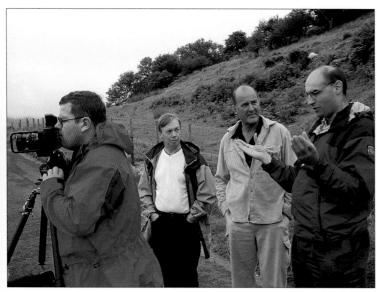

You must therefore never take your picture in haste. Most of us look at a landscape through the 24x36mm frame of 35mm camera, so I took the opportunity to show Stephen, Alen and John how our view looked through the stretched ratio of my 6x17cm panorama camera. It seemed an appropriate format given that whoever named this stretch of bitumen Panorama Road, must have appreciated the broad sweep of the view.

Sure enough, with a 90mm lens attached, the 6x17 framing marks seemed like natural boundaries. Of course, such a format is not cheap, but you could hire such a camera for a day or so, particularly if you have a favourite location that would suit it.

After all, you're not just spending money on a camera, you're investing in the opportunity to create a picture that is your own creation, and of immeasurable value to your development as a photographer.

Doorway to the sea

Durdle Door is probably one of the best known geological formations in the country. It is well worth visiting with a camera to see what else the location has to offer

Right Like Sid, I felt black and white worked best on a day where sky and contrast were insufficient to convey the depth of the scene. I loaded Konica infrared, a film I have known and loved for years. When used with a red 25 filter it darkens the sky, but does not make green vegetation appear snow-like.

There is a relationship between the distant promontory of Dungy head and the sky above. If a link between land and sky can be made (albeit a tenuous one, as in my photograph), then all to the good. Unfortunately, I was forced to interrupt the rhythm of the near arc of beach by using grass tufts to conceal some people on the beach below.

The rocky outcrop to the right is a distraction and upsets the serenity of the sea. Also, a nondescript area of foam lying just off the beach weakens the image. However, I do like the serrated effect of the breaking surf on the beach, though I would have liked more of it. Oh well, outdoor photography often requires persistence!

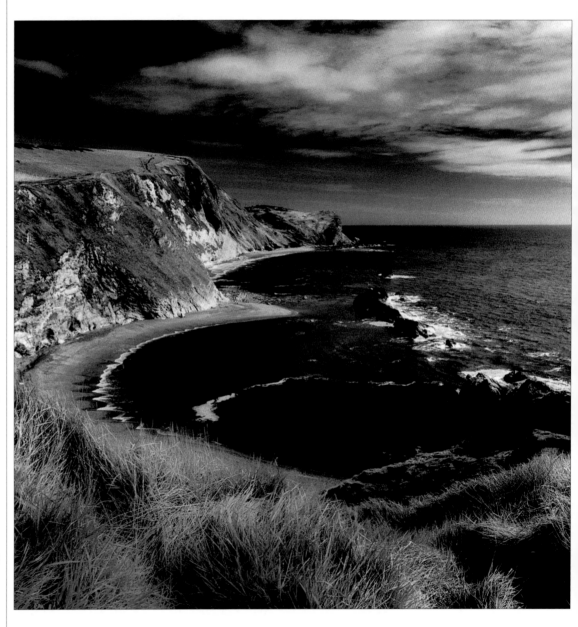

FOR SHEER DRAMA and wonderful photographic opportunities – whatever the weather conditions or time of year – it's hard to beat the coastline of Dorset. All windbeaten cliffs and rugged coves, you can attempt wide, sweeping seascapes, or close-ups of texture and shape.

One of the highlights of the Dorset coastline is the Lulworth estate, with its castle, park and museum and, of course, the spectacular and much-photographed Durdle Door – which is where we unpacked our camera rucksacks for this month's On Location shoot.

Above Charlie points out that the grass in the foreground echoes the distant cliff faces in tone, while providing a contrasting texture – great for foreground interest!

Below The gently curving bay is a lovely viewpoint, but Sid and Charlie decide that the rocks a little further out to sea are more of a distraction than a complement

While the geologically fascinating archway is the inevitable draw to this part of the coastline, don't let it blind you to the other photographic opportunities which also exist within a few hundred metres of Durdle Door. If you stop for a moment on the pathway which leads from Durdle Door holiday park, the view eastwards towards Dungy Head is also

Planning

How to get there Durdle Door can be reached from Lulworth Cove or via the car park at Durdle Door Holiday Park (there is a £2 charge).

Time of day If it's good weather, as early or as late as possible so there aren't too many people around! Stormy weather is also ideal as it suits the ruggedness of the stone arch.

What to shoot As well as Durdle Door itself, shoot the cliffs in either direction.

What to take A wideangle lens will convey the drama of the scene with the crashing waves, while a standard or short telephoto is more suitable for the cliffs. Warm clothing as it can get very blowy in this part of the world. And don't forget the tripod!

Nearest pub The Weld Arms, East Lulworth; The Red Lion, Winfrith Newburgh

Ordnance Survey map Outdoor Leisure 15; Landranger 194

Recommended reading *Dorset: the Complete Guide*, by Jo Draper, £12.95, Dovecote Press, ISBN 0946 1594 08; *Dorset 1900-1999: the 20th Century in Photographs*, by David Burnett, £14.95, Dovecote Press, ISBN 1874 3366 87.

Website www.travelengland.org.uk; www.dorset-info.co.uk

SID JONES

Occupation
Retired – is now chairman of Dorchester Camera Club
Photographic experience
Too many years! Works mainly in black and white

Sid says 'Most people who are seeing Durdle Door for the first time are quite taken by the view coming over the cliff, and just fire away, but I find it needs to be approached thoughtfully to get it at its best. I have had some success very early in the morning when there is some mist about (and no people!). The St Oswald's Bay scene, looking towards Dungy Head, always grabs me from that clifftop, but the picture I chose here could have been improved with a heavier sea running. The rock outcrop in the foreground is also a distraction and a better viewpoint was available – Charlie was already there! The weather really chose that I should use monochrome, and try and get as much drama out of the print as possible. When changing to a 50mm wideangle on my Bronica SQA for this shot, I realised I had left my yellow filter behind. This would have given more punch to the sky.'

Bronica SQA with 50mm lens on Ilford Delta 400; 1/60sec at f/16; Benbo tripod; printed on Ilford Multigrade IV RC at grade four

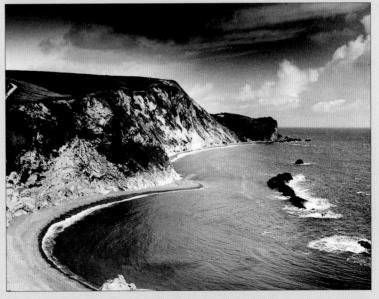

CHARLIE'S VERDICT

Sid has captured some enviable light on the sea (not so easy with infrared) and the rhythm of the 'W' is much more coherent than in my image. He knows this area well and, as he told me, he has persevered for years to get the photograph he is after in his mind's eye. We both agree about the distraction of the breaking surf on the rocks out to sea, but even at high tide I suspect they would be evident, albeit with less turbulence. I am not sure about the little nodule of rock in the foreground. Would it have been improved by either omitting it or having more of it? Perhaps, like me, Sid was trying to conceal people. Also, the brightness of the path at the top left of the frame seems to haul the eye away from the main theme of the photograph, so either cropping it or toning it down in the darkroom would help.

COASTAL

MARY CANTRILLE

Occupation
Works in doctor's surgery
Photographic experience
Seven years – likes natural history

Mary says 'I started off by trying the view east, which overlooks Warbarrow Bay. There was still a bit of sun at this stage and the polariser was effective, showing up the clouds. But the resulting picture, in my opinion, was just a reasonable record shot. So I then moved onto the path which leads down to the beach at Durdle Door. I came across this broken-down fence and thought it might provide a bit of foreground interest – and make my picture a bit different from everyone else's! By this time the sky was stormy, it was very windy and the sun was now intermittent. I tried vertical and horizontal shots and although at the time I thought the vertical composition would work best, I actually prefer this horizontal one.'
Canon EOS 100 with 20-35mm lens on Sensia 100; polarising filter and Benbo tripod

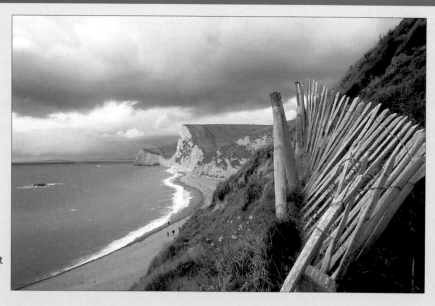

CHARLIE'S VERDICT

Full marks for perseverance, Mary. The success of a landscape photograph depends on everything from atmosphere to design – and a lot in between – and for this shot Mary was clearly studying the design element. The fence works well as, to a degree, it repeats the curvature of the cliffs. It could be argued, however, that it dominates to such an extent that the cliffs are a little diminished. Mary has cleverly avoided (just) the sweep of the seat being interrupted by the diagonal of grass in the foreground. As a result, she has constructed another triangle. I strongly approve of the way she has made the beach exit cleanly from the bottom left hand corner. This is not always crucial but from a geometric perspective it works well. All in all, Mary's photograph is very successful.

DAVID CANTRILLE

Occupation
Retired
Photographic experience
Seven years - shoots a lot of natural history and seascapes
David says 'I believed Charlie when he said there might be a slight break in the dense cloud cover which developed as the afternoon wore on! There was a slight break, and although I took a picture I was pleased with, my favourite of the day was actually this one looking south through the rock of Durdle Door itself. The reflection on the incoming tide and the long shutter speed make this picture for me. The surf and seaweed also provide further foreground interest. I used a Cokin P blue/yellow polarising filter to lift the picture, but I only turned the filter about half way, otherwise the result would have been too yellow. It would have been a bonus if the lighting had been better, but the sun actually never reaches this far round – allegedly!'
Canon EOS 3 with 17-35mm lens, Velvia, Cokin P polariser

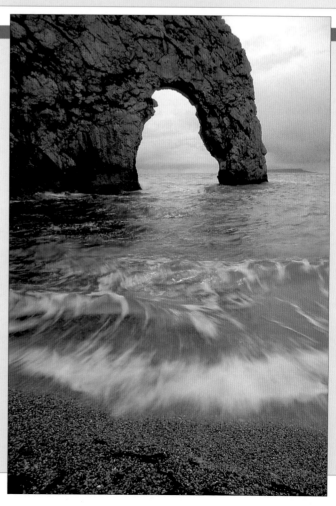

CHARLIE'S VERDICT

I think this is a terrifically imaginative image – it's rare to see the surf rushing towards the camera. David clearly worked on this idea and has created a very striking result. It was a difficult day, lighting wise, and he has produced a dynamic and semi-abstract result, which is very effective. I have mixed feelings about the blue/yellow filter but he wisely used it as modestly as he could, and while the sea has taken on an artificial iridescent look, the content and strength of the photograph wins the day.

MALCOLM KITTO

Occupation
Retired supervisor
Photographic experience
12 years – main interests are landscape and natural history, with an emphasis on dragonflies and damselflies

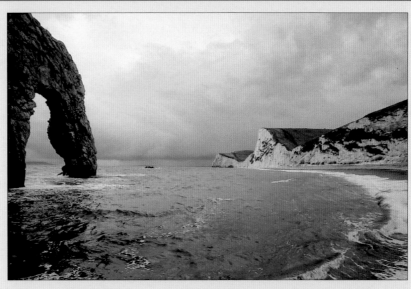

Malcolm says 'I found the day extremely interesting, useful, and entertaining! OK, so the weather conditions were disappointing, but they didn't deter anyone. I took a few different viewpoints around Durdle Door, including this one which looks west towards the Bat's Head with the Door on the left. The failing light – owing to the impending storm – made life difficult. However, some detail is evident on the rock face of the Door. A shaft of sunlight on the white chalk cliffs would have greatly enhanced the image, but it wasn't to be – much to the disappointment of all of us!'
Nikon F90X with 24mm lens, Velvia, 1/15sec at f/5.6, polariser and tripod

CHARLIE'S VERDICT

In Malcolm's photograph, I can see that he wanted to encompass both the remarkable keyhole of Durdle Door and the sweeping cliffs beyond. I tried to do the same but found that the two elements refused to come together. As a result, the eye finds nothing to rest on.

Somehow, there does not seem to be enough of the rock on the left and I feel it is a pity to deny the viewer the graceful continued curvature of the beach to the right. To bisect it with the hard vertical edge of the frame struck me as being a rather harsh way of dealing with

that right hand edge of the photograph. However, I do believe there is a photograph to be had here and I guess it may need a little more experimenting. One day I too would like to make a photograph that would incorporate both the famous keyhole and the cliffs beyond.

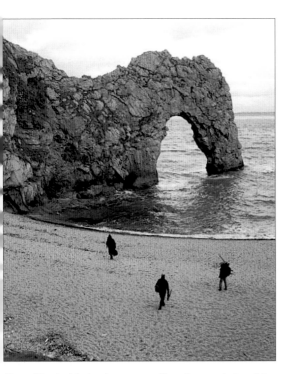

Above After tackling various compositions from vantage points up on top of the cliffs, the intrepid On Location explorers make their way down to the (sadly rubbish-strewn) beach. The sky is still not providing quite the right light to bring out the best in Durdle Door, but there are still pictures to be had, as David's slow shutter speed image demonstrates. Everyone dreams of the Door being lit by soft, warm light. One day it might happen!

of photographic merit. Two coves form an elongated 'W' shape, with the clifftops rising up towards the sky. The main problem with this scene, however, is the scarring caused by the footpaths, which form very distracting white stripes on an otherwise green surface. Obviously these can be removed or toned down – either in the darkroom or on a computer.

We met in the afternoon, hoping the sun – assuming it would be sunny – would be low enough to warm the archway from the side. As it turned out, the weather came close to providing just the conditions to suit the drama of Durdle Door. Frustratingly, they were close, but not quite close enough. Out to sea were the most dramatic cloud formations you could hope for, with the sun breaking through every now and then to light up patches of the water towards Portland, while closer to shore it was an altogether greyer scene.

Once down on the beach, you can also point your camera towards the west, with Durdle Door behind you. I attempted such a composition myself, convinced that the gradually strengthening sun would eventually break through the cloud cover to light up the white cliff faces, forming a stark contrast with the stormy sky behind. I waited, and I waited. Unfortunately, it didn't quite work out as I had hoped, as the light – when it came – wasn't quite strong enough to create just the tension I was after. Oh well, another time, as I always say!

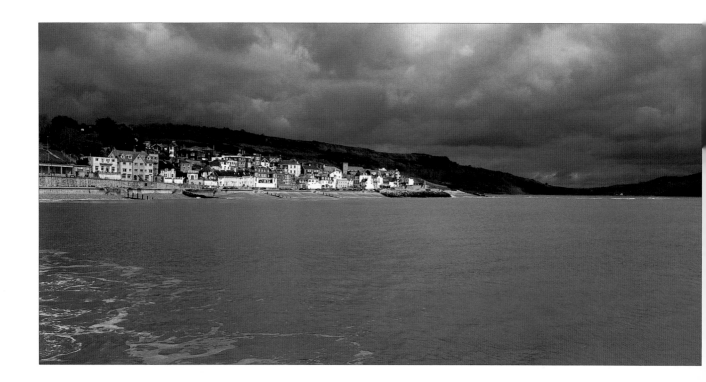

In the Lyme light

Follow in the footsteps of the French Lieutenant's Woman to explore the historic charms of Lyme Regis, even more appealing when bathed in good light

Above Having worked in the theatre for a good many years, I recall how important the lighting director was to the 'look' of the play. In photography, lighting is everything of course and the distribution of light within a photograph has to be considered and organised to convey the photographer's artistic intention.

I would have liked the expanse of water to be more interesting instead of two thirds of the photograph being composed of monotonous grey. Large areas within a photograph that contain no information can be rather dull. Perhaps the water would have been improved if it had not had light on it.
Hasselblad X Pan, RMS Multispeed with 90mm lens

OUR DAY BEGAN inauspiciously with rain falling. But as we finished our coffee we saw, through the window of the teashop, a faint gleam of sunlight struggling to penetrate the cloud. It was time to get moving. With wind off the sea and waves thudding on the beaches our walk along the promenade gave us a chance to assess the scene. Lyme Regis, famous as

Left Getting the right shot sometimes means getting down to ea

ALAN HUMPHRIES

Occupation
Chartered shipbroker
Photographic experience
Strong interest since the mid 1980s

We were so lucky with the weather, the Dorset sun came out to match Charlie's smile and there were some wonderful cloud formations over the town and bay.

The great obsession with photography started for me in the mid 1980s with photo essays in landscapes, and candids, giving my work focus. I like to keep the equipment simple and usually work in transparency or monochrome.

My eventual choice of photograph, while being a bit of a cliché, works well for me – there is a lot of foreground interest with strong textures and specular highlights. The cannon nicely frames the town and its backdrop – although a little sun on the buildings would, I think, put the icing on the cake.

My lasting impression of the day will be Charlie's relaxed, yet businesslike approach. I had fun and I learnt a lot.

Leica M6 with 50mm f/2.8 Elmarit lens, Kodak Elite Chrome 100 Extra Colour, 1/250sec at f/8

CHARLIE'S VERDICT

Virtually a single element image succeeding in telling a story. All of Britain's past history is conveyed in this one old relic. The steely blue/black of the barrel with the bright highlight running along it gives the image a lot of impact. The whole photograph has a boldness to it and I find it appealing.

I was interested to see that none of 'the team' made anything of the fact that Lyme Regis was 'on fire' with light and in all cases, the town itself has been given a secondary position of importance. I feel that perhaps it did not deserve to be left out. But what a terrific day we had and all the images here testify to good light with some wonderful skies.

Left Charlie and Alan discuss the joys of the Leica M6 – a camera more usually associated with taking classic street photographs than landscape photography

Planning

Location Lyme Regis is on the coast of south west Dorset near to the border with Devon.

How to get there By car it is a pleasant drive from the north via the M5. Exit at Taunton and take the road for Ilminster, Chard and Axminster or from the east via the M3, A303 heading for Ilminster or Crewkerne.

By train, travel on the London Waterloo to Exeter line to Axminster. From there you have a choice of bus or taxi for the final 5 miles.

What to shoot The harbour and Cobb have an unspoilt charm of their own while the town itself, seen from the harbour, is a delightful patchwork of buildings that are largely unchanged from the 19th century. The only drawback is that the town attracts a vast amount of visitors in the summer so choose your timing carefully.

What to take On windy days you'll need a solid tripod and a hat that won't blow into the sea.

Nearest pub There are plenty of pubs and tearooms offering either light refreshment of something more substantial – a local speciality is crab.

Ordnance Survey Map Landranger sheet 193

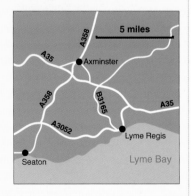

COASTAL

and those elegant Regency and Victorian villas lining the seafront – and, of course, the harbour with its curved wall known as the Cobb where the lady herself stood and waited.

The nice thing about Lyme Regis is, apart from the cars which actually don't feature because you can't really see them from the harbour, there is nothing unsightly about it – there isn't a single offensive building.

By the time we reached the harbour it looked like there was no time to lose. The sunlight was coming and going and it was time to set up and wait for the right moment. It's so important to do this. Whether you have to wait ten minutes or ten hours, it's the waiting that counts. It's the most crucial thing. It's what I call 'a little bit further up the road' – it is too easy just to say 'that's it' and pack up and go.

While we waited we discussed what our ideal shot would be. I find it fascinating to hear how someone pre-visualises a photograph. Once I've imagined what I want, I spend time wrestling with how many compromises I am prepared to tolerate, and if I have to tolerate too many then I don't take the shot. It's like a pursuit of truth. I have a feeling that one will never actually get the perfect image but that's what drives us on – we're trying to secure something that we experience emotionally, and we can never really turn an emotional experience into a visual one but the nearer we get to it the greater reward there is. The whole impulse behind any artistic endeavour is the

Above The Cobb provides a good starting place for taking photographs

the setting for the film version of John Fowles' *The French Lieutenant's Woman*, is tucked neatly between steep hills and fossil filled cliffs. A medieval town, it was for centuries a port for the wool traders of Somerset and later a thriving centre for ship building. I think its charm lies in its colour washed cottages

TONY BAGWELL

Occupation *Retired computer manager*
Photographic experience *Had cameras for years but only started using them seriously in the last two years*

The forecast said occasional showers which usually means occasional sun and by the time we'd walked to the Cobb there were a few brief bright periods. Because of these changeable conditions we tended to all do our own thing rather than each trying to take a variation on the same shot. Whilst Lyme is a pretty place, I found it hard to get that one photograph that shows the whole town with its painted buildings. The initial location looking back towards the town gave a large expanse of dull grey sea in the foreground so a move to the far side of the harbour allowed the more colourful boats to take centre stage. My shot is more 'boats with Lyme Regis' rather than the other way round. Luckily, as the tide went out these two boats leant in opposite directions, nicely framing the houses peeping over the harbour wall.
Minolta 700Si with Sigma 28-300mm zoom lens set at 150mm, Velvia, 1/20sec at f/16, polariser filter

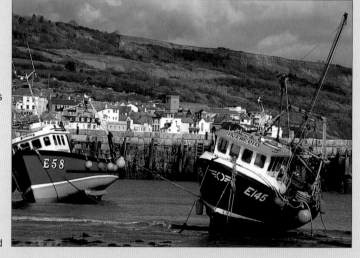

CHARLIE'S VERDICT

I have always had a passion for boats and these two lopped over in opposite directions on the mud make a good foreground. Lyme Regis glowing in the background completes the story nicely. Being a pernickety person, certainly when

it comes to photography, makes me ask what was on the other side of the left hand boat to need to crop it so severely? It looks as if it is being jammed up against the edge of the frame and as a result looks uncomfortable. Generally a

little more space would have been nice. There was nothing Tony could have done about the mast but just covering it up with one's finger seems to make it a more coherent image. It's worth noticing these things.

TONY SMITH

Occupation *Sterile services manager*
Photographic experience *Has been interested in photography on and off since he was about twelve but has become a lot more serious since joining his local camera club six years ago*

On getting up on the appointed day and looking out the window I thought 'Here we go, grab the brolly and waterproofs' but the weather did improve.

Once Charlie arrived it was down to business, cup of coffee and introductions. I must admit I was really looking forward to the shoot and it proved to be as good as I thought it would be. The hardest thing for me was picking which photo to send in – the one that I have chosen is one of the best. The reason I took this shot was that I wanted something slightly different than your normal view of Lyme Regis and I think it works even though I have chopped one of the boats in half. A polarising filter may have improved the image.

Canon EOS 5 with Sigma 18mm lens, Fuji Sensia, f/16, daylight filter

CHARLIE'S VERDICT

I feel that this image would have been better in black and white. I like the low viewpoint. We so often tend to photograph at the height that we stand and getting down low is often very effective. Consider taking the centre column out of your tripod if you have one, achieve the smallest aperture on a wide angle lens and enjoy getting close.

The bollard I feel could have been placed a little more to the right of the image, and I would have liked to have seen more of the rope which is strong – but I feel that the semi coiled nature of it would have been made clearer if we could have seen it. There's a good sky creating some triangles but I think in black and white it would have had more pathos than the colour version. Perhaps Tony could scan it and drain the colour from it to see if this is the case.

pursuit of something, I don't know quite what it is – it's like an attempt to get to the core of things, get to the heart of the matter – get near to God if you like. The day that an artist sits back and says 'this is perfect' is the day that artist is finished.

Our waiting time was happily short that day. The weather performed for us – great banks of dark cloud moved menacingly across the sky, sunlight peeked through and skidded on the surface of the sea, and small fluffy clouds added light relief. We walked round the harbour and out onto the Cobb, taking the full force of the wind. While we set up we talked about our choice of film. I use Velvia, and I've used it for so long now that I can generally guess at what the exposure will be. I think people chop and change film so much that they don't get to understand the film's personality or character and so there's a chance you end up not really being familiar with all its idiosyncrasies.

As we walked back along the Cobb to the end of the harbour, thinking about crab sandwiches and beer, we were entertained to an unexpected light show that detained us for a good fifteen minutes. Sunlight lit up a patch of sand, water and shingle for a final photographic treat.

Left Charlie checks out Tony's right angle finder – a useful device when taking shots from low down

Bay watch

The delights of Robin Hood's Bay prove irresistible to **Charlie Waite** and his merry band of photographers, but look what's rolling in from the sea...our old friend mist and fog...

Right My humble effort on our morning visit to Robin Hood's Bay. Despite the misty atmosphere, a polariser and fine grain film helped maximise the little contrast and detail available *Hasselblad 501CM with 250mm lens, Agfapan 25, polariser, 1/2sec at f/22, tripod*

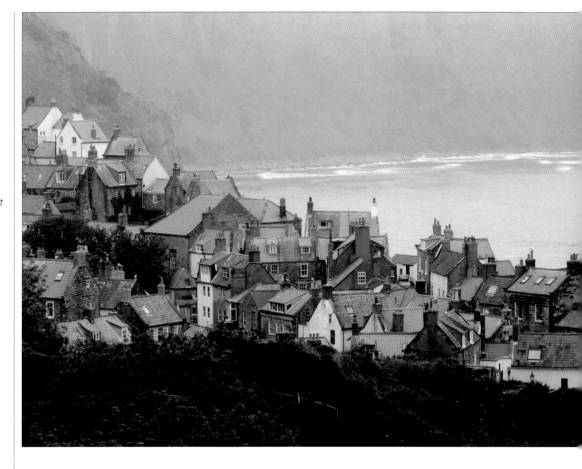

I'VE ALWAYS wondered why Robin Hood's Bay is so named, given that its location is some way off the leafy home of the 12th century outlaw who so infuriated the Sheriff of Nottingham with his radical policies of wealth redistribution. In fact, Robin Hood and his band of mead-drinking vagabonds have no association with this month's location, given that this historic former fishing village is considerably older than the legendary archer.

Robin Hood's Bay is the latest name in a string of aliases dating back more than a thousand years: Bay Town, Robbyn Huddes Bay, Robin Hood's Town are a few others, but it seems there is no explanation as to when/how/why it was so named.

What is easier to understand is why smuggling played such a prominent part in the history of this settlement. Lying at the bottom of a steep and narrow street, winding down to the sea from the moors, Robin Hood's Bay is a well hidden maze of alleys and lanes providing plenty of escape routes for seafaring coves hiding their hauls of contraband.

As with Staithes the geography and position of Robin Hood's Bay presents a set of peculiar conditions for photography that make this striking and picturesque location a far from straightforward subject. Mist, from both sea and moor, is a frequent visitor, while low tide has a dramatic affect on the shoreline, revealing a vast shelf of rocky beach and seafloor stretching 5km southeast to Ravenscar. When we visited we had the worst of both sets of variables – the tide was in and mist hung above the horizon,

RACHEL CHAPPELL

Occupation *Software developer*
Photographic experience *I dabbled in photography for the past ten years but it's only in the past two years that I have begun to take it seriously*

Variety is the spice of life and the British weather is nothing if not variable. On the day I awoke to heavy rain, drove through thick fog, arrived two miles up the coast to gentle sunshine and finally descended to a rather grey Robin Hood's Bay. However this did not dampen our spirits and after an informative chat with Charlie we climbed to the cliff-top to look down over the sweep of the bay. We spent some time discussing how we would approach the subject before getting down to some serious picture taking.

Unfortunately, due to Kodak losing my film instead of processing it I had to make a return trip to the bay. This time the weather was much brighter and who should I meet on the cliff top but Lynn and Joe Cornish. I was obviously in good company!

I chose this photo as my favourite as I liked the fact that it is

mainly comprised of three colours (red, white and grey). Although the roofs and windows form a random pattern they themselves are each made up of a regular pattern of tiles and window panes.
Nikon F90X with Sigma 28-200mm zoom, polarising filter, tripod

CHARLIE'S VERDICT

The first thing that is conveyed to me in this image is its "expression". The windows and chimneys tell a story of community spirit and coziness and the hard light, throwing the attic dormer windows into relief provides a sense of depth taking the eye comfortably up to the top/back of the image. It is a compressed scene, with nothing to steal the attention of the eye away from the story. The grey rooves of the foreground houses do not conflict with the teracotta tiles behind. Masking elements of the image is an easy pitfall with photographs such as this one. It is very easy to at first see the entire image made up of the sum of the parts but it is the parts that one must analyse within the whole to ensure that the meaning is clear. It is easy to "post rationalise", but the expression in this image obviously comes from the face like nature of the windows and so the key is to reveal as many of the windows as possible. Perhaps a small pan right may have allowed two further windows to have become unobstructed by chimneys thereby amplifying that meaning.

blocking out all semblance of sunshine, as well as the top of Ravenscar.

Normally, I would pack up and move on, or if a wind was blowing wait to see if the mist would disperse, but no such luxuries are permissible when this is your one and only chance to photograph a place that you're unlikely to revisit in the foreseeable future. We decided to join the coastal path leading up from the harbour to the cliffs above the south end of the village. This allowed us to keep the grey formless sea to our backs and out of frame, while focusing entirely on the ramshackle arrangement of cottages and terraces that cling to the cliffs in a collapsing line of tiers.

Where the cliffs aren't so steep, trees and other vegetation have taken hold and provided a verdant covering of green around the cluster of buildings. Consequently, composition became an exercise in deciding how much of this greenery to include and where to place it in the context of the overall scene. Telephoto zooms are ideal for making the small adjustments in composition to keep unwanted details from intruding in the frame, but how many of us use cameras that feature a viewfinder with a 100% field of view? Very few, I guess, given that the vast majority of 35mm SLRs offer around 90%, so don't be surprised, having made all these critical adjustments in the

viewfinder, when your print or tranny shows the very details around the edges that you had tried so hard to avoid!

Although Rachel, Lynne and Phil set up their tripods in close proximity, their focal lengths and

Below While Lynne and Phil set up and check out the view, Rachel uses Charlie's framing masks to help select a suitable composition

COASTAL

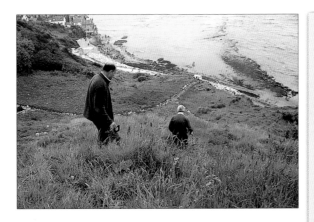

Above Charlie and Phil stride through the undergrowth to try an alternative vantage point for a photograph

cropping produced markedly different compositions. Phil opted to show more of the village in the context of its surroundings, while Rachel zoomed in dramatically on the local architecture to emphasise a random pattern of rustic red rooftops. Some people may question whether such an image is 'unmistakably Robin Hood's Bay', feeling that it could apply to any

Planning

Location Northeast coast of England between Whitby & Scarborough.
How to get there Well signposted off the A171 between Whitby and Scarborough. Parking is at the top of the village – don't try to drive to the bottom. It's a steep walk back up so don't carry too much with you.
What to shoot Plenty! The rock pools are a good foreground for lansdscapes and the town itself is full of history, reflected in the old buildings and alleyways.
Best time of day Morning and evening light is best, although late afternoon can be good
Other times of year Whitby is photogenic most of the year round but mist can be challenging!
What to take Tripod is essential. Zoom and telephoto lenses up to 300mm, macro lenses for close-ups of shells and marine life in rock pools. Warm clothing, watertight boots or Wellingtons.

Nearest pub The Dolphin (tel 01947 880337), serves a good range of reasonably priced counter meals.
Nearest accommodation Many B&Bs or try the Yorkshire Tourist Board's website www.yorkshirevisitor.com. Campers could try the Northcliffe Holiday Park roughly three miles away (tel: 01947 880477).
Ordnance Survey map Outdoor leisure no.26, grid ref 95405.
Essential reading *North York Moors* by Ian Sampson, £8.99, David and Charles, ISBN 1 8986 3016 X

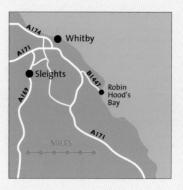

PHIL PIDD

Occupation
Teacher
Photographic experience *Eight years since joining Nothallerton Camera Club*

Having been put at ease by Charlie I found it a most enjoyable day, despite the weather. The chosen location was on the cliff to the south of the village. That part of the coast was shrouded in mist giving a flat light with an uninteresting sky. To reduce the foreground I chose a viewpoint 20 feet below the top of the cliff. I experimented with filters but found the results disappointing. I kept a record of each frame and I will analyse the results accordingly
Nikon F-301 with 28-70mm zoom, Sensia 400, 1/125sec at f/8, tripod

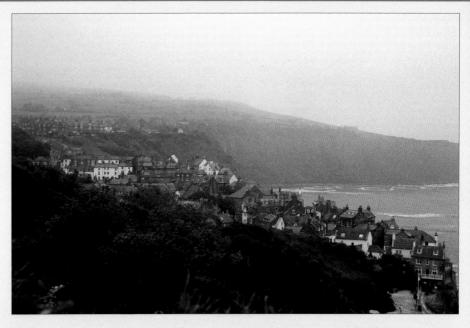

CHARLIE'S VERDICT

Here's an image of how all of Robin Hood's Bay appeared on the day that we visited. It is Robin Hood's Bay in the raw; heavy overcast sky, light so diffused that it seems lit through a thousand sheets of grease proof paper! It is not often that I am condemnatory but this photograph of Robin Hood's Bay is not good! However, positives arise from negatives and here is a case in point. So I should thank Phil for producing an image that gives rise to

good debate. What if a photographer from overseas had been commissioned to produce an image of Robin Hood's Bay in just a day? This was the weather that prevailed and an exposure had to be made – there was no choice! To begin, a ND graduated filter, perhaps as much as point six (2/3 stop) would have allowed the exposure for the light absorbing land to be opened up by compressing the subject brightness range. Perhaps the

sliver of green bushes in the foreground could have been dispensed with, thereby making the village take up the same surface area as the greenery, and creating two slim triangles that lend a more panoramic feel. Warm filtration might then come into play. Ultimately, all landscape photographers would wish to come upon an image that requires minimum filtration but Robin Hood's Bay was in need of some help that day.

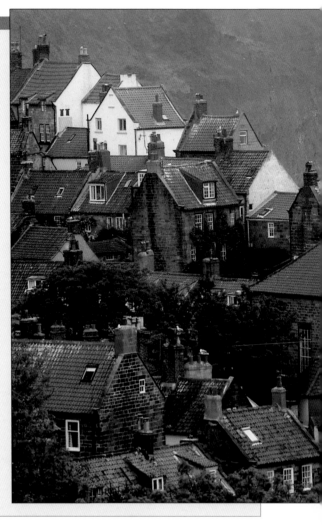

LYNNE EVANS

Occupation *Scientist*
Photographic experience *Started photography from scratch less than three years ago. I am now working on an OCA Art of Photography course*

Selecting my best picture from the day was not easy – not because they were particularly stunning but because there was a divergence between the one I like best and the one which is the stronger composition. As the brief was to shoot something that was unmistakably Robin Hood's Bay I have chosen one of the first shots of the day, taken from the coast path overlooking the village. Because of the poor weather I closed in on a section of the roofs using a long lens. The resulting photo has a strong composition, with a number of diagonal lines taking the eye from the bottom of the picture to the top, drawn by the whiteness of the final row of cottages. In addition to Charlie's pearls of wisdom, which will be invaluable in improving my photography, I think I have also benefited from his enthusiasm and encouragement.
Canon EOS 3000 with 200mm zoom lens and 2x converter, polarising and 81a warm-up filters, Velvia, 1sec at f/22, tripod

CHARLIE'S VERDICT

Perhaps only a few yards away from Phil's photograph and yet with a totally different atmosphere. Here the weather on the day dictated the mood and the vertical crop lends a greater feel of the village cascading down toward the hill. Regrettably the sea and the hill had to be excluded as the wider image would have revealed the poverty of the weather and light. The white painted buildings helping to make the diagonal more pronounced have rescued the image from looking too subdued; they have served to compensate for the lack of highlight light and shadow.

The darkish corner of cliff at the top right may just possibly have benefited from a little further darkening with perhaps a one stop neutral density graduated filter. The most useful piece of the landscape photographers kit offering the ability to locally attend to excess brightness anywhere within the broad perimeter of the image. Perhaps if one had been used here some increase in overall apparent brightness would have been suggested.

number of villages, but landscape isn't just about easily identifiable vistas. Conveying a sense of place through isolated details, transitory elements, or unnoticed features can be more revelatory.

I will admit to having an almost evangelical devotion to the importance of neutral density (ND) graduated filters to landscape photography. As the light was so

Below Good work! Lynne makes a note of her exposures – something few of us do on a regular basis

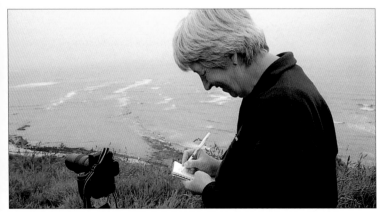

diffused and constant on this particular day, I gave the group a practical lesson on how to test their effect. I use Lee 0.3, 0.6 and 0.9 ND grads most of all and each step up in the density value equates to +1/3 stop of exposure, ie. 0.3 (+1/3 stop), 0.6 (+2/3), 0.9 (+1 stop). Using Rachel's Nikon F90X set to aperture priority, I first fired the shutter with no filter in place for an exposure of 1/250sec. Taking another frame with the 0.3 ND filter resulted in an exposure

of 1/200sec, while exposures for the 0.6 and 0.9 filters were 1/160 and 1/120sec respectively.

I then repeated the process but switched the camera to manual, so that the exposure values were the same for each frame. The resulting frames from this sequence would then clearly show the difference in the density of each filter to the scene on film (unlike the first exercise, which merely serves to demonstrate how exposure has to be compensated to maintain a 'correct' value when a filter is used).

It's important to remember that every camera manufacturer's meter responds slightly differently to the use of graduated filters, depending on what filter is attached and how much of it is pulled down over the image.

The best advice to give – once you've got your own set of grads – is to test them in the way that I demonstrated to Rachel and check the results. It's well worth it!

Cook's tour

Mid-afternoon in June is supposed to be perfect for photography in the Yorkshire fishing village where Captain Cook learnt his trade. However, the weather is not always obliging...

Right The most noticeable change to Staithes since I took this photograph is the new breakwater protecting the harbour. I used a wideangle on my Hasselblad to include more foreground interest and accentuate a gentle sweep created by the line of houses on the right of the picture

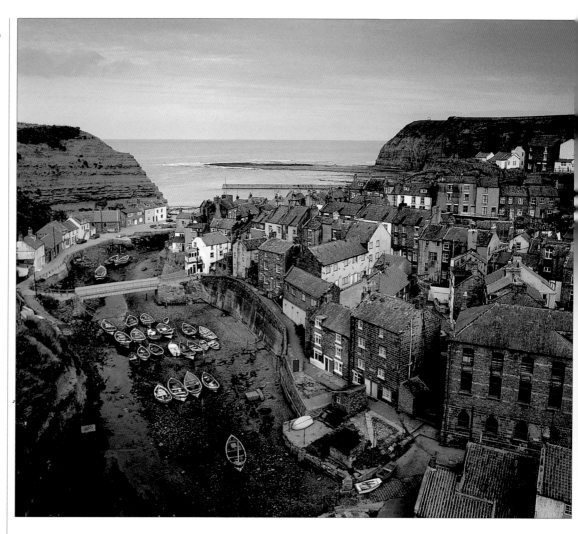

THE IMPORTANCE of Staithes on the history of the late British Empire far exceeds its size or appearance. A collection of ramshackle cottages separated by a maze of narrow lanes and winding steps, Staithes clings to a steep-sided inlet on the east Yorkshire coast, 11 miles north of its bigger and better known neighbour, Whitby. But the two fishing ports both played a prominent role in

the life and career of one of the world's greatest mariners. As plaques, history books and proud locals will tell you, the young James Cook received his first taste of the sea and ships in Staithes, where he worked as an assistant to a merchant, William Sanderson, for 18 months from 1745.

Twenty five years later, in a ship built in Whitby, Captain Cook, would land on the east coast of

Australia and claim that mighty continent as part of the realm of King George III. The rest, as they say, is history – and don't our cricketers know it!

The image of Staithes from the viewpoint off Cowbar Lane is a favourite among photographers and visitors alike, especially when it is so magnificently portrayed as the much reproduced image taken by my colleague Joe Cornish. But

MIKE WILDE

Occupation *Church minister* **Photographic experience** *More than 30 years with favourite subject being landscapes and natural history*

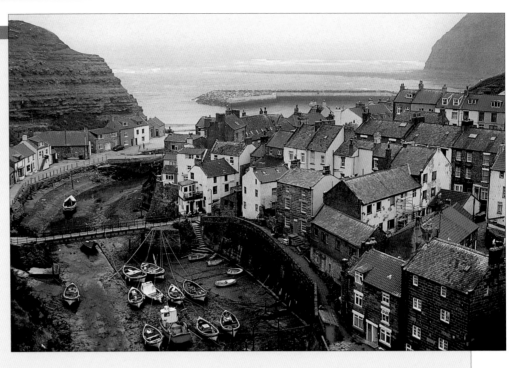

'I've forgotten the number of times that I've visited Staithes, there on the east coast, just above Whitby. In the past it's always been when I knew the weather would be good and the tide in, but on this occasion it can only be described as a February day in June! However, I was really excited at the prospect of meeting Charlie, which I duly did, and he began immediately to share some of his amazing fount of knowledge and experience with us. It was while listening to Charlie talk about photography and challenging us to not just 'take pictures', but to think deeply about what we were trying to convey, that I realised what I suppose I always suspected – that most of my stuff, while technically OK, lacked soul.

When we finally set off to a viewpoint above the harbour in Staithes, I was a little anxious. Looking at the dull leaden sky with no sidelighting, the harbour and environs looked totally uninspiring. However, encouraged by Charlie, and having considered the view, we set up our tripods. The shot I've chosen, which was taken with the help of one of Charlie's pale red filters, is the best of a meagre bunch. It certainly makes the place look warmer than it looked in reality, but not obviously so. It's strictly a record shot, at best, and I've got too many of them already, but armed with the advice of Charlie I shall return and endeavour to try and convey something of the character of the place. It certainly has plenty!'

Nikon F90X with 28-105mm zoom lens, Kodak EliteChrome 100, pale red Lee filter, 1/30sec at f/11, Slik tripod

CHARLIE'S VERDICT

Again the poor light was against us all and a heavy warm up filter would not have helped. However, the composition is a classic one, with the huddle of cottages telling a tale of endurance and community.

The sky is always the 'sneak' when it comes to revealing the nature of the weather when the image was made and I wonder if it might have paid to crop it a little. Alternatively, a soft 0.3 or 0.45 ND grad might have dropped a little tone into the sky area. It could have been dragged slightly down across the two promontories without being too conspicuous. One of the great attributes of neutral density graduated filters is their wonderful versatility.

In conclusion, I would urge our trio to return one day to this magical place. The image will be there for them if they persevere.

as Joe would readily concede, photographing Staithes at its most splendid is filled with so many concerns and considerations that a few prayers to the almighty wouldn't go astray in your preparation. The primary factor to determining your chances of emulating a Cornish 'special' is the sunken position of this village. Staithes sits in an inlet so steeply sided that it seems a wedge of Yorkshire moor has been cut from the cliffs backing onto the North Sea. Just two miles north of the harbour these cliffs rise to nearly 700 feet affording protection from the fierce North Sea gales that pound these shores. One such cliff, Cowbar, protects Staithes's northern flank, but signs of erosion to its

soft red clay strata are apparent everywhere. Indeed, the original shop where the young James Cook was employed has since been washed away out to sea.

Being sunk so deep within this landscape of towering northeast-facing seacliffs, means there are only a few summer months of the year when the little streets and blue-painted boats are illuminated by direct sunshine. So, here we were at 2pm in early June – surely a perfect time to visit Staithes? Oh Lord, humour me! We were wrapped in a shroud of mist that hugged the moors and stretched out to sea as far as the horizon – except the horizon was lost in a wash of grey as pale as porridge. Well, look on the bright side, I

told Mike, Ian and Sharron. Metering won't be a problem; there are no harsh shadows or contrast so variable that even a 0.9 ND filter would struggle to contain it; no featureless blue sky to contend with. Their puzzled expressions revealed a lack of conviction. But hear me out.

Below As Mike and Ian listen to Charlie, Sharron discovers that the master's suntan looks even warmer with an 81B filter!

COASTAL

Above Charlie holds up his array of Lee ND graduated filters for Sharron to see the difference (from left to right) 0.9, 0.6 and 0.3

A scene such as this focuses the mind. Observing details becomes more important, especially as we were likely to crop out the sky and use a telephoto or zoom to crop in on part of the scene.

Although Staithes has changed little in appearance since James Cook was an apprentice, closer scrutiny reveals the telltale signs of

Planning

Location Staithes is situated on the east Yorkshire coast, 11 miles north of Whitby.

How to get there From Whitby take the A174 north through Sandsend and Ellerby and turn right about a mile after Port Mulgrave.

What to shoot For the famous view looking down over the harbour you need to drive back out to the A174 and head north for half a mile towards Boulby. A right hand turn called Cowbar Lane takes you back towards the coast to a car park. Follow the lane on foot then cut across the back of a line of houses to the cliff top view. Also the harbour for closer views of the boats and the narrow streets of the village.

What to take A range of lenses from wideangle to telephoto. Tripod, warm-up and polarising filters.

Other times of year Summer is best as the village's northeast facing position means the sun barely

reaches the Staithes harbour during the winter. Try the surrounding moors or cliff tops in winter.

Nearest pub The Cod & Lobster at the harbour entrance beneath the towering cliff of Cowbar.

Ordnance Survey map Landranger 94

Further information Read *A History & Geology of Staithes*, by Jean & Peter Eccleston. Visit www.yorkshire-tour.co.uk/yt/staithes for a potted history and a selection of views. More images can be viewed at www.staithes-uk.co.uk

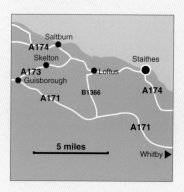

IAN McINNES

Occupation *Supply teacher* **Photographic experience** *More than 20 years covering vintage transport, travel and landscapes*

'The light in Staithes on the day of our shoot was pretty dire – flat, grey and hazy, but nevertheless Charlie encouraged us to make the best of what we had got. Staithes is a wonderfully picturesque village, but in the poor light I felt that a general scenic overview would not do it justice. Instead, I chose to concentrate on one small area that seemed to have plenty going on. I particularly liked these building with their colourful doors and window sills. There is plenty of detail in the picture, such as a couple of men playing chess at a table by the harbour wall, and I liked the steps that lead the eye further into the village. It is a pity about the scaffolding at the top of

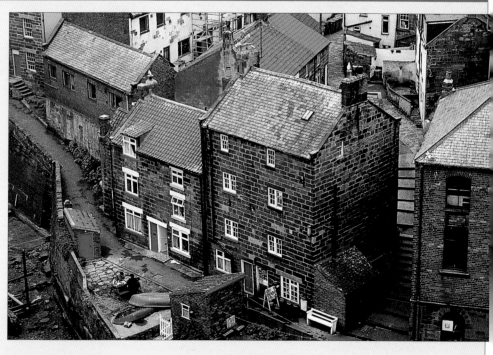

the frame, but hopefully this doesn't detract too much.'
Nikon F100 with 28-105mm Nikkor zoom lens, Kodak EliteChrome 100, UV filter, 1/30sec at f/11, Slik tripod

CHARLIE'S VERDICT

In bad weather, the photographer is often forced to exclude the sky unless, as is often the case, the image is drenched with an 85B or some such similar amber filter to give the impression of lovely Mediterranean light!

Here, Ian has made an image that is very

tight and with a clever bit of positioning he has introduced the steps to the viewer along with the road leading off to the left of the image. The houses in the centre seem to be nicely 'cradled' within the steps and the road down to the slipway.

Photographing down to buildings is fairly unusual and the possible consequential diverging verticals do not seem very pronounced. The image is predominately about windows and they help to give a sparkle to the the whole despite the gloomy day.

SHARRON BOULTON

Occupation *IT support manager*
Photographic experience *Six months*

'The photograph I have chosen isn't at all good and lacks the soul Charlie mentioned, but before I master that, I think I'll settle for technique, where I've still got a lot to learn. However, in fairness, the conditions were far from ideal. Overcast and threatening rain, so I'm not going to give up yet – I will definitely go back when I have more time and capitalise on some of the fabulous spots within Staithes. After taking some shots over the bay, Ian and I walked up to the top of the cliff and this is where I took this picture. Trying to shoot pictures amid thousands of nesting seagulls requires particular skill and nerve, so perhaps a lower location would have been wiser.

A faster shutter speed may have been better but with an aperture setting of f/22, even had the weather been nicer, I don't think I would have changed it. I think I have left too much beach on the right hand side of the shot and could have done with a more powerful zoom lens, in order to get closer.

A hair seems to have been trapped between my shutter and lens and appears on all my shots. On reflection, a general health check of my camera before setting out would be good practise. With the poor lighting conditions, perhaps a filter would have added some warmth to this shot.'
Canon IX7 with 28-200mm EF zoom lens, 1/45sec at f/22, tripod

CHARLIE'S VERDICT

There is a strangely sinister feel to this image. Perhaps it is that the seagull is reminiscent of Hitchcock's *The Birds*, although it was crows in that film of course and not gulls.

I feel that the magic of Staithes has been denied us in favour of a photograph that could be anywhere on any coast. That being said, the weather was bad and the real issue is that a photograph was made despite the poor light.

A landscape should have a mood and tell a story. This can be created either by content or light or both. Perhaps if the white boat had not interfered with the red hull on the left, then the image would have had a cleaner feel to it. Waves are always nice to play although these are not significant enough. I would strongly suggest another visit on a better day. This is a wonderful corner of the north east.

modern maintenance and 'improvement'. A Velux window opening out from a 1990s loft conversion; new roof tiles without the accumulated lichen and moss of a well weathered past; freshly

Below Ian gets as close as safety allows, finding his composition through a zoom lens

painted doorframes and sills; and the ubiquitous skylight. These details aren't immediately apparent when looking at the general vista, but the compressed view of a telephoto makes them glaringly apparent, raising questions about composition and framing, lens choice and focal point. How much of the modern do you wish to include in your photograph of old Staithes?

Now, the light being what it was (Where?!) I suggested to the group that they consider appraising the scene using some of the filters that I regularly employ. At one stage I held up to the sky three types of neutral density (ND) graduated filters made by Lee to show the difference to the scene. The 0.3, 0.6 and 0.9 ND grads are favourites of many landscape photographers, each one equating to an exposure difference of one stop respectively.

A polariser, too, makes a difference, even in mist. After all,

light is getting through, albeit heavily diffused, but where buildings, walls and roofs form most of the subject area, there are many different surface angles in the scene, some benefiting more noticeably by the use of a polariser.

Even warm-up filters can make a difference, and on this occasion I brought out a new pink warm-up filter made by Lee, which was enthusiastically received by our happy band for the subtle warmth it added to the roofs and walls of the old buildings that were before us.

So all was not lost. We may have felt all at sea when we first arrived, but as for Captain Cook, Staithes provided a chance to learn more about the craft and skill of a vocation that can lead to unexpected discoveries. Can you imagine Cook's reaction to the clarity of light in Australia after a life of Yorkshire skies infused with coal dust and sea mist?

Come rain or shine

The British weather is anything but predictable but that doesn't mean that a good landscape photographer can be put off. A rainy Leigh on Sea provided a constructive opportunity for planning

Right Old Leigh has long been a favourite location for photographers and artists – and today remains relatively untouched by the modern world

THINGS DON'T ALWAYS go to plan – especially when it comes to photography. As I drove to Leigh on Sea on the Thames estuary, the day looked promising with intermittent cloud and sunshine which, for a landscape photographer, is just the ticket. But this is Britain, and the unexpected is never far away. It rained. Luckily our three readers were familiar with the area, all being keen members of the Leigh Camera Club, and had been out in the preceding weeks taking photographs with just this eventuality in mind.

Mere rain, however, should never put a landscape photographer off. There's still plenty that can be done – planning being the most important – and you never know, rain can turn to sun in a matter of moments and you need to be prepared.

But first things first – we retired to the pub on the quay for morning coffee and to talk about landscape photography in general. It seems to me that our form of photography is quite different from any other – it requires a different approach entirely. It's a very solitary experience and one that needs

total concentration. To my mind you can only really do it alone, however nice it is to have a companion, you need to be out there, prepared to wait for hours on end if necessary for the precise moment when you will take your shot. Having someone along with you will inevitably mean that you will feel tempted to leave before you should.

Of course, landscape photography is not just about the end result. Quite apart from the joys (or otherwise) of being out in often wild and remote places, the whole business of taking a photograph,

LILLIAN FLEMING

Occupation *Retired office service manager* **Photographic experience** *Started taking photography seriously after completing a number of City & Guilds courses three years ago*

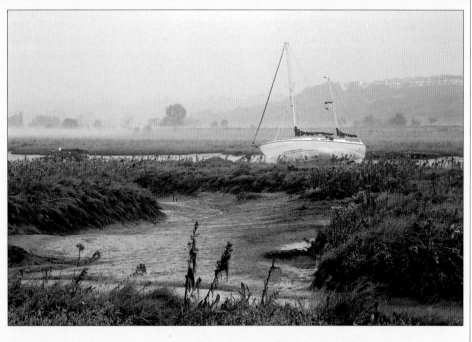

We spent an inspiring time with Charlie in which he gave us lots of pointers to think about in our future picture taking.

The shot I chose was taken on Leigh Marshes on an early foggy morning. It was quite an eerie sight with the fog floating over the marshes. I took several shots from different angles. I like this one best because there is an inlet in the foreground which leads the eye up to the boat. At first I was unsure whether to include the blue boat on the left-hand side but I decided to leave it in as I particularly like the floating fog in the distance. It was a pity that I didn't spot the object in the right-hand bottom corner. As the light was very bluish I used an 81A warm-up filter to give the picture a touch of warmth.

Minolta 7000i with 35-105mm lens, Kodak Elitechrome Extra Colour 100, 1/7sec at f/22, 81A warm-up filter, tripod

CHARLIE'S VERDICT

The colour on the hull of the boat is what pleases me about this photograph. Its very low contrast gives it a painterly feel and the sheen on the mud is just sufficient to prevent the image from becoming too flat. I like the way the river bed exits the frame out of the bottom right hand corner and the reeds sticking in the foreground are quite supportive. There is a lovely soft pastoral calm spreading throughout the image and there seems to me to be a kind of pity for the boat that seems so listless and broken. The grey mist in the distance is so fitting and even the monotonous sky is appropriate. There is a bright area of blue to the left which contrasts with the browns and creams of the image, which is a shame, but it would have been sad not to have made this photograph because of it. I guess there is a certain software programme that may be called upon to help.

the endeavour if you like, is just as important. It begins with the pre-visualisation – the point at which your mind translates the scene in front of you into the picture hanging on a wall. You see it as perfect – if you didn't there would be no point in taking it – but sometimes the end product doesn't live up to the visualisation. Why is that? Of course, there is the technical aspect – not using the right lens, not getting your composition quite right, bad lighting, or even not getting the exposure spot on – but often it is just that the reality simply cannot be re-created. Everything you felt at the time, the smells, the cold or heat, the awe you felt about the place – a whole combination of things that make the atmosphere – cannot be represented in a two dimensional picture. It is really only once in a blue moon – for me, perhaps only two or three times in a year – when something

almost 'god-like' happens at the moment you release the shutter and you know that the photograph you have taken is really going to capture everything that was there at the time – a true representation.

In analysing why you feel disappointed with a photograph, you will often find that it is a matter of how much compromise has gone on. If your end result is too far away from your pre-visualised picture, you won't be pleased with it, but when you achieve the least number of compromises (and there will always be a degree of compromise going on) from what you originally conceived, you will feel a greater sense of satisfaction.

Re-visiting

A break in the weather dictated that we leave the pub and explore this charming fishing village. It's situated on a tidal creek with

working boats fishing for cockles, shrimps and white bait. Old Leigh is part of Leigh on Sea which was divided by the railway line back in the 1850s. There are only about 20 dwellings on its cobbled streets, but it does boast three pubs! In the past ten years it's become a tourist attraction (and no wonder) but there are still times of day and year when you can find it relatively deserted.

From the surrounding marshland there is plenty of chance for views across the mud flats at low tide, and there is a huge

Left Charlie and Lilian discuss how best to use the light available to highlight, or hide, aspects of the landscape – bearing in mind that this will take time to achieve

COASTAL

Right Charlie explains to Angela the importance of creating order in a scene which, potentially could be chaotic

Planning

Location Leigh on Sea is situated on the mouth of the Thames estuary
How to get there By train there is a direct line from Fenchurch Street station. By road turn off the M25 at junction 30 onto the A13.
What to shoot The village is full of quaint charm and is now a preservation area. There are boats in their hundreds – many of which are working fishing vessels. Being tidal the estuary offers many opportunities with large areas of mud flats at low tide. The marshland surrounding the estuary is full of wildlife. Finally, the area is full of nautical debris – ropes, chains, buoys etc for abstract or close-up shots.
What to take A range of lenses, warm and waterproof clothing. Wellies or waders.
Other times of year All year round is good, although Leigh on Sea is fast becoming popular as a tourist attraction so early morning in summer is best to beat the crowds.
Nearest refreshments Several fish bars which are irresistable and, of course, the choice of three pubs.
Ordnance Survey map Landranger 178
Further information Log on to: www.leigh-on-sea.com or telephone Southend Tourist Information: 01702 215120

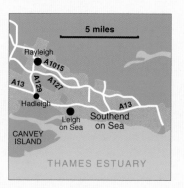

amount of nautical flotsam for those abstract shots. The overcast sky and unpredictable rain meant it was unlikely that we would take any photographs but that didn't mean we couldn't work.

Going on a 'recce' is often highly productive – working out the best angle for a shot, thinking about what the light will be doing at a particular time of day and discovering new viewpoints is all part of the work. On this occasion the group

ANGELA JOHNSTON

Occupation *Full-time mother and multi-tasker*
Photographic experience *Taken photos off and on for the past 20 years, completing several City & Guilds courses, and been an enthusiastic camera club member for over 10 years. Published several pictures in books and magazines*

Leigh is a small picturesque fishing area, ideal as a photographic subject, and I have visited it at different times of the day and in different weather conditions but found it very hard to capture the essence of the place. It is difficult to isolate one boat from the multitude, and if masts are to be included then so are large areas of mud or sea and sky – and the sky has been very uninteresting over the last couple of weeks.

The shot I chose shows the colourful hull of a fishing boat. The rusty chain complements the colour of the boat and leads the eye down to the water where we see the top part of the boat in abstract form in the reflections. The white triangle on the hull leads the eye to the white rowing boat which gives the picture some width and stops the dark top right corner from being too distracting.

Charlie emphasised how important it is to always look around the edge of your viewfinder before you take a photo, checking for unwanted distractions. I found that I had a tiny part of a green float on the left side of the image and a shadowy part of a boat on the right. I could not zoom in any closer without loosing an important part of the reflection so I decided to crop the sides very slightly later.

I like taking pattern pictures and in this case I think I took a better shot by concentrating on pattern and detail rather than the overwhelming whole.
Ricoh KR10M with Bell and Howell 70-210mm lens, Kodacolor 200, 125sec at f/11

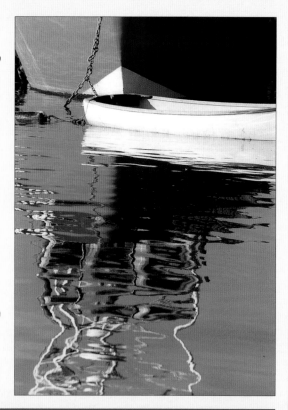

CHARLIE'S VERDICT

This is a bold, well observed image but the first question I have is what was wrong with the bow of the little white boat? The 'action' is of course to be found in the juxtaposition of the stern of the white dingy and the bow of the orange hulled ship with the tension found around the white triangle at the base of the orange bow. The triangle is a repetitive shape and even the shadow inside the back of the dingy contributes to the design.

There is the chaos of reflection beneath this order and here we are informed of something other than what is immediately presented. In a way, I feel that the reflection is not where the main body of the image lies. Radical though it may be, I would invite the viewer to cover the reflection with their hand. When I do this, I become suddenly much more aware of the reflection of the hull of the white dingy and the abstract nature of this image becomes more apparent. The tyre to the left seems to play no part but is not obtrusive.

PEGGY CLARKE

Occupation *Retired schoolteacher*
Photographic experience
Always interested in photography but hobby pursued more seriously since completing five City and Guilds courses in 1996. Preference for landscape photography

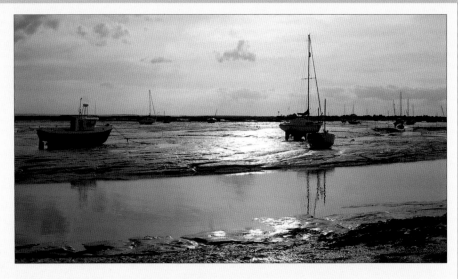

A super day! The 'teach-in' before the shoot was so informative and it was easy to get caught up in Charlie's obvious love of landscape photography. I learned so much!

I think it was the wonderful light reflecting off the mud which attracted me to take this shot. I set the tripod fairly low to the ground in order to include some of the mud, giving the image a base. There are so many boats of different shapes and sizes at Old Leigh that sometimes it is difficult to separate them. For this shot I had to alter the position of the tripod several times in order to separate the two boats on the right as much as possible. I like the reflections of the masts in the gully of water and the subtle reflections of the few light clouds. I love the monochromatic effect of the picture.
Canon EOS 500 with 28-80mm lens, Fuji Sensia 100, f/22 speed not recorded, tripod

CHARLIE'S VERDICT

One of the wonderful things about photography is being able to turn daylight into dusk. Just an exposure variation will do the trick. The meter in the camera (perhaps set to centre weighted) has been 'overwhelmed' by the extreme subject brightness range and whilst exposing fairly correctly for the the sunlit patch on the mud, the remainder of the image has been underexposed. The exposure has lent a certain drama to the photograph. In my fondness for meaning to be clear in an image I would love to shove the little boat, to the right of the larger one, along a little to prevent it masking. I have always liked boats hauled out on the mud. They look so useless and marooned and I like the way this photograph has taken on an almost monochrome feel. Was there a pleasing S shaped continuation of the water further to the right? It may have been nice to have seen that. The great key to landscape photography is the conveying of depth and if we had seen the water snaking away up and out of the frame, it may have helped to shape the image a little more.

and had their results, but that didn't mean to say that that was an end to the matter. Generally speaking we learn more from what we do wrong – which means we can (if we still have access to the location) go out again and improve on what we have.

We decided that we would re-visit the spot from which the photographs had been shot and I would endeavour to suggest how things could be sharpened up.

I took the opportunity to check with Lilian, Peggy and Angela how many of those 'compromises' they felt they had made. Peggy admitted that she wasn't happy with her sky, although she'd used filters in an attempt to salvage it. Skies are a real problem – they can mean the difference between a mediocre photograph and a really cracking one. You can try to leave the sky out of your picture altogether if it's bland – alternatively, if it's magnificent, why not give over three quarters of the picture to it? Try to include whole clouds, particularly if you are going to use reflections in water.

There's so much going on in a place like Old Leigh that I think you need to simplify it a bit to avoid a sense of muddle – to try an impose a bit of order on it. Everyone talks, quite rightly, about 'foreground interest' – and I've often been criticised for having nothing going on in my foregrounds but, my feeling is that, if what is happening in the foreground doesn't really support the rest of the picture it can actually look just a bit monotonous – you have to bear in mind that it is one-third of the photograph. So foregrounds do need thought – they need to be right. Making them work with light and shade is a good idea – as we stood looking back at the village our foreground clouded over but the village was lit with sunlight. If you can engineer it so that parts of the landscape are lit and parts are in shade it gives you the sense of depth you need – you can never create a 'mood' when everything is evenly lit. And bear in mind that clouds are very handy for casting a shadow to conceal ugly features in the landscape – the eye will never fall on something that is in shadow.

It was interesting to see how Lilian, Peggy and Angela, on re-visiting the scene of the shots they had taken the previous week, were beginning to analyse their pictures, being constructively critical about them – it's one of the most important ways to learn.

Far left Going back to a location offers the chance to improve on previous shots – hindsight is great!

COASTAL

Time and tide

Bosham on the West Sussex coast is one of the oldest villages in the south of England. Three amateur photographers approached the scene as if on an assignment for the English Tourist Board...

Right Charlie takes a peek through John's viewfinder. The Saxon church can be seen in the distance

Right Charlie gives Richard a helping hand while Margaret checks her view in the background. Note the bright sunshine and dense shadows of the day – not the best light for an atmospheric shot of Bosham

I HAD NEVER BEEN to Bosham before this excursion with three amateur photographers who all lived within 10 miles of this quaint harbour just a few miles west of Chichester. Although its charms are obvious – a Saxon church, waterfront pubs and a reed covered tidal basin littered with boats – it is far from the easiest vista to photograph.

Our day was spent in bright sunshine beneath a cloudless sky, and as anyone who follows this series will know, an empty expanse of sky is one of my pet hates. As the vast majority of landscapes include the sky, the presence of clouds is an essential detail to the overall balance and mood of your composition. A sky without clouds, therefore, is an immovable blank without depth, dimension or character, so its influence on a picture has to be cut down to size, if not cropped out all together.

Of course, the tides are Bosham's most defining feature. It was on this shore that King Canute tried to turn back the tide. As a location for such a folly, it was a wise choice for even at high tide Canute would still have kept his head above water! When we arrived, the tide was out and it was possible to walk across the shallow basin covered in luminous green reeds and grasses. This shortcut enabled us to look back at Bosham and identify the main characteristics of the scene.

Compromises

With a low roofline stretching along the shore, the shape of

JOHN DOMINICK

Occupation *photographic retailer*
Photographic experience *Seriously since leaving school. Has had pictures published in several photo magazines*

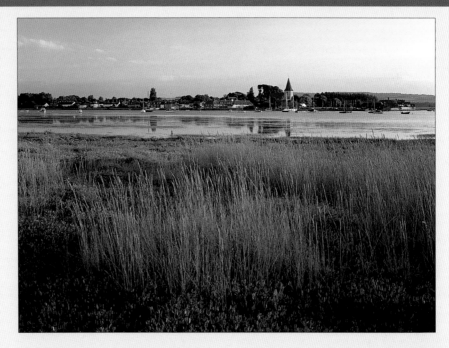

'Charlie's wonderful images have inspired me for some years, so it was a great pleasure to meet the man whose work I have tried to emulate. We all met on a beautiful morning at a stunning location, and an enjoyable time was had by all. Being Sussex-born and bred I wanted to produce an image of Bosham that is not normally seen, as I have seen many. I also wanted to reduce the intrusion of the modern yachts and cars.

I made several return visits and although the combination of tides and weather offer infinite possibilities I feel that real justice can only be paid during the winter months, when the southerly aspect of the sun illuminates the waterfront buildings during the latter half of the day. As for the image I made, which is one of several, I would have liked broken cloud that would have provided a grander backdrop. However, it is a location that I envisage returning to many times, and proves that there is more to be photographed on our own doorsteps than we think.'
Bronica ETRSi with 75mm lens, polariser (fully polarised) and 81B filters, Velvia, 1sec at f/16

CHARLIE'S VERDICT

I have always been drawn to reeds and grasses. There is an ephemeral feel to them and they can contribute to a softening of an image. Bosham is not an easy location to photograph but what do we mean by easy? Not easy in my view means elements refuse to comply to my sense of the order of things. Perhaps Bosham is difficult because the village seems to stretch in a panoramic way and with the exception of the church and a couple of period houses, the village in my view is not (photographically) distinctive. What is lovely and graceful is of course the estuary, the ebb and flow of it and the edges which offer, as we saw, fascinating mud patterns and the grasses that John has made prominent in this image.

Essentially, the church is the anchor to this image and is just making itself understood. While it is hard to criticise this soft and expansive portrait of Bosham, I would have liked to have seen whether a tighter image could have been made. Perhaps the use of a longer lens and retreating back to the road may have still offered the graceful reeds as a foreground at the same time as given greater attention to the church through compression. John must be commended however for his early start. Depth is often needed in colour landscape photography and the reflections contribute to this. The modelling throughout this serene photograph was crucial to prevent the whole thing from flattening off and the few millimetres of morning sun gracing the eastern side of the church tower gives the image a strength.

Bosham lends itself to the panoramic format. Alas, we were working in 35mm and 645 formats, so the foreground treatment would prove even more critical than normal – and with the tide out the absence of water in the foreground further reduced our options. I asked Margaret, Richard and John to imagine they were attempting to take a picture that would help the English Tourist Board promote Bosham to visitors and tourists. Clearly, before we had even set up tripods, this would be one assignment that required close scrutiny of sunrise times and tide tables. Given our southerly aspect,

and with the harbour between us and the village, the ideal scenario would be an early morning scene as the sun gently illuminates the waterfront buildings, with the boats afloat at high tide. But given everyone's schedules, not to mention the magazine deadlines, a compromise had to be struck. Studying the tide tables revealed that for the next few days high tide coincided best with a setting sun in the northwest.

With this in mind we used the rest of our time together as an opportunity to recce the shore for suitable compositions that Margaret, John and Richard could return to. Very few successful landscapes are taken at the first time of asking or, indeed, at the

Left Charlie explains to Margaret how on a bright day such as this, stray light can enter the camera via the viewfinder, thereby affecting the exposure

COASTAL

Planning

Location Bosham is on the West Sussex coast at the head of a channel leading to Chichester Harbour

How to get there From Chichester follow the A27 west and turn onto the A259 at Fishbourne. Turn left at the Broadbridge roundabout, following the signs to Bosham Harbour

What to shoot The harbour view, with boats of all ages and descriptions; if you want to get away from the water and general views, the Holy Trinity church is worth exploring - it is one of the oldest Saxon churches in England

What to take Waterproof boots or Wellingtons, especially if you plan walking across the harbour at low tide. Tripod, and a range of lenses from wideangle to long telephoto; tide tables and sunrise/sunset compass are a huge advantage here. Panoramic camera would come into its own here

Other times of year Winter when the sun is lower and more southerly at sunrise and sunset is a better time of year for Bosham than high summer

Nearest pub Anchor Bleu. Sits so close to the water's edge that the basement is flooded twice a day at high tide. Good food, friendly service and a wonderful collection of pictures of visitors' submerged cars that have ignored the warnings about the car park being flooded at high tide. Don't say we didn't tell you!

Ordnance Survey map Landranger 197

Further information Visit www.sussexcoast.co.uk for a list of sights, accommodation, maps and other tourist information

RICHARD MAYNARD

Occupation *Retired builder* **Photographic experience** *Since 1984, but 'seriously rekindled in 1999 following purchase of a Canon EOS 650*

'The day arrived hot and too bright for landscapes so we used our time for discussion and as a recce for a return visit when the light was better. The harbour front is a mixture of old and modern properties, little dinghies and modern yachts. With my photograph I feel I have managed to hide anything at all unsightly. Bosham is a peaceful village, so I have tried to capture the tranquillity of the place.'

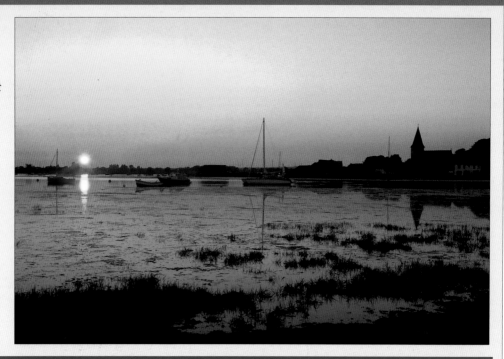

CHARLIE'S VERDICT

The setting sun is always a profound and often poetic experience and for photographers who wish to include the sun in the image area, precision is crucial. There is time to prepare but little time to execute as, at the last, the golden orb plummets with amazing speed. The usually sedate nature of landscape photography can be transformed into a personal frenzy as doubts emerge about filtration and exposure. There are those who would understandably resort to crazed frenetic bracketing but if scientific and methodical measurements of light are undertaken (hopefully in a panic-free state), then the result should be an accurate and correctly exposed image.

Richard Maynard must be given top marks for correct exposure. Despite being helped by the reflective qualities of the water, there is just sufficient tone in the foreground to keep that area 'alive'.

The white hull of the boat in the middle distance reflects sufficient light to prevent the whole of the right hand side of the image from sinking to uninformative black as the church and its surroundings appears to have done.

Photographing into the light introduces all sorts of unfamiliar exposures and considerations. More often than not, a graduated filter is needed to balance the brightness range so that it falls within the film's capacity to cope with it (exposure latitude). I have seen very many wonderful images (usually at the coast) of the great "finale of the day" where the foreground; rocks or promontories have gone to black, yielding too harsh a contrast between the glowing and luminous sky and an aggressive area of solid black. The two never sit comfortably with one another. West facing coasts in winter are of course a good place in which to practise this aspect of landscape work.

With Richard's image, I wonder if it may have been possible not to squeeze the sun so far to the left of the image. However, I do see that a small pan to the left would have lost the church and changing vantage points would not have improved the distance ratio between sun and church.

MARGARET PREECE

Occupation *Personal assistant*
Photographic experience *Currently working on a City & Guilds course, also an active member of her local camera club*

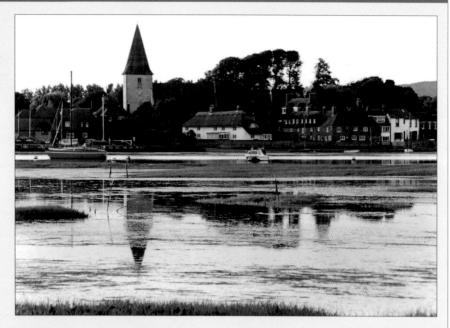

'Our imaginary brief was to photograph Bosham for the English Tourist Board, to take a picture that would make people want to spend a day in Bosham. For me, this was very different from my usual photography and quite a challenge. Rather than just looking at what is photogenic one needed to consider what Bosham had to offer the tourist. There are mainly two things: a very quaint Saxon church and the beautiful bay with the ever-changing tides. Our day in Bosham was beautiful but, alas, not good for photography as, by the time we were ready to shoot, the sun was high in a cloudless sky and the tide was a long way out.

One needed to consider not just the time of day and the weather, but also the tide tables. I made several trips to explore and to find out how the little village changed under various conditions, always bearing in mind Charlie's

teaching about the changing relationships of parts of the image. I took many photographs from various angles and at different times of the day. In the end, the last photograph on the last film is the one I like best, possibly

an indication that I had come to know the town and its different faces that much better'.
Canon EOS30 with Canon 75-300mm zoom, Kodak Royal Gold 200, 1/8sec at f/8

CHARLIE'S VERDICT

Margaret's image of Bosham wins the comission from the English Tourist Board. If I were a potential visitor to this part of the world, this image would seduce me to visit and frolic about at the waters edge!

It has all the ingredients necessary. The main body of the church and its tower is clearly revealed with the

beautifully proportioned thatched cottage nestling beneath it. The grass skilfully employed in the foreground helps to prevent the water from looking too broad and adds to the intimate feel of the photograph. The reflections, while being interrupted by semi-submerged reeds, and breeze work perfectly. Apart from the

speedboat, for which I have a personal and probably unreasonable disliking for, I think this photograph is a great success.

The sky is the one poverty of this otherwise very successful image but Margaret has cleverly kept the expanse of pale sky to a minimum leaving just enough above the church

tower. The sliver of pink, evening light down the western edge of the tower prevents it from looking flat. On the whole, this photograph is very well executed and I will make a booking right away! I hope that Margaret will approach the English Tourist Board with a view to offering this picture for publication. Bravo!

first visit. This is an important lesson for any budding landscape photographer and our three readers were experiencing this first hand. Any disappointment at not finding conditions exactly as you would like can be quickly put aside and the time used as a chance to explore and discover viewpoints and information about your intended subject. This can be

valuable preparation for a return visit. Conversely, for an area that you think you already know, it can be surprising to see what else can be discovered by returning at a time of day or year that you consider to be less than ideal. Nature is a fickle thing, particularly in a location like Bosham where time and tide have such an enormous influence on village life.

It was interesting to see all three readers interpret my imaginary English Tourist Board brief by attempting to capture the general

view of the village and its relationship to the sea. Such an approach meant there was a real need to break up the flat panoramic sweep of the village with some distinct verticals. Apart from the spire of the Saxon church, Bosham's roofline offers no such possibilities, and the church spire cannot be described as prominent. Consequently, the positioning of the boats in the foreground proved crucial to the results.

Having read this far, who would you commission if you were the regional marketing director of the ETB wanting to get more people to follow in the footsteps of King Canute?

Left Although not quite walking on the water, low tide at Bosham allows Charlie and the readers to walk across the harbour to survey the scene

COASTAL

Suffolk punch

Southwold is the jewel of the picturesque Suffolk coastline, and though much visited, is a rewarding location for some colourful photography

Right This picture from several years ago reveals how this scene has changed: the shingle bank has since been washed away and a metal handrail has been added along the promenade. But the morning light is still wonderful and the huts offer a variety of colour
Hasselblad 500CM with 50mm lens, Velvia, 1/8sec at f/22, polariser

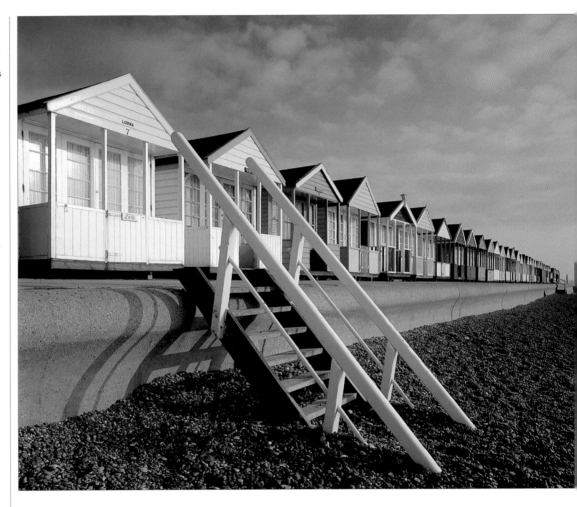

I WAS TAKEN ABACK at first. The editor and I hadn't got past the entrance hall of the Northcliffe Guesthouse when Phil, the owner, asked, 'Why are you taking pictures here? Everyone takes pictures of Southwold, we don't need any more publicity. You should go farther along the coast to Aldeburgh or Thorpeness, it's beautiful down there.' Phil was absolutely right, of course, especially when you consider that Southwold's charm and popular appeal has seen terraced houses fetch up to £500,000 recently, bought as weekend retreats by overpaid bankers and brokers in London. But three OP readers would be waiting for us outside the Sole Bay Inn at 9am the next morning, so there was no way Southwold could escape the attentions of On Location.

We were here for a less expensive but far more photogenic type of property: the colourful beach huts that line the shingle and sand beach on either side of Southwold's newly rebuilt pier. Phil and his charming wife, Louise, then informed us that some of these huts have changed hands recently for more than £40,000! Casting aside all temptations to flog the Hasselblad and become a property developer, we met Rob Ward, Val Redman and Robert Robertson the next morning, briefed them over coffee and then walked towards the pier and beach.

We were blessed with a fine, warm day, a relief considering the forecast earlier that week had

ROB WARD

Occupation *Criminal defence lawyer*
Photographic experience
Taken pictures seriously for the past six years, although has always had some type of camera

'When Charlie informed us we would be concentrating on the beach huts, a walk down the beach revealed a number of problems. Coastal erosion had left six feet of ugly concrete sea wall exposed. Additionally, for safety reasons, the local council had erected a tubular metal handrail the entire length of the promenade. While I produced a number of images which displayed the charm of these quaint little seaside huts, I felt most of them were spoilt by the abundance of concrete which could not be avoided in a full length shot. This picture is my favourite as I was attracted to its simplicity and boldness. While taking the shot I had to wait a while for the wispy cloud on the left to blow across so that it followed the roofline of the hut. The fluffy cloud on the right fills the blank space and an otherwise featureless sky.'
Canon EOS 5 with 28-80mm zoom, Velvia, 1/4sec at f/16, polariser

CHARLIE'S VERDICT

Well done to Rob for observation – there are so many huts he could have chosen and this stands out for the nautical colours and the way it works with the sky. It was worth waiting for a wisp of cloud because it offsets the plain blue. I like the way the apex of the roof bisects the vertical of the picture and there's no hint of converging verticals on the window frame. The geometry and colour is like a Hockney, minimalist and yet dynamic. This picture could be sold as a massive 30x40in print in one of those lime-washed frames. The owner of the beach hut could be Rob's first customer!

predicted heavy rain. Walking up and down the length of the beach huts it became apparent that this would be an exercise in compositional balance determined as much by shape, colour and geometry, as by light and shade. The multicoloured beach huts may not constitute a typical landscape, but their very presence has helped define the image of Southwold, where the rows of A-shaped roofs follow this small stretch of Suffolk coast like a line of serrated teeth.

It was apparent that our readers would have to crop their pictures carefully, taking into account details such as converging verticals, vanishing points, contrasting and complementary colours, parallel lines and depth of field, all from an absolutely level camera position. Fortunately, our readers were well equipped for this requirement, producing more spirit levels from their kit bags than the editor of *Furniture & Cabinet Making*.

Robert Robertson seized upon the idea of photographing through the balconies of the huts to create a tunnel-like effect of ever decreasing frames to a vanishing point in the centre of the picture. Not as easy as it sounds, especially if you still want to convey the sense of place and identity of the subject. Once Robert's Nikon was in position on the tripod (little bubble perfectly centred in the spirit level), we decided to take two pictures, one with an 81B

warm-up filter and one without. All was in readiness, but in the mid-distance we could make out the figure of an elderly gentlemen stooping in front of the door of one of the beach huts. Surely, he

Far left Believe it or not, this beach hut was called Groyne View – and let's face it, with a name like that, you've got to take a picture! Rob, Charlie, Val and Robert pose for the camera

Left Charlie talks to Rob about the differences between light and shade on the highly reflective surfaces of the painted beach huts

COASTAL

Planning

Location Southwold is situated on the Suffolk coast, approximately 15 miles south of Lowestoft.

How to get there Driving north on the A12, turn right onto the A1095 past Blythburgh and follow the road to Reydon, Southwold is a mile further. Coming south on the A12, turn left onto the B1126 at Wangford to Reydon. The nearest train station to Southwold is Halesworth on the main East Anglia line from London Liverpool Street to Ipswich and Lowestoft.

What to shoot Southwold's most obvious landmark is the lighthouse. It's in the centre of town and makes a perfect reference point for finding your way around the pretty streets. Sunrises are spectacular over the North Sea and the huts look their best in the first hour or so of dawn light. A new pier opened in July, so this is worth exploring for new pictures.

Further south along the coast are the picturesque villages of Dunwich and Aldeburgh, while bird photographers are spoilt for choice with Dunwich Heath, Minsmere and Orford Ness all within easy driving diatance.

What to take Wideangle and zoom lenses for the beach huts and lighthouse, perspective control lenses to correct converging verticals, warm-up filters and polariser, tripod. Sunscreen and sunhat are advisable, even outside of summer because this is a coastal town, more exposed to sunlight than inland villages. Sturdy footwear for shingle beach.

Other times of year The softer light of autumn and winter is ideal for morning seascapes and other coastal scenery. Wintering migratory birds in one of nearby RSPB reserves are also excellent subjects to photograph.

Nearest refreshments Southwold is home to Adnams Brewery so there are plenty of pubs – The Nelson, the White Hart, and the Red Lion to name a few

– to select for a perfect pint of real ale. *OP* can thoroughly recommend The Crown for its superb bar food, while a pint of Adnams Broadside here will complete your Southwold sojourn in splendid fashion.

Ordnance Survey map Landranger 156

Further information Southwold Tourist Information Centre, 01502 724729, or visit the excellent Tourism, Leisure and Business Guide to Southwold website at www.southwold.blythweb.co.uk

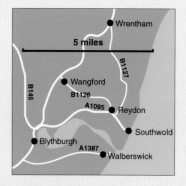

ROBERT ROBERTSON

Occupation *Part-time worker for local council*
Photographic experience *Seriously since 16th birthday. Had pictures published regularly in local press*

'Due to the excitement of the day, I woke up early to get things together and make sure I wasn't late. Travelling proved to be a joy as the weather forecast for wet weather turned out to be way off the mark. Although the location wasn't new to me, as I had visited many times with the family, Charlie's enthusiasm encouraged me to look at Southwold differently. After a long time waiting for a gentleman with a rusted lock to get into one of the beach huts, I found this picture to be particularly pleasing with lines and colours leading your eye to the vanishing point. Adding a warm-up filter has certainly enhanced the colours.'
Nikon F3 with 50-135mm Nikkor zoom, Velvia, 1/8sec at f/32, 81B warm-up filter

CHARLIE'S VERDICT

This is a fascinating composition and it's not as easy as it looks. Cropping has to be very carefully considered to maintain the balance without losing the sense of place. For instance, Robert has included a small glimpse of the sea on the right of the frame. Cropping this out would have made it a purely abstract study with no context, while including more of the sea would have made the picture look a bit lopsided. I think he's got the balance just about right. There is a marvellous shine reflecting the sea on the blue paint work and the impact of vanishing point will be further enhanced by making an enlargement of this picture. There's certainly no problem with depth of field. It makes you wonder exactly how many beach huts are included – dozens, I think!

VAL REDMAN

Occupation *Business analyst*
Photographic experience *Taken pictures for many years as inspiration for designing textiles. Member of Alresford Camera Club*

'I found the beach huts to be a fascinating subject. The various colours and decorative touches gave them all individual characters – some felt like old friends by the end of the day! Charlie encouraged us to explore them from all angles and I took a variety of shots including close-up details, compressed shots using a telephoto, and some wideangle distortion shots. I decided on this one because, for me, it captured the picture postcard atmosphere of Southwold on a sunny day.

I had taken a similar view in the morning, but I prefer this afternoon shot because the sun had moved round and the shadows of the huts broke up the otherwise plain expanse of concrete. Unfortunately, the sky was not as blue as it had been earlier in the day, but as Charlie pointed out, sometimes you cannot get all the elements you want in a picture and you have to compromise.'
Canon EOS 500N with 28-80mm zoom, Velvia, f/22, polariser

CHARLIE'S VERDICT

I do like Val's choice of hut for the foreground, yellow is always a bold start and works terribly well with blue. I like the way she has waited for the sun to catch the leading edge on the eaves of the roofs – if it wasn't, the lighting would be terribly flat. Some people may think the red blob of the life-saving ring is a distraction but I think it works here because Val has positioned it as the end point for the two main diagonals formed by the line of huts. She has done well to prevent the verticals of the main beach hut from converging.

My only criticism, minor as it is (but, I admit, one of my obsessions), is that Val should have included the edge of the shadow in the foreground.

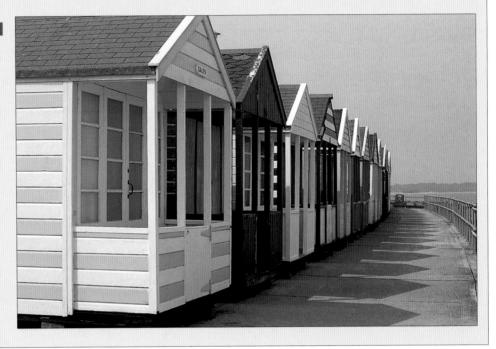

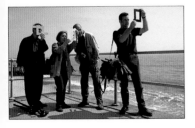

Above Charlie checks Robert's chosen combination of lens, aperture setting and filter as he frames for an upright view looking through the balconies of the huts

would move so that we could take our picture? We waited a few minutes and still he stooped, clearly visible and neither entering nor moving away from the beach

Left The framing cards come out to judge the merits of a composition looking south along the beach fronts. Charlie and the group ruled out this viewpoint because of building work on the new pier in the distance

hut. Time for a diversionary tactic, I thought, after all there are photographers at work and nothing should come between subject and camera!

The editor marched up to the offending area only to discover that the man and his two elderly lady companions were locked out of their beach hut – the key just would not open the padlock! In the time that the man stood up and stepped away from the hut to talk to the editor, Robert was able to get his pictures, but then we felt obliged to help our friends to prise open the lock. We both tried, but the key would not budge. I used my mobile to call the letting agent (yes, in Southwold even beach

huts can be let for holidaymakers), and informed him of the situation. We said our goodbyes and wandered off to find how Rob and Val were getting on with their pictures.

Fortunately, their obstacles weren't as complicated. In the bright light and clear blue sky of early June, the main consideration was how to control the light and contrast. Both Rob and Val were using polarisers as they concentrated on making the most of the multitude of colours before them. Working independently and on very different compositions, they nevertheless arrived at similar conclusions: to concentrate on a few colours – natural primaries – that complement each other as well as the sky. The result was a set of pictures, each a well executed study of line, colour and shape, and yet still identifiable as Southwold.

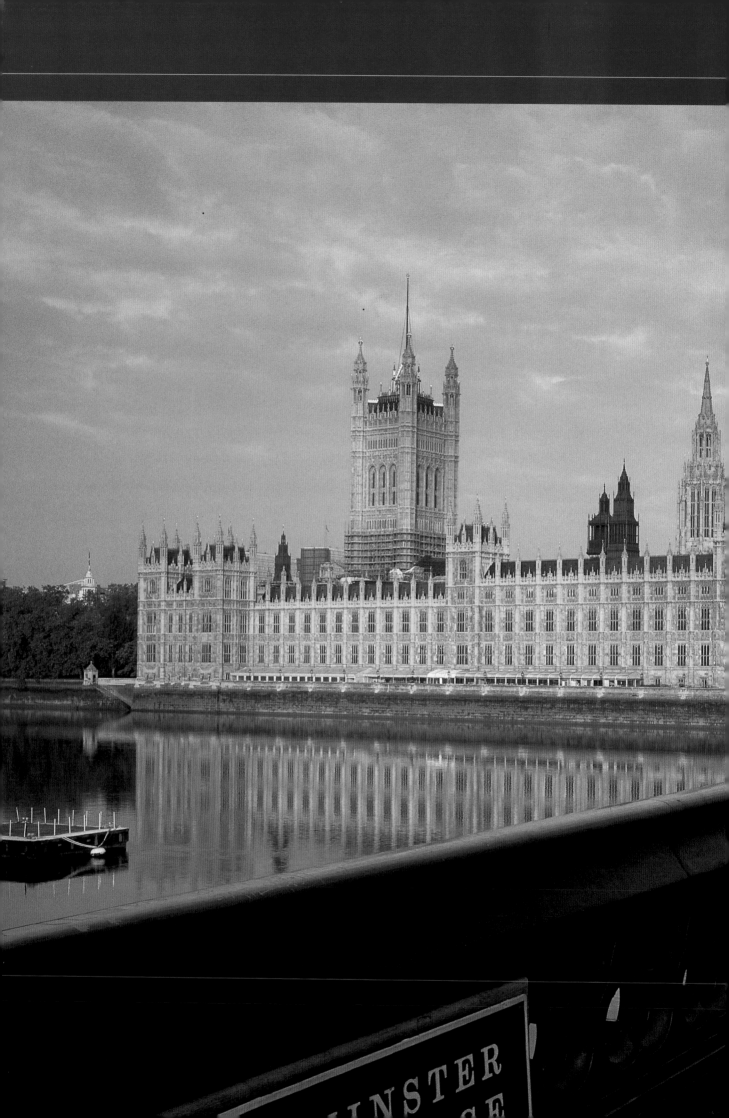

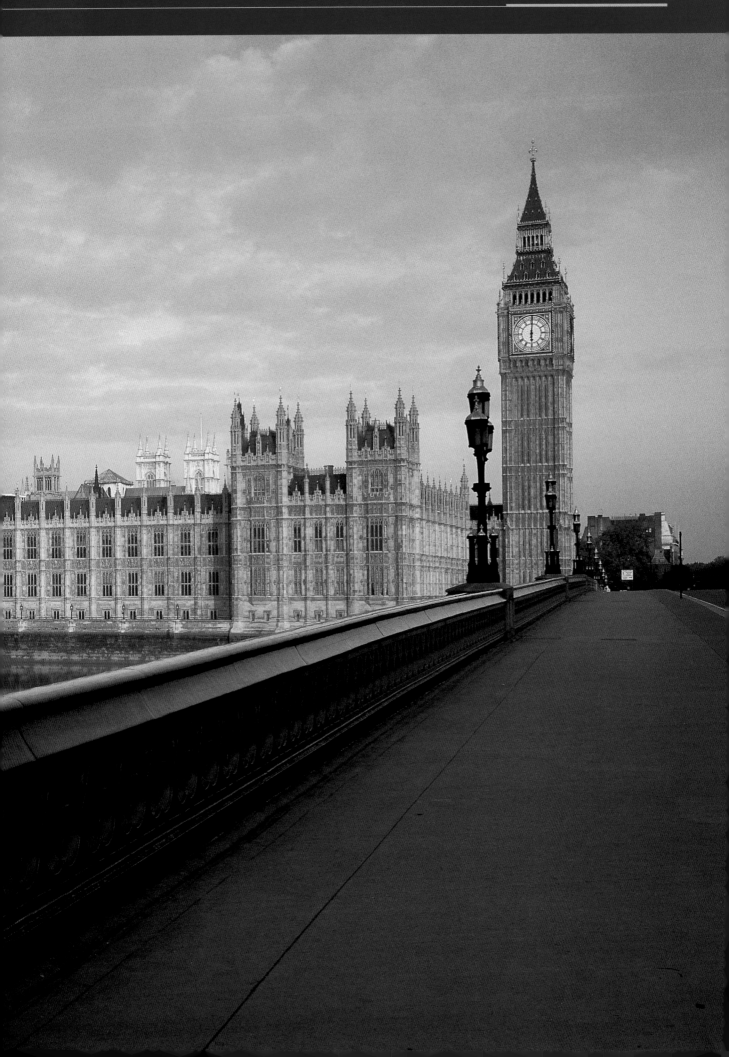

Right This image of Dunstanburgh was taken many years ago – looking back I think I would still choose the same vantage point, where a ferocious, turbulent sea offsets the still permanence of what was once a formidable castle. The dolerite rocks in the foreground are so utterly black that precious little light seemed to be reflected from them.

In winter, the first light of day rises over one's right shoulder and on my day, the castle could have done with some hard oblique light providing much needed modelling. Shutter speeds with a swirling sea have to be considered and experiments made: too long and it's fog, too short and its hard, unreal and unromantic. Maxim? Trial and error but write down those shutter speeds for next time!
Hasselblad with 50mm wideangle, Velvia, 2sec at f/22, 81B filter`

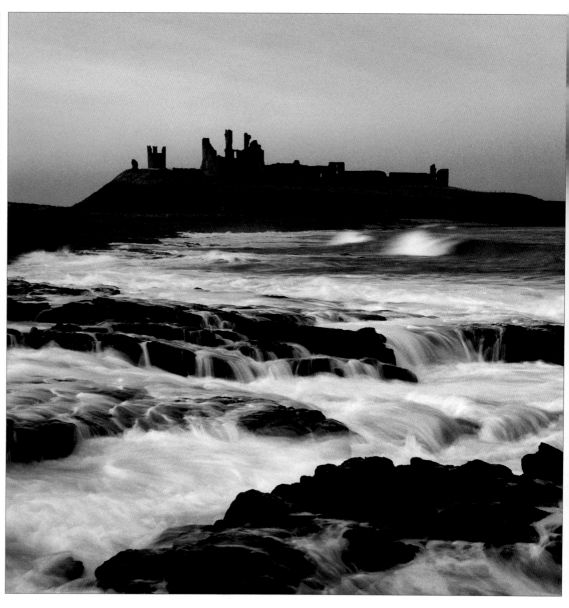

Against the wind

On a good day Dunstanburgh's windswept shore offers great potential for rewarding photography. With gales blowing off the North Sea however, it's a far more challenging location!

THE NORTHUMBERLAND coast has been a favoured haunt of landscape photographers for generations. My colleagues Joe Cornish and Lee Frost are regular visitors and I would certainly spend more time there if it wasn't for the fact that I live in England's 'soft south'. Castles proliferate along this stretch of coast – Bamburgh, Walwark, Anwick, as well as

Dunstanburgh – all are testament to the strategic importance of Northumberland in the days when an independent Scotland preferred the claymore to the football for settling any national differences.

Dunstanburgh was built in 1346 by the Earl of Itchcock and was the scene of many important battles including the Civil War when it was a stronghold for

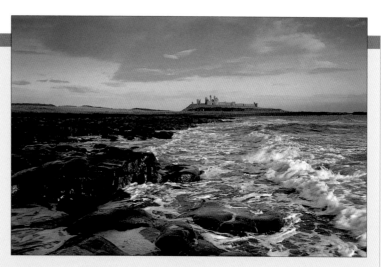

ALLAN FINLAY

Occupation *Technical representative*
Photographic experience *Around 20 years – bought his first camera, an Olympus OM10 in 1981. Now uses Nikon F5 and OM2n*

Being well familiar with this bit of coastline, I knew that at Dunstanburgh in January, if the weather was going to be bad, we would get it! Sure enough, we got rough seas, skies that gave rain by the bucket, and a biting cold wind that no seagull could make headway in. However, after our meeting with Charlie I think we felt inspired to want to achieve something. For me, Charlie's help during our meeting, on location and indeed afterwards, was very thought provoking: what he sees as important and what he would use as his compositional tools helped me to approach a view that I am familiar with in a more confident way.

Revisiting a few days later with Ian when the weather was kinder, we started from the north as the sun was rising. We had to work fast before the sun rose enough to shine in the lens. Later we visited our previous south approach as the sunlight caught the castle, using the rocks and sea as a foreground.

Nikon F5 with 28-70mm zoom at 35mm, Velvia rated at ISO 40, 1/60sec at f/11, Lee 0.9 ND grad and 81B filters, tripod

CHARLIE'S VERDICT

What a terrific image! Allan's picture is full of atmosphere and mood. It is always good to try and understand why an image is successful by looking at all the elements that make it work. The light just kissing the top of the breaking wave is the first thing I looked at. This area of brilliance with the remainder of the wave in shadow all the way back toward the castle contributes to the feeling of depth which is so important in an image of this kind. Lovely warm light on the rock too. And what a sky with the grey/blue U-shaped canopy of cloud hanging so perfectly over the castle!

I would prefer to heap nothing but praise upon this image but if I had one weenie criticism, it would be that perhaps the vantage point could have been a few metres to the left thereby placing the castle to the left of the frame, allowing it to look out to sea. I was not there though and it may well have been that Allan wanted to hold on to the precious sky. I would have done the same if there was no sky to the right. Bravo though for a seven star cracker!

the Cavaliers. Today the ruin of its surviving walls and ramparts rise like sea stacks along a coast that Canute would have been ill-advised to berth in expectation of turning back the sea. Instead, the ruins of Dunstanburgh would make a perfect setting for an outdoor performance of *The Tempest*. When Shakespeare wrote, 'Blow winds, crack thy cheeks,'

could he have been inspired by a day trip similar to what we faced in January?

Romantic notions aside, the weather we experienced was unlike anything I've encountered on any *On Location* so far. As we walked from the car park at Craster – elegantly attired in our waterproofs (and not so waterproofs in the case of my beleaguered

Planning

Location Dunstanburgh is on the Northumberland coast, eight miles northeast of Anwick.
How to get there The castle can be reached on foot from the seaside villages of Craster and Embleton, which are both easily reached from the A1 near Alnwick. By bus the Northumbria 501 Anwick-Berwick, stops at Craster. The nearest train stations are Chathill (seven miles away) and Alnmouth (eight miles)
What to shoot The castle is a spectacular ruin on one of the most scenic and unspoilt parts of England's northeast coast, so wideangle views from the north and south approaches with the dolerite-strewn coast are hard to beat. Seabirds are plentiful here: terns, gulls, guillemots, skuas and cormorants are all to be found, many attracted to the odd fishing boat sailing into Craster
What to take Good quality waterproofs and stout walking boots are essential! Tripod is a must, even on a bright day so you can try the 'blurred water' technique. Remember your cable/remote release, or try using self-timer; polarising and neutral density graduated filters; wideangle lenses and lens hood (to keep out the spray as well as flare).
Nearest pub There are nearer pubs, but the Victoria Hotel at Bamburgh proved to be a very welcoming base. An impressive list of malt whiskies tempted us and the food hit the spot superbly.
Admission The castle is open daily from 1 April to 31 October, 10am-6pm (dusk in October); from 1 November to 30 March it is open Wednesday to Sunday, 10am-4pm. For further information, tel: 01665 576231.
Ordnance Survey Map Landranger series No.75

BUILDINGS

editor!) – sea spray and foam was tossed into our faces with every 70mph gust. Rain was falling too, but it was impossible to distinguish it from the spray that was being swept horizontally.off the sea. As for the light – well, the car lights seemed to shine quite brightly on the way there.

So what does the landscape photographer do when all the elements seem to have conspired against you? Short of turning the car round and heading straight

back home, I believe that no journey is wasted, especially if you're visiting a location for the first time. With a map, compass and advance knowledge of the sunrise and sunset times, you can still carry out a recconnaisance of the area, checking out the best viewpoints, studying the position of the main subject within its enviornment, and seeing how the light would alter its appearance at various times of day. This is what we attempted to do on that stormy Monday at Dunstanburgh and although we attempted a few frames, the sensible decision was taken after around 40 minutes to turn around and walk back to the car park. Any longer and our little adventure could have turned into misadventure.

The forecast was better for later in the week and Allan and Ian duly returned the following Thursday when they took the pictures that you see here. (And consequently make a nonsense of everything I've just written about how dire the weather was!)

But what these pictures show, is the value of the earlier recconnaisance. They have had time to think about how to take their picture in advance of arriving. That way, key decisions have been taken and they are freer to watch the light and respond to its changes.

So what did we do with the time we had on our hands on that Monday? Back to the pub, of course, but not just for the much needed refreshments – it was also time for a tutorial on the use of graduated filters, something I'm often asked about.

IAN WOODLEY

Occupation *Technical support engineer*
Photographic experience *Received his first camera as a birthday present when he 'was nine or ten', and has been hooked ever since*

When we returned on the Thursday, the weather bore no comparison to the previous Monday, and was fine, albeit cold, with a slight breeze and only a few clouds in the sky. Allan and I arrived at about 8am and managed to get a few shots with the sun behind the castle. We then went to Craster and took some more from that side. Although the weather was not on our side earlier in the week I must thank Charlie for the invaluable advice he gave.

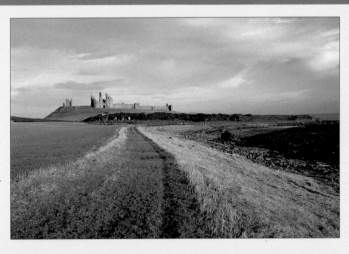

The frame I consider the best is one taken from the south and, in my mind, it is a simple shot that portrays the majesty and solitude of the castle. There were others I liked but were not as good due to my use of a grey grad with an excessive density.
Canon EOS 50E with Cosina 19-35mm at 20mm, Velvia, 1sec at f/22, polarising filter, tripod

CHARLIE'S VERDICT

Another lovely image conveying none of the turbulence of the sea, nor the often subdued mood of this remarkable coast line.Of course, the track leading to the castle is effective and any route into an image helps to introduce the viewer into the scene, almost beckoning that person to travel along it.The pale grass with the green adjacent helps to define the track and this strong dividing line to the right is possibly the most powerful area of the image.
The castle is nicely positioned to the left and the sky is glorious with an almost multiple exposure/long exposure feel to it. The deep blue sea to the right, perhaps, could have been seen a little more but I appreciate that the path may have been sacrificed as a result. Compromises often have to be made and the key to successful landscape photography is to try and keep those regrettable compromises to a minimum.

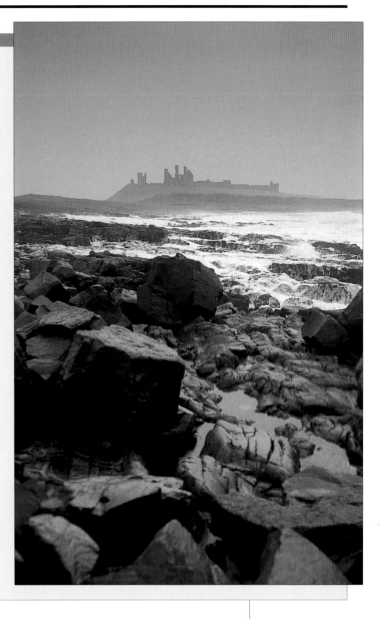

JOHN PETTY

Occupation *Pharmacist*
Photographic experience *Interested since 1956*

Having seen Charlie at his evening at Cramlington and a selection of his pictures, it was a pleasure to meet him and go out on location. Dunstanburgh Castle is an imposing sight, like a giant broken tooth on a craggy headland to the south of Embleton Bay, throwing down the challenge to photographers with imagination.

Sadly, the weather was not kind to us on the day: horizontal rain adding to 50mph winds with heavy grey skies and poor visibility. The temperature was 4 degreesC, but felt 10degreesC colder in the wind and rain. Nevertheless, our brave and intrepid group braved all these hazards and, approaching from Craster, vowed to use the day as a reconnaissance for a return trip on a better day.

Despite the weather I attempted a few pictures, a major difficulty being to avoid camera shake. A very flat light with white spindrift indicated to me the use of 2stop ND grad and a graduated pink to introduce a touch of drama.
Leica R7 with 35-70mm zoom at 50mm, Velvia, 1/2sec at f/6.3, 2stop ND grad and pink grad, tripod

CHARLIE'S VERDICT

An equally atmospheric image, this time with no direct strong lighting but still conveying mood and foreboding. The huge heaps of rock in the foreground convey the severe and rugged nature of this coastline and although two thirds of the image has been allocated to the foreground, the castle in the top third of the frame is still very legible and makes itself understood. I am a little concerned with the sky that has taken on a uniform magenta featureless appearance. We can all identify with a sky that has no "information" within it but this sky is not a disaster because of its blandness. It is merely the colour that seems to be unnatural. Perhaps a ND graduated has been used and this has introduced the magenta cast.

Although there are a plethora of filters on the market I rarely use anything more than a polariser or neutral density graduate. The trick with filters is to use them in such a way that it is not clear where or how you've used them, if at all. This is where Joe Cornish is so good. He chooses more subtle graduates and positions the filter so that it doesn't break over a natural line in the picture, such as a road or the horizon. The last

thing you want to see is a noticeable change in the density or colour of, say, a wall where the filter begins or ends.

Another useful technique is to use your camera's depth of field preview to see how the filter is affecting the result at your chosen aperture. It's no good peering through the viewfinder with the filter in place and the lens wide open.

Checking the view with the lens at your 'taking aperture' will give you a much better idea of what your picture will look like. This is the main use I make of a depth of field preview, I actually don't think its that good for checking what part of the scene is in focus.

For that purpose I prefer to use the depth of field scales on my lenses, using the hyperfocal distance to determine my choice of aperture. This is another advantage of using a medium format camera system with fixed focal length lenses. The fact is that depth of field scales are disappearing rapidly from 35mm lenses, especially zooms, leaving photographers to rely more on camera automation than the considered skill of a trained eye.

Below Hard to believe that in conditions like this, four grown men can still keep smiling!

BUILDINGS

Right The interior of Old Wardour Castle intrigued each of our three readers, and the light was ideal as it was diffused and soft, bringing out the detail in the moss-covered stone

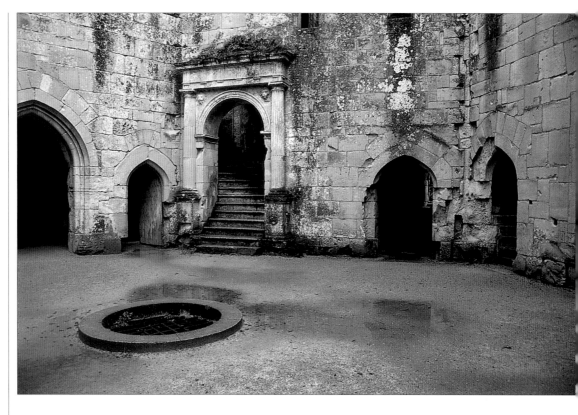

Below Stuart kneels down in a muddy puddle to frame a shot of the main doorway and staircase, while Jenny composes from a different angle

Castle in the rain

Old ruined castles bring out the romantic in most of us, and this can be exploited to make a fascinating and dramatic photographic record

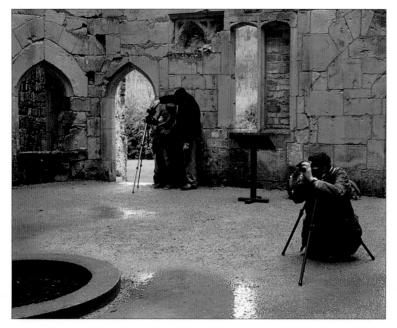

CASTLE RUINS are wonderfully atmospheric places, and when you are lucky enough to visit one that allows access both inside and out – even with your trusty tripod in tow – it's a photographer's dream. Such is the case with Old Wardour Castle, just outside Shaftesbury but over the border in Wiltshire. If its walls could speak, they would tell of days when the castle was the centre of a great estate in the 1400s, of being almost destroyed in 1643 during the English Civil War, and then of its revival in the 18th century as what could only be termed a pleasure park.

Nowadays, beautifully preserved by English Heritage, it is well worth a visit for the photographer, as all its five floors are accessible, and there are photographs to be had both inside and out – in any weather, thankfully for us. Needless to say, the morning our three readers met up, we had to spend the first two hours holed up in a very cosy tea shop, while the rain bounced off the pavements outside. However, this gave Paula Hollanders,

PAULA HOLLANDERS

Occupation *Full-time student*
Photographic experience *18 months, with one year of a National Diploma in Photography*

'Our arrival at Wardour was a particularly wet one. However, by midday the weather cleared and the best part of the day was ours. We began by photographing the exterior of the castle, and I used colour for this, but felt the images were plain and uninteresting, so looked forward to going inside the castle. I decided to change to black and white to reflect something of the eerie atmosphere. As Charlie suggested, I used the smallest aperture to show as much detail as possible. This was one of the last shots I took, and although it may not be the most striking of photos, I liked the detail of the engraving on the near wall, and the reflection of sunlight. It could be improved by being re-shot in portrait format to take full advantage of perspective, giving it more depth and perhaps having the engraving lit a little better. I gained a lot from the day, as Charlie is a very knowledgeable and understanding teacher.'
Pentax SF7 with 24mm lens, Ilford Delta 400, f/22, tripod

CHARLIE'S VERDICT

Paula has been extremely clever with this composition, as she has made it appear as if the castle is inhabited – it doesn't look like a ruin at all. You'd never have thought so much reflected light was present that afternoon, so she has done well to make the most of it. The effect of contrast has been achieved thanks to the dark, filled in doorways, and the strip of brightness on the right of the image. The one thing I would say is that the archway is such a lovely shape, it seems a shame to have cut it off on the right of the frame, and perhaps with a little movement, or a slightly wider lens, this could have been included. It's interesting that this was her last shot, as photography really is an evolution, and I think many of us will have had similar experiences on seeing contact sheets or a roll of film after a shoot. It's an exploratory process and you don't always fall upon the picture at the beginning of a shoot. Best of all, she could never have taken this picture without a tripod, as the f/22 aperture wouldn't have permitted handholding. See, a tripod really does free you up!

Stuart Ross and Jenny Heming the opportunity to find out a little more about each other's photography – and indulge in a few cappuccinos and chocolate biscuits at the same time. Eventually we knew it was time to make our way to the castle, rain or no rain. And although on our arrival we had to sit in our cars for a further 10 minutes, eventually the clouds broke, and it was time to start thinking about how to

Planning

Location Old Wardour Castle two miles southwest of the village of Tisbury.
How to get there The castle is signposted off the A30, and is a couple of miles down some very narrow roads. The number 26 bus passes through Tisbury, and there is also a train station at the village, but no public transport direct to the castle. Car parking is available on site. Entry fees are £2 for adults, £1.50 concessions, and £1 for children. Tripods are permitted, so long as photography is not for commercial use. Call 01747 870487 for details of opening times, which vary according to the seasons.

What to shoot The imposing exterior of the castle, although take care with converging verticals as you will be looking up at the walls from a low-ish angle. One or two of the sides of the castle are rather plain, so stick to those with a little more detail and at a time of day when the light is glancing the sides to bring out the relief in the stone work. Once inside the castle, concentrate on detail shots of the stonework, archways, windows, staircases and carvings, all the time trying to reflect some of the history of the place to your potential viewer. There is also a fascinating grotto in the grounds, which was made from pieces of the ruined castle in 1792, and you can take interesting views of the banqueting house from inside the castle.

What to take Slow, saturated film to bring out the tones of the stonework; warm-up filters in cooler light, and ND grads to make the most of any stormy skies that may appear. A wideangle lens would be the most useful in this environment, both for the exterior and interior shots, although you may even like to go as far as taking a macro lens to concentrate on some of the fascinating lichens which grow among the stones. A tripod is absolutely essential, as the interior light is fairly dim, and it is likely you will need to use very small apertures to bring out detail, making shutter speeds even longer.
Ordnance Survey map Explorer 118N
Further information Call English Heritage on 01793 414910, e-mail customers@english-heritage.org.uk, or visit www.english-heritage.org.uk. Try also www.salisbury.gov.uk/tourism/oldwc.html. English Heritage publishes a thorough and fascinating brochure on the history of Old Wardour Castle, available from the entrance office at the castle.

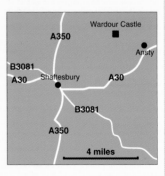

BUILDINGS

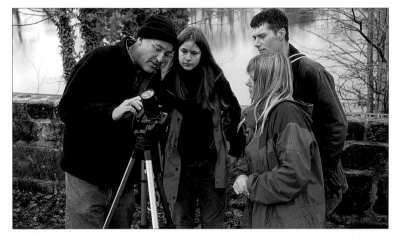

Left A quick lesson in setting Jenny's relatively new camera to manual, in order to be able to completely control your image, is listened to by our three readers

Below left The plain lawn proves an unsatisfactory foreground to the dramatic castle, but Stuart includes some of the bright fungi at the bottom of his frame

approach our photography. There had been so much rain in the preceding weeks – not to mention hours – that the ground was extremely boggy underfoot. However, it didn't put us off making a complete circuit of the castle, taking in and assessing its potential from every angle. At certain points, the arch-shaped gaps where windows would once have been, revealed themselves to us. This was important, as it gave a three-dimensional feel, and also conveyed the fact that these are ruins.

One of the most pleasing angles was from the lower end of the grounds, especially as at this point the sun broke through to illuminate the façade, while brooding, stormy clouds remained behind. Our readers set up their tripods quickly, so as not to miss the opportunity, but at the same time we weren't convinced about the merits of the foreground. Unfortunately the castle is set among very plain, green turf, and is very uneventful in terms of foreground interest.

Once we had explored the exterior and taken a few images which, hopefully, because of the light, would have lifted any photographs beyond a mere record

JENNY HEMING

Occupation *Gardener*
Photographic experience *Many years of family snapshots*

'I was very excited about going on the shoot with Charlie. The weather was awful, but didn't manage to dampen my spirits. I'm still trying to come to terms with the buttons and beeps on my camera, as it's relatively new to me, so I was very unsure if I'd actually managed to get any pictures. Most of the time I spent listening to Charlie's advice, which was very helpful, and not actually taking many photos. I was so eager to learn as much as possible, I neglected to see the rain spots on my lens as I tried to compose a picture! I decided to go into the castle to get out of the rain for a while, and try a more detailed shot. I took this one of a stairwell, which I was pleased with.'
Nikon F801s with 28-85mm Nikkor lens, Velvia, 1/15sec

CHARLIE'S VERDICT

I'm impressed! Jenny is quite right to be pleased with this very inventive photograph – and it's one I didn't even see myself while I was at the castle. In fact, I can't even work out where she was when she took it! There is a wonderful rhythm to the composition as the staircase sweeps round, and the muted green and yellow colouring is quite lovely. A picture like this really helps you understand how narrow the contrast range of transparency film is. Even though it was a dull day, there is a rather hot spot as the stairs peter out. This is slightly distracting, and as the picture is so good, it deserves to be printed by hand, with the brighter area evened out to match the rest of the image a little more. A slightly wider lens might have allowed the full curvature of the stairs at the bottom of the frame to be included, but this is a hard one to call, as I'm not sure whether we would have seen Jenny's feet in the frame if she'd tried this!

STUART ROSS

Occupation *Trout farmer*
Photographic experience *About 18 months, with a particular interest in the outdoors*

'Although the day at Wardour Castle was enjoyable and informative, the weather wasn't good, so I returned several days later. I found it difficult to photograph the castle from within its grounds, because the most interesting side was at the top of a grass slope. With little to use for foreground interest, the image contained too much green grass, unless the camera was pointed upwards, which gave converging verticals. I sought permission to photograph the castle from the far side of the adjacent lake. There were only a few brief bright spells, so I had to shoot quickly when they occurred. I'm not entirely happy with this image, largely because it contains too much sky, which is too pale. I like the reflection of the castle in the water, but it would have been better if conditions were calmer. I certainly intend to go back and have another attempt.'
Minolta 505si with 28-80mm lens, Fuji Provia 100, 1/2sec at f/22

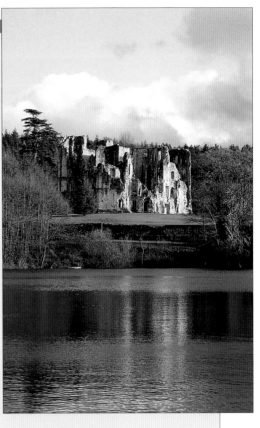

CHARLIE'S VERDICT

Good on Stuart for going back to Old Wardour Castle a second time, he deserves a real pat on the back for persistence. His approach has been extremely professional, in that he made a real effort to find the best viewpoint possible – and a very classic, impressive viewpoint at that – showing the castle in its context. And even better that he intends to return yet again, because that's what landscape photography is all about. He's right about the sky, but it could be worse, and there are many other things to commend the image. One of the main points in its favour – and something I admit to being quite obsessive about – is that Stuart has composed so that the top of the castle sits underneath the line of trees, rather than encroaching into the skyline. The Scots pine on the left rather spoils this, but nothing can be done about that. But from the Quink ink blue of the water, to the highlight and shadow areas on the castle, and the overall perspective, I don't find much wrong with this picture at all.

shot, it was time to explore the interior. I don't think I'm wrong in saying that for one or two of us, this is where Old Wardour Castle really came alive. There was so much potential in the details, the archways, the lichen-covered stone spiral staircases and more, that it was difficult to know where to start. Best of all, the light was soft and diffuse, which really brought out the best in the stonework. Without allowing ourselves to get carried away, however, we needed to realise that the stone was a little brighter than a mid-tone, so expose accordingly.

Below As we all squelched our way through ground made boggy by weeks and weeks of rain, we wondered whether the puddle which had formed as a result could be used as a foreground. At the right angle, and with a wideangle lens, a shot reflecting the castle in the puddle might be possible

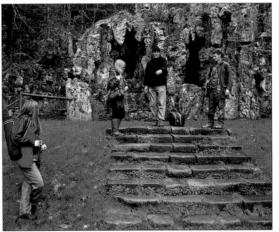

Left The fascinating grotto, created from pieces of the ruined castle in 1792, is worthy of a photograph in its own right. It also provides a useful elevated viewpoint

Best of all, because the light was coming from the top, through what would once have been a roof, it delineated and gave depth to certain vital areas which would otherwise have been lost to the gloom. This was particularly the case with the spiral staircases, where each step was illuminated by a single strip of light as they swept upwards.

Tripods working hard – low light and the necessary small apertures made these as vital as ever – our readers worked their way around the various nooks and crannies on each floor, but all too soon it was time to take our leave. I know I, for one, will be back to visit this delightful castle, with all its potential for a great photograph.

Right Perfect morning backlighting greeted OP's readers as they strolled into Lacock, ready for a day's shooting. It wasn't to last!

Below Charlie stands on top of the perimeter wall to gain an elevated view of Lacock Abbey, the former home of photography pioneer William Henry Fox Talbot

Coming home

On a day trip to Lacock, the spiritual home of photography, the *On Location* team found inspiration in the beautifully preserved village architecture

FUNNY, ISN'T IT, how the birthplace of photography, Lacock Abbey, is well-known to photographers, but so few of us have actually been there. With such important heritage on our doorstep, it made perfect sense to come to the charming National Trust village of Lacock, in the heart of Wiltshire.

I have to confess that this was my first time to Lacock. For some unknown reason the abbey where William Henry Fox Talbot made the first negative/positive still images has never been a subject for my lens. Furthermore, none of our chosen readers had been there either, even though they all lived within a 10 mile radius. Then we began asking each other, 'Have you seen any pictures of Lacock, apart from Fox Talbot's historical detail of the lattice window taken over 160 years ago?'

Everyone shrugged their shoulders and shook their heads before Sandra Newman of Melksham reminded us that all those Jane Austen adaptions so lavishly

Left The editor was concerned about Sandra's safety as we set up in the middle of Lacock's main street, but overcoming physical obstacles in order to obtain the ideal perspective is all part of the fun of location photography. Sandra and Charlie survived unscathed

produced for the screen in recent years have been shot at Lacock. A walk through the main street revealed why. Like their neighbouring Cotswold villages, Lacock's streets are fronted by rows of biscuit-coloured sandstone buildings, and the occasional, vertically-challenged whitewashed and timber-framed cottage, so beloved of postcard purchasers.

It is a scene from pre-industrial revolution England, carefully manicured for 21st century tourism and costume drama television. From a photographer's perspective, one of the real pleasures is the absence of overhead power lines and modern street lamps. The offending cables have been laid underground, saving hours of time later retouching with Photoshop!

Early in the day, the sun hung low against a clear blue sky, but soon clouds rolled in from the west. Fortunately, they were moving at a steady rate, so sunny breaks prevailed for a few moments – precious moments given that this had been the wettest autumn since records began in 1766.

Our first subject was a two-storey timber-framed cottage in the main street known as the Chancellor's House. Long lenses were deployed here to crop out the white road markings and prevent the converging verticals inherent with using shorter focal lengths. Then again, such is the age of this building that converging verticals come built-in! While Chris Terry and Bob Deary set up their tripods off the road, I encouraged Sandra Newman to ignore the perils of this very quiet main street and set up in the middle of the bitumen. I think three cars crawled past us, but it was not the traffic

that defeated us, just the lack of light and an interesting sky. I don't think people run photographers over, generally. I have actually set up in a road in Italy that was really quite busy but then the police came and started wagging their fingers. You don't get that in England!

Planning

Location Lacock is in Wiltshire, three miles south of Chippenham, and four miles north of Melksham on the River Avon.

How to get there The village is on the A350, which bypasses Chippenham to join the M4 at Junction 17. By train the nearest station is Chippenham, the last stop before Bath on the Great Western Railway from London Paddington.

What to shoot Lacock Abbey is the main attraction, it dates back to 1232 and the extensive grounds include an 18th century summer house and 19th century rose garden. Although the abbey is closed between November and March, the village has plenty of unspoilt Bath stone and timber-framed cottages to photograph. Upstream of the Avon are the gardens of Lackham College, while the Georgian gem of Bath is only 20 miles away

What to take Tripod, polarising filter, neutral density filters and a well saturated reversal film like Velvia or

E100VS. A telephoto zoom lens may be preferable to a wideangle in order to crop out unwanted peripheral distractions and to help correct converging verticals.

Nearest Pub The team imbibed at The George, which had a comprehensive menu and Wadworths 6X on tap, brewed at nearby Devizes.

Ordnance Survey Map Landranger 173

Essential reading *The Photographic Art of William Henry Fox Talbot*, by Larry J Schaaf, $60 (available through Amazon.com).

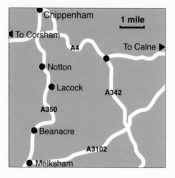

BUILDINGS

CHRIS TERRY

Occupation *Pilot*
Photographic experience
Always carried a camera in his pocket but more serious interest developed when he received an SLR for Christmas, 1994

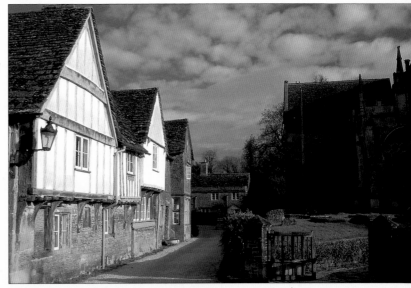

'It was an enjoyable occasion at Lacock, especially for the tips and opportunity to meet Charlie. I like Charlie's masking frame – I'm sure plastic or metal would be far better than my card one which crumpled readily.
Lacock is a delightful village, but like most outdoor subjects it needs the sun to make it sparkle, hence why I went there the previous Sunday afternoon – just in case! The brief spell of sunshine during our afternoon stroll lit these cottages nicely and the dappled sky was enhanced by a polarising filter. I liked the lane disappearing into the middle distance with the open church gate inviting you through. Maybe the church is too dark, but its silhouette adds an interesting skyline and balances the picture quite nicely, focusing attention on the cottages.'
Minolta 5000 with 35-70mm zoom, Sensia 100, 1/60sec at f/11, polarising filter and tripod

CHARLIE'S VERDICT

What a lovely sky. Puffy white clouds verging on a mackerel sky always give an image character. The deep shadow on the right helps to give the houses left a greater sense of drama. Chrome films are unforgiving, though, only just able to hold detail at both extremes. Perhaps an ND soft edged grad filter subtly introduced at a 45 degree angle over the houses would have allowed a third of a stop exposure increase for the abbey. The lamp is an important element, too. A strong image, though, and no serious evidence of the dreaded converging verticals (fine if intentional) and the road almost exiting at the bottom left corner of the frame should make this another contender for a high class postcard of Lacock.

BOB DEARY

Occupation *Packaging technologist*
Photographic experience
Occasional due to commitments with family and work

'Despite the dull weather, it was a most enjoyable day which has only served to stimulate and renew my interest in photography. Charlie has the ability to put people at their ease no what their level of photographic ability. Finances permitting, I hope one day to join him on one of his Light & Land excursions!
I was thrilled to receive the call inviting me to attend the photo shoot. On the day the light proved very elusive, and this, combined with the large number of parked cars, made it difficult to capture a landscape scene within Lacock. I therefore chose to capture and submit a more detailed image, after discussion with Charlie over exact cropping of the shot. A range of focal lengths and bracketed exposures were tried.'
Pentax MZ50 with Sigma 28-80mm zoom, Velvia, 'slow' at f/22,

CHARLIE'S VERDICT

I have always had a fondness for quaint cameos such as this. The crop has been successful, although the image seems askew as a result of the lens not being parallel to the wall, although I know there were difficulties with the gutter running along the top. It would have been nice to have seen the far side of the pot right, likewise the base of the statue's plinth. These may seem small and insignificant things but collectively they contribute to a tight, cohesive image. An entertaining image, though, and one I could enjoy looking at. Try making a nice large print of it, Bob, with judicious cropping.

SANDRA NEWMAN

Occupation *Packaging assistant*
Photographic experience *Studying City & Guilds photography course*

'Although it was a fine day when we arrived at Lacock, when it came to photographing the abbey, the sun stayed behind a cloud. So, as we had been encouraged by Charlie to return and take some pictures, I made another visit two days later to take advantage of some early morning sun. The low sun was lighting the abbey, as well as slanting across the stone wall, revealing its texture. I chose a low viewpoint to use the wall and some trees to frame the abbey and to exclude most of the grass that would have filled the bottom area of the picture with a higher camera position.

I switched from autofocus to manual focus and focused a third of the way into the picture to maximise depth of field, however I didn't succeed in making the wall sharp, possibly as it was too close to the camera.'
Canon EOS 100 with zoom set to approximately 80mm, Sensia 100, tripod

CHARLIE'S VERDICT

Well done to Sandra for having the enthusiasm to return, and for succeeding in making a well thought out image. She has made the most of the good light and shadows, which gives the sense of dimension that is often so crucial for the photograph to convey depth. There are lots of good points here. For a start, the top of the wall does not encroach into the base of the abbey (nearly... but not). There are good shadows on the stones, which convey the chunky nature of their construction. Another positive aspect are the tree's leaves running along the top - it's an old fashioned style but one that helps to give an essentially large and elongated building a degree of intimacy and secrecy. I like the tree trunk to the left, as it echoes well with the perpendicular tower in the centre: it might seem like a small thing, but it's something that the eye (in conjunction with the brain, of course) will find satisfying. There are nice tones in the sky, and the trees behind provide an effectively dense backdrop for the abbey. These factors all contribute towards making this a very good image indeed, and if the National Trust were to have this image on sale in their shop, I'm sure it would sell very well.

The abbey grounds were closed, but a clear view of the south facing wing of Lacock's most famous building was obtainable by training cameras over the perimeter wall. It is a composition with promise, especially for the panoramic format, when early morning or late afternoon light during the winter months would slant across the this aspect of the abbey. A polarising filter would also come into play then. We were sizing up the possibilities at the middle of the day with the sun behind us, an angle too direct, you might say, for a polariser to have any affect. But this is where I beg to differ. Funnily enough, polarisers do have an effect on something regardless of where the sun is. As far as the sky was concerned at Lacock, it wouldn't do anything. But suppose you had an oak tree in your foreground and that was lit, then the polariser would have an effect on some of the leaves, depending on their angle.

Back in the village, we wandered up a quiet street which led to an impressive church flanked on one side by a row of timber framed cottages. At this point we were blessed (it must have had something to do with sanctimonious surroundings), because the sun's warming rays turned the whitewash of the buildings cream, complementing the intense blue of the sky which was now decorated with streaks of high white cloud. It wasn't a mackerel sky, but it was close. The light only lasted 20 minutes but it was long enough for our readers to have captured something from what Fox Talbot had so aptly described as 'the pencil of nature'.

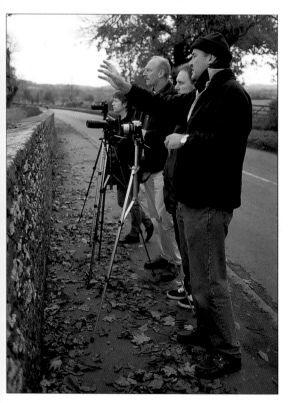

Left As it was a weekday, the abbey was closed, so OP's readers listened attentively to Charlie's advice about composing the scene from a considerable distance

Aspiring heights

The magnificent Salisbury Cathedral looks even more impressive picked out by bright winter sunlight, and proves to be a striking subject for photographing

Right Seen from across the rooftops, St Mary's spire glows in the soft winter light – majestic and grand *1/4sec at f/22, Velvia, polariser*

IF OXFORD is the city of dreaming spires, then Salisbury Cathedral is the spire of dreams. The magnificent spire rises above the town with such certainty and purpose that you can't fail to be drawn closer to its precinct. There can be few other buildings – of any age – that serve as a greater focal point to the life of a town, let alone the lens of an appreciative photographer. Of course, other great English cathedrals spring to mind – York Minster, Canterbury and Durham – but the scale and setting of Salisbury, rising above a tranquil setting of the expansive water meadows, is unique.

In York and Canterbury, walls and buildings have crept ever closer and higher over the centuries to their grand and imposing cathedrals, presenting photographers with limited and challenging options for composition. Salisbury is different. Here there is space, acres of it,

JOHN MILLS

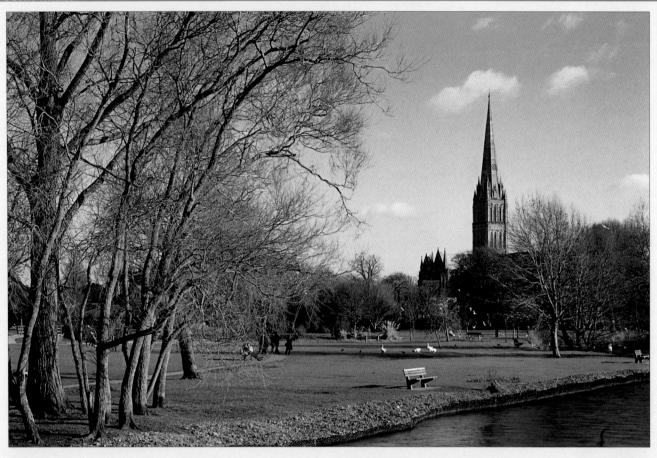

Occupation *Civil servant*
Photographic experience *Started around 30 years ago but only taken it more seriously in the last five or six years*

'Having photographed Salisbury Cathedral on numerous occasions without success, my heart sank slightly when I learned that it was to be our subject for the day. However, bathed in warm spring sunshine and listening to Charlie's gentle words of wisdom (and using his famous masking frames), I thought that if I couldn't get it right this time I might as well give up photography! In the event, I learned an enormous amount about selection of viewpoint and the importance of light, so much so that in the end I had some difficulty in choosing which of my efforts to send in! I like this picture because of the beautiful side lighting and the fact that the trees on the left seem to be pointing towards the cathedral, which in turn dominates an area of lightly detailed sky.'
Asahi Pentax Spotmatic F with 55mm SMC Takumar lens, Kodak Elite Chrome, 1/125sec at f/11, Slik 88 tripod

CHARLIE'S VERDICT

I can't believe that John claims never to have taken a successful picture of Salisbury Cathedral. He has now! This is a bitingly sharp image right across the frame. He has shown how the cathedral dominates even when it is a small area of the picture. The line of trees, footpath and riverbank create a series of diagonals that fan out from the bottom of the picture to the cathedral in the distance. Normally, I would warn against including so many people in a composition but here, with the addition of geese on the lawn and gulls in flight, this activity becomes a valid part of the scene. After all, this is a manmade setting, typified by the unoccupied park bench in the foreground. Does it distract or complement the scene? I think the latter, but the protruding branch in the river (or is it dust in the film gate?) near the bottom right hand corner of the frame needs to be remedied by PhotoShop or careful masking.

room to breathe and walk freely without the rush of shoppers and carrier bags. Although I have photographed St Mary's Cathedral (for that is its proper name), across an expanse of rooftops, our objective was to convey the cathedral in a setting that John Constable first popularised in his painting nearly 200 years ago.

So we walked from the railway station to the Harnham water meadows on a day of glorious early spring sunshine and a clear blue sky. This was mid-February and such weather was completely out of character for the time of year – the editor kept pinching himself in disbelief, being far more used to howling gales, freezing fog and torrential rain, such has been our luck on these shoots!

We first stopped at a little bridge that provided us with the vantage point for the picture that John Mills chose as his pick of the day. The river provided a natural lead-in line to the cathedral precinct in the distance, but the sun hadn't swung round enough to light the

BUILDINGS

side of the cathedral facing us. Sensibly, John returned in the afternoon and was rewarded with some cloud detail in the sky.

That morning, we were eager to take advantage of the weather while we could and within a few minutes four tripods were assembled in a line along the bridge. Cable releases were attached, meter readings taken, polarisers added and the comforting sound of shutters firing soon absorbed us. However, a major obstacle was overlooked. As people passed behind us while crossing the bridge, I noticed a very slight vibration on one of the cameras. This wasn't nearly as obvious as London's infamous Millennium 'wobbly bridge' across the Thames, but the risk of camera shake presented by the vibrating bridge was – photographically speaking – potentially calamitous. In landscape

Planning

Location The town of Salisbury lies on the southern edge of Salisbury Plain at the junction of the rivers Avon, Bourne, Wylye and Nadder.

How to get there Direct links by train from London Waterloo and Southampton. By car from London via the M3 and A303; from Southampton via the A36; from Swindon south along the A346 then the A338; from Bournemouth north via the A338.

What to shoot The cathedral can be captured in a variety of ways, from the water meadows to closer detailed studies of the architecture. Nature photographers will enjoy the many species of wetland birds inhabiting the Harnham water meadows, which is also home to the furtive otter.

What to take Tripod; boots or Wellingtons; polarising, warm-up or ND grad filters; telephoto zoom lens, cable or remote release.

Other times of year Winter and early spring are ideal for low light and bare

trees offering a better glimpse of the cathedral from a distance. Autumn for tree colours.

Nearest pub The Old Mill Hotel and Freehouse, a short walk up from the Harnham Water Meadows.

Ordnance Survey map Landranger 184.

Further information The Salisbury Cathedral website: www.salisburycathedral.org.uk is an absolute mine of information, with a detailed map and photographs of the buildings in the cathedral close.

TED STRAWSON

Occupation *Retired personnel director*
Photographic experience *On and off for 35 years, but as a second hobby to his main one of motorcycling. Many years of camera club membership, but not at present*

'In spite of being extremely fortunate with the weather – it was the only dry sunny day for weeks – I was very disappointed with my results. Most of my shots ended up in the bin due to wildly incorrect exposure, in spite of generous bracketing! I can only assume that I was not paying enough attention to what I was doing, plus the fact that I was using an old Weston lightmeter, which I hadn't used for years. This shot is the best of the bunch and I rather like it. The detail on the cathedral and the way that the river breaks up the green of the foreground is very satisfying. The trees on both sides intrude too much, but they were there and gardening to that extent would have been unpopular! There are many other viewpoints of the cathedral to choose from but it would take a long time to do justice to them all. I certainly intend to return to that spot again.'
Nikon F3 HP with 36-72mm Nikkor zoom at the long end, Sensia 100, polarising filter, f/16, tripod

CHARLIE'S VERDICT

Ted's choice of viewpoint gives a pleasant blend of sunlit cathedral and clear blue sky with a foreground and middle distance of water and meadow. It is the romantic image we all have of Salisbury, the February sunshine depicting a scene of English splendour. He's even managed to create a slight leading diagonal out of the riverbank from the bottom left corner. Although it leads us to the base of a bare and bisected tree on the edge of the frame, it is the bright light on the spire of the cathedral that draws the eye. Ted has been observant enough to keep the pale cross at the top of the spire within the frame, but I think the picture would be marginally improved if it wasn't quite so tightly cropped at the top.

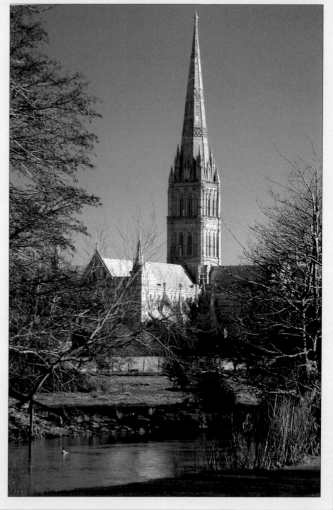

ALAN TOOGOOD

Occupation *Computer systems manager*
Photographic experience *Many years of snapping but only began taking it seriously six months ago when he joined a City & Guilds course*

'I had a very enjoyable shoot. Charlie encouraged us to think deeply about the image we are creating in a rectangular frame rather than the real life subject in its context. The weather was on our side, of course, and that helped with the results. During the day the light fell on the cathedral at different angles, and as we moved around the water meadows different aspects came into view, including some unsightly scaffolding, hidden in my shot by a tree. I tried to get the framing offered by the leafless branches and used a polarising filter to deepen the blue of the sky and give more emphasis to the light cloud that just happened to float by.'
Canon EOS 50E with 28-105mm zoom, Fuji Superia 200, polarising filter, 1/90sec at f/16 tripod

CHARLIE'S VERDICT

Shooting square on to one face of the cathedral, Alan has conveyed the scale and magnificent proportions of the building. Including foreground branches of trees to frame a distant scene is always a risk and raises another set of questions. How much? Focus, or defocus? How close? In this instance it has nearly worked, because the cedar and other trees adjacent to the cathedral make a very visible link to these periphery branches. Alan has made effective use of the polariser to give greater prominence to the soft white cloud, and this would have been made more striking if he had included fewer branches at the top of the frame. Parked cars and the ubiquitous white van man make an appearance – while the picture would be improved without them, they are well obscured by trees – thankfully!

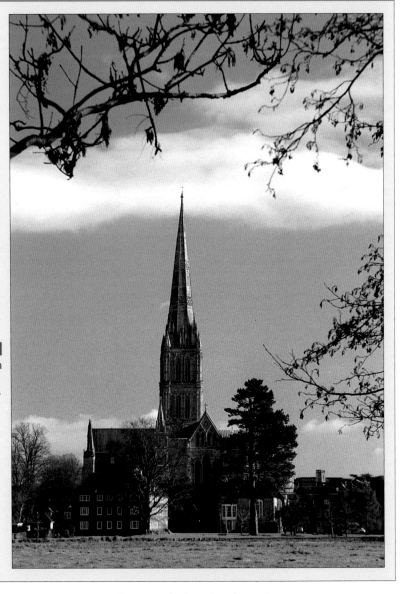

photography, optimum image sharpness, depth and clarity can only be achieved with a perfectly still tripod. Consequently, we became more circumspect while on the bridge, releasing the shutters only when no-one else was around, and being careful to remain quite still ourselves.

Salisbury Cathedral's spire is the tallest in England. Indeed, it is the tallest medieval structure in the world, reaching a height of 404ft (123m). Given such a pronounced vertical shape, it is not surprising that so many pictures are composed within an upright format. And yet, the beauty of the vantage points we chose along the water meadows, shooting from a distance through surrounding trees and encroaching branches, is

that we managed to retain the option of the landscape format. Interestingly, John and Ted both preferred this option, while Alan went for a short telephoto portrait study taken from the perimeter of a privately owned field.

Whether shooting a structure like this in portrait or landscape format, it is important to keep enough room between the edge of the frame and the top of the spire. Spires and pointed roofs, like tall and slender trees, are incredibly acute and pronounced shapes. They create strong diagonals that determine much of a picture's depth and dynamic.

In the case of Salisbury, a tall spire also means lots of sky in the frame, posing problems for exposure and suggesting the use of graduated

filters. And when that sky is plain blue, then placing peripheral trees in the frame is about the only recourse left to the photographer if no cloud looks like coming. Fortunately clouds did form later in the day when we were there – the sort that are soft and not substantial enough to block out the sun.

This is when polarising filters come into their own and both Ted and Alan made good use of them to add contrast to cloud and sky.

The sun stayed with us all day and if it really does shine on the righteous, as the saying goes, then we have the souls of the 300 workers who constructed Salisbury Cathedral over 38 years in the 13th century to thank. It was truly a job well done.

Right A romanticised view of Gold Hill, shot in the 645 format with a 150mm lens on Velvia, and with an 81C warm-up filter

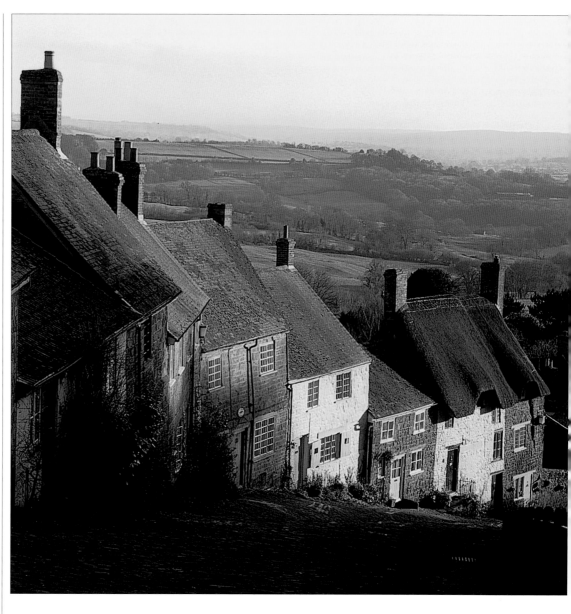

Gold rush

The steep ancient street of Gold Hill was the setting for a famous 1970s TV commercial, but how does it look through the viewfinder of a still camera?

KING ALFRED rebuilt and founded the town of Shaftesbury in AD880. This delightful town sits some 700 feet above sea level on a greensand spur affording the community and visitors the most wonderful view over the vales.

During these early years, water had to be hauled from the pastures below and for this the bearer would receive 'two pence a horse load and a farthing for a pail...if fetched upon the head'. In the great Abbey of Shaftesbury, King Edward the Martyr, murdered at Corfe, was brought to rest in AD980 and from that moment Shaftesbury became a place of pilgrimage.

Pilgrims no longer come to see the old abbey remains; it is a loaf of bread that helps draw thousands of people a year to this ancient town. Balanced on a plinth like a contemporary sculpture is

GOLD HILL

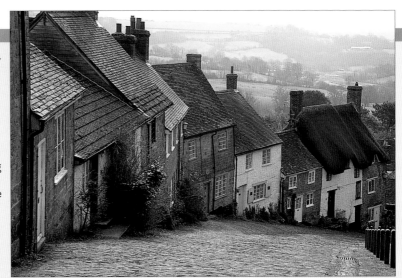

COLIN HUNTER

Occupation *Technical author*
Photographic experience
40 years on and off, more consistently in the past 10 years

'Charlie doesn't teach – he lets you learn from his wealth of experience. Among other things, he explained in his easy conversational style how to view a scene and, in particular, how to interpret and use light. Despite continual sunshine, the light changed subtly throughout the morning. My early attempts were disappointing; the bright sky was either washed out or fooling the camera's meter into underexposing the cottages. I suspected this might be a problem, so I moved in tight to exclude most of the sky. This was my best shot of the day. I like the way the long end of the zoom has compressed the cottages, the hazy background sets off roofs, and the handrail posts keep you from falling out of the picture on the right. Some smoke rising out of the mist in the distance would improve it – perhaps someone could burn down that tin-roofed barn!'

Canon EOS 50E with 24-85mm USM lens, Provia 100, 1/125sec at f/11

CHARLIE'S VERDICT

It is hard to fail with Gold Hill and the proportions of this image are perfect. The railings running down the far bottom right of the image may not at first sight seem important but they are, the top of each reflecting a dot of light enlivening that corner. Although Gold Hill was fairly top lit on that day, leaving the faces of the houses fairly flat and lifeless, it is amazing how a small amount of specular reflection can assist in lifting an image. The little highlights on the window ledges as the eye travels down the left of the image help enormously to convey atmosphere and bring a sparkle to the scene.

Where to crop? The endless question. I always feel that a photograph should end at the edges in not too abrupt a manner.

Here a chimney has to be cropped and if it was not this one then it would have had to be another.

Perhaps a very gentle grad could have helped hold the sky a little. It may have encroached into the roofs and chimneys of the house top left but the under exposure that would have arisen as a result would have been minimal here.

a giant loaf of brown wholemeal bread. It was a well known national bakery, Hovis, that put Gold Hill on the map for a 1973 television commercial. They put something back though. In 1982 they presented £10,000 to the town to be put toward the restoration of the cobbles. The film director John Schlesinger also used Gold Hill for his beautiful film of Thomas Hardy's *Far from the Madding Crowd*.

For Shaftesbury folk however, Gold Hill has been a part of the community for many hundreds of years. There are those that still traipse up and down the cobbled street to the summit in preference to taking the car along upper roads. Some used to say that if one house collapsed, the remainder would all go down like dominoes. Thankfully, they appear to be as steadfast today as they were when they were built.

Planning

Location Gold Hill is a steep residential street that rises to the centre of the ancient market town of Shaftesbury, 700 feet above sea level in northern Dorset
How to get there Shaftesbury is 20 miles southwest of Salisbury on the A30, and 13 miles north of Blandford Forum on the A350. The nearest railway station is Gillingham, about five miles northwest of Shaftesbury on the B3081
What to shoot The view straight down the cobbled street of Gold Hill. The scene is defined by the descending line of cottages on the left and the unobstructed horizon straight ahead. Once Gold Hill has exhausted you (picture-wise that is), Shaftesbury offers other picturesque possibilities, most notably the ruins of the old abbey
What to take The usual combination of a slow, fine grained film with a sturdy tripod and cable/remote release for shake-free long exposures. Depth of field is important here, so with working apertures of f/11 or smaller, exposure times will be long. Warm-up filters will enhance the earthy colours of the stone cottages and cobbles, while neutral density graduates are also recommended, especially if the sky is a few stops brighter than the rest of the scene. Don't forget a stout pair of walking boots – if you're going to walk up or down Gold Hill, your ankles will need supporting!
Nearest pub No shortage of pubs in Shaftesbury – for good food and family accommodation, try The Royal Chase Hotel, tel: 01747 863355, or visit www.theroyalchasehotel.co.uk
Ordnance Survey map Explorer 118N
Further information The annual Gold Hill fair takes place on July 7&8, visit www.goldhill-fair.org.uk; the old abbey is open April to October, 10am-6pm, admission £1.40 – King Canute is said to have been buried here in 1035, visit www.virgin.net/travel/guides;

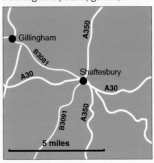

PHOTOGRAPHERS ON LOCATION WITH CHARLIE WAITE **81**

BUILDINGS

Right Jerry listens as Charlie gives advice on what part of the scene he should compose for his view of Gold Hill

Far right Colin peers through the lens as a couple heroically reach the top of Gold Hill's steep incline – hope they haven't left anything at the bottom, like their sandwiches...

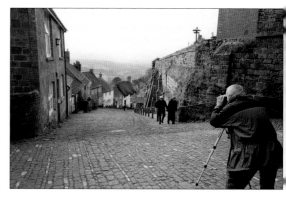

For the past 16 years, I have been very familiar with this little street and as I look down Gold Hill I am transported to a time and an atmosphere that I am sure many folk from the USA might think of as still existing today through most of England.

Right Jerry checks the view through his lens – note the giant Hovis loaf on his left, a reminder of the 1973 TV ad that introduced this location to millions of Brits

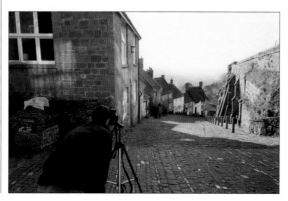

In some people's minds, this is quintessential England. The narrow cobbled street with almost toy tiled and thatched cottages clinging to the sides. Television advertising continues to use Gold Hill to seduce us by this portrait of a romantic England that in reality barely exists.

On a crisp February morning we arrived to see Gold Hill bathed in glorious, golden morning light. The fronts of the cottages received no direct light as they face west but despite the light absorbing nature of the giant old buttressed abbey walls, there was sufficient light being reflected to fill in what might have been quite dense shadows. The cobbled street too picked up light and reflected a little back to the house fronts providing a pleasant glow to what is still arguably one of the loveliest streets in all of England.

A cliché it may be, but I defy anyone not to make a photograph of this enchanting street. From the

ROSEMARY COX

Occupation *Retired*
Photographic experience *Eight years*

'I discovered my passion for taking pictures as a stress buster about eight years ago. I was then managing a hectic occupational health department. I went on a monochrome course in Somerset for a week and I was hooked! Since then I have retired from paid work, but work even harder for my family (mother, husband and six grandchildren), and other interests, including photography. I had a new camera, Canon EOS 300 with zoom, for my last birthday and hope to add a flashgun this year. I usually take black & white, anything from candids to landscape, but have recently begun to try colour. My picture was taken after Charlie had pointed out there was too much contrast between the shadows and light areas on Gold Hill on a bright spring morning, and that the polariser I was using was likely to deaden the sparkle in the reflections on the windows and leaves. There was a corrugated iron roof on the distant hill, which was glittering in the sun and it also had to be considered in the composition. I tried to exclude the sky as contrast was so great and I now wonder if I should also have excluded the railings on the right hand side'.
Canon EOS 300 with 28-105mm zoom, Sensia 100, 1/30sec at f/19, tripod

CHARLIE'S VERDICT

Rosemary's image of Gold Hill suggests a more Dickensian feel, a more rickety and higgledy piggledy look to it. Being a much tighter photograph gives one the feeling of being involved with the people who live in those delightful houses. Her photograph makes me feel that I could almost live there myself. The omitting of the sky helps to convey this and being a less expansive view lends a more intimate feel. I am not sure about the rocky base of the old abbey wall on the right as there is not enough of it to make its identity known. I suspect the intention behind its inclusion was to provide a stop to the right of the image. The railings, as with Colin's photograph, are useful to add to the feeling of descent. They also help to conceal the red car parked just beyond! There appears to be a blurred pink ghosting to the left which worries me. Was it the photographer's hand masking the lens from the sun coming from the top left?

JERRY WILDING

Occupation *Aerospace designer*
Photographic experience *three years seriously, and I would love to make a living out of photography*

'It was great getting the call inviting me on the shoot at Gold Hill. We were very lucky with the weather, a wonderful sunny day amongst some very wet ones. It was great to meet Charlie, and he soon had us looking at the very well known view of Gold Hill in many different ways. I will now look at other scenes with similar eyes. Although the sun was out there was a lot of haze that washed out the sky. I wanted to try and recreate the old-fashioned 'Hovis Advert look', hence I used quite a lot of sunset filtering. The chimney on the left would have looked better if it had been more against the hills and not the sky. The red door adds just a touch of colour and leads you into the picture'.
Canon EOS 50E with 75-300mm zoom, Superia 200 and tripod

CHARLIE'S VERDICT

This photograph has a totally different mood to it. The warm graduated filter that has been introduced has clipped the tops of the houses but left the bases unscathed. The great danger of using a coloured graduate is precisely illustrated here. The key to good graduated filtration is for its introduction not to be conspicuous. The sky and the roofs have taken on a pleasant warmth which suggests a nice balmy summer evening but then the cool colouring of the houses beneath annul that mood and confuse the viewer. In short it looks too artificial. I think it may have been better to have introduced an overall warm filter which might have been more effective. I like the strong chimney and the fact that it juts into the skyline is not too much of a problem here. In Jerry's image he has photographed only four of the eight or so houses, removing in my view the feel of antiquity and the lumpy cobbled road which is part of the charm of Gold Hill.

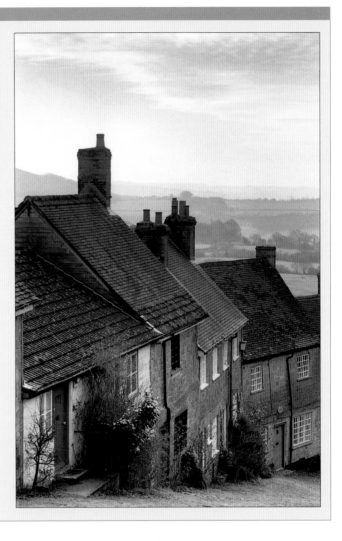

top of Gold Hill, the chimneys sit comfortably below the skyline giving the whole scene a contained feel. Beyond lies some of the loveliest country to be seen in Dorset.

For us though there was one irritant. I often think that photography is so much about compromises. If the photographer is forced to tolerate too many then the image should not

Below Time for a bit of spot cleaning as Colin takes the airbrush to the lens of his Canon

be made. The aberration from an otherwise near perfect scene in this case was a barn in the far distance on the right. It lent nothing to our photograph and with its gleaming corrugated iron roof, it would have the effect of plunging the viewer into the 21st century and away from the dreamy, timeless romantic feel that we wanted to convey in our photographs.

Here perhaps is a perfect opportunity for some judicious digital imaging. Surely, this is where the ubiquitous Photoshop comes into its own as an electronic darkroom tool. In a flash, the clone tool could have demolished the barn and all would be well. No doubt, there are those who would (perversely in my view) claim that the barn was reality and that it should remain but I would challenge this view by placing the two images side by side, one with barn, one without. May I dare assume that the majority would prefer the 'barn less' image?

Gold Hill will, I hope, remain as a living street with the residents going about their daily business as they have always done. We should thank them for tolerating us photographers who take such delight in just standing there and inevitably raising our cameras to our eyes.

All around the houses

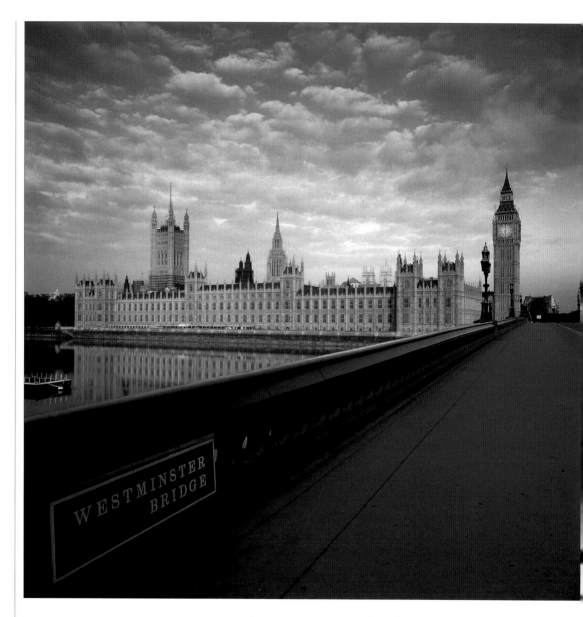

WESTMINSTER BRIDGE

When a building is as well known as the Houses of Parliament, sometimes it's too easy to just snap. Three amateur photographers take time to look again...

IN THE LANDSCAPE photographer's constant search for new things to photograph, often the monuments and locations which are known throughout the world are overlooked – particularly if they are on our own doorstep. However, this does not make them less worthy of study through our cameras' viewfinders. Quite the opposite, in fact, as trying to find a different way of looking at famous landmarks presents even

Above On a June morning at exactly 6am there was a gap in the clouds and that longed for brightness appeared and lit up the Houses of Parliament. There are always things that one would wish had been sorted out at the time but when under pressure they slip past without being noticed. The gaps in the bridge near the sign irritate and distract. The floating pontoon to the left I remember cursing! I also recall regretting the expanse of nothingness occupying a third of the photograph. Might an Elliott Erwitt-type dog have come in handy here?

Above Ever seen the Houses of Parliament photographed from here? Neither had this lot – until now

more of a challenge than normal. It was for this reason that we chose to visit the south side of the River Thames in London, to see if we could find a new way of seeing the Houses of Parliament – possibly one of the most photographed buildings in the world.

We decided to meet at 7am, as at this sort of time the morning sunshine – theoretically – would be bathing this fascinatingly ornate building in golden hues. I say theoretically because our three hardy readers – who refused to be put off by the early start – were greeted with merely a plain wash of grey for their efforts. In such a situation it is only possible to

do what any self-respecting photographer would: use the time at our disposal as a recce, working out from which angles we would like to shoot, then hotfooting it to the nearest café for a warming cup of coffee!

Time spent carrying out a recce is never wasted, especially with a location such as the Houses of Parliament, because there are infinite viewpoints

Below left Turning their backs on the modern construction of the London Eye, our On Location participants try to find a new perspective on an old building

Planning

How to get there Don't bother driving! The nearest tube stations are Westminster, Embankment and Waterloo. From Westminster and Embankment you must walk over the bridge to reach the south side of the river.

Time of day Early morning is the 'classic' time to take a photograph of the Houses of Parliament. When your luck is in, the building is bathed in golden sunlight, setting it aglow. You might also like to consider late afternoon as the sun goes down, silhouetting the ornate roof against the skyline. For this, however, you would need a pretty dramatic sky, and make sure you watch out for unnecessary intrusions into the skyline. Late

afternoon/early evening also gives you the option of trying to balance the fading natural light with the artificial streetlights on the south bank of the Thames – always a great choice for creating a real cocktail of colours.

What to take A wide – or even ultra-wide – angle lens would give you a really dramatic perspective on the building. A telephoto would compress the perspective and might make any boats on the river appear more cohesive within the frame. Look out for reflections and make the most of them in your composition. A polariser, used carefully, will enhance the sky, but make sure it doesn't cut out those important reflections. An ND grad is also useful, as is a tripod – of course!

Ordnance Survey map Landranger 176 and 177

BUILDINGS

CLAIRE VIVIAN

Occupation *Sales co-ordinator for an airline*
Photographic experience *Many years of holiday snaps, but only one year of taking it more seriously*

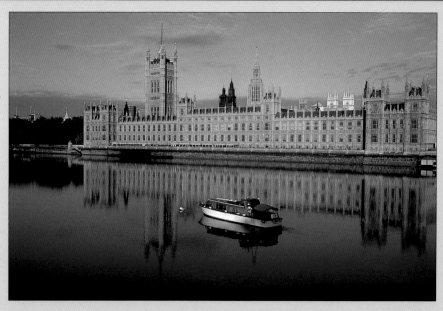

Claire says 'When we met up with Charlie he had told us, "The Houses of Parliament can be golden at sunrise", which took some imagination that morning! The day I returned to take my picture, however, proved him right. I was attracted by the reflection on the river and the early morning light on the Houses of Parliament. I cropped the picture this way to avoid several visual obstructions such as cranes, but this meant excluding Big Ben. If it were possible to set up the scene, I would place the boat closer to the bottom of the frame to detach it from the reflection of the building. I feel the soft light and the calm of the river give a very peaceful atmosphere to the picture, and the boat in the foreground adds a touch of originality.'
Canon EOS 5 with Sigma 28-200mm lens, Velvia, tripod

CHARLIE'S VERDICT

Another excellent photograph and of course I agree with Claire that to separate the boat from the reflection would have been good, but what light! The sky in Claire's photograph is good, with just a few flecks to break up what would have been a monotonous blue. I remember looking at the boat when we gathered on that first grim morning. I mentioned that it might be a bad thing to have included it but here it looks absolutely intentional...unlike my ugly pontoon! Congratulations to Claire for her determination, and in my opinion the loss of Big Ben is no big deal!

ALAN SIMPSON

Occupation *Works for Department for Culture, Media and Sport*
Photographic experience *20 years, in particular landscapes, and is a member of Woodford Photographic Society*

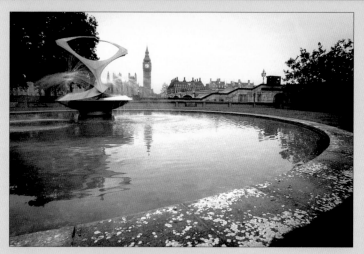

'As the weather on the day of the shoot was so poor, I returned and took this photograph later that week. The time with Charlie was well spent, however, as I came away with an idea of where I might shoot from and which lens to use once the weather improved. As my job is based only 10 minutes from the location, I took my camera into the office each day and, a few days later, the weather was fine enough for me to take this one morning before work. I was trying to get a different view of the Houses of Parliament, and this fountain and pond next to St Thomas's Hospital provide some foreground interest. Normally I shoot on colour slide film so the black and white used here is something of a rarity for me. I toned the print blue to emphasise the watery nature of the scene, and to give it an early morning feel.'
Canon EOS 1N with 20mm lens, Ilford Delta 400, 1/60sec at f/16, print made on Epson Premium Glossy paper using an Epson Stylus Photo 870 printer

CHARLIE'S VERDICT

Alan's photograph is really imaginative. A view point of the Houses of Parliament that I have never seen before and again a very well produced photograph. I remember Alan wanting to go and have a look at this spot and when we arrived I could see that he knew he was on to something. It breaks new ground in that it departs from the stereotypical scenes of London and his decision to go for a black and white blue toned image paid off I think. The subtle reflection of Big Ben in the water is all that is necessary to make the photograph cohesive. The relationship between the fountain and Big Ben makes itself clear and the 20mm lens has not given too much of that 'wideangle feel'.

SIMONETTA RIGO

Occupation *Management consultant*
Photographic experience *18 months, mainly outdoors and wildlife on colour slide*

'After four days of waking up at 6am to check the weather, I was finally rewarded with a sunny morning, and was so excited about it that I forgot to study the light. All my pictures came back with too much contrast! Also the angle was too low (thanks to my not great stature). So once again, I kept setting the alarm for dawn, until I was blessed with another sunny morning. This time I climbed onto a bench to improve the angle and used a graduated neutral density filter. Cropping in also helped the contrast. I learned a lot from this shoot – not least about being relaxed and putting any pressures aside. Had I put it into practice, it would not have cost me so much in film and processing, as I was so concerned that the sun would disappear that I thought too little and shot too much! This was one of the best learning experiences I've ever had, but I spent the whole weekend catching up on the sleep arrears!'
Nikon F100 with 28-105mm f/3.5-4.5 Nikkor lens, Ektachrome E100VS, ND grad

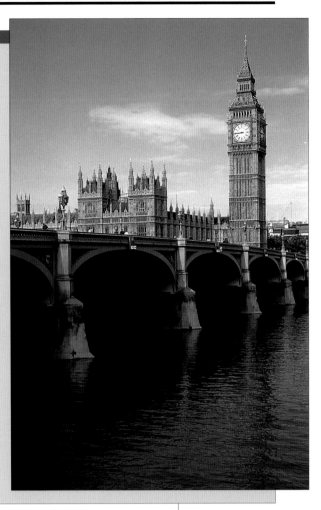

CHARLIE'S VERDICT

I felt this was a strong and positive image and Big Ben dominates the scene wonderfully. Perfect verticals do not go unnoticed and just holding the tip of the spire in shows the care with which this image was executed. The flecks of light along the bridge help bind building and bridge together. I wonder whether Simonetta was wishing for an assistant to set up a ladder for her just to give her that extra foot or so to enable the viewer to enjoy just a little more of the base of the Houses of Parliament. This is merely an observation. The lower elevation does not, however, diminish the photograph. All those early rises will be forgotten but her photograph remains as testament to her determination.

from which to photograph it. And because on this occasion we weren't concerned about missing any wonderful light (we should be so lucky!), it meant we could focus all of our attention on the potential compositions. This was a good discipline, as it is amazing how sometimes the eye can ignore any potential aberrations when the light is good.

We quickly discovered, as we walked back and forth along the south bank of the river, that the impact of the building could be strengthened or lessened significantly within a stretch of only some 20 or 30 metres. Not least because, for example, a polythene-covered area would be revealed at one point, while at another the Westminster Abbey showed itself, which seemed to confuse any potential composition rather than add to it. Realisations such as these really bring home the fact that photographers work much harder than some people give them credit for. And I am convinced that, as photographers, we see the potential for a picture before anything else. Then we start to work towards the picture we see in our mind's eye, which usually involves making quite a few compromises along the way!

With the Houses of Parliament, it is hard to resist the thought of including their reflection in the Thames in any composition. After all, it is rivers which make so many cities great. Other potential elements to include are the ornate lamp posts, with their intertwined fish – and it's worth bearing in mind that, in the evening or very early morning, it would be possible to include them in the frame in order to create that wonderful balance between artificial and natural light. In conclusion, I would advise any keen photographer never to see bad light as wasted time – it forces us to analyse the elements of a picture in a way which we would be unable to in perfect light. And never forget what is on your own doorstep!

Above Looking for foreground interest other than the obvious takes time and exploration

The river of many turns

Right I made this photograph of the Cuckmere Meanders (as some folk call them), nearly 20 years ago. Of course, I now see things in it that I would like to change. I was offered only a few seconds of orange glow, and would have wished for more. I should have placed myself nearer to avoid the diagonal slope in the foreground. The diagonal seems to now conflict with the obvious horizontal nature of the photograph. Would I now use Photoshop to remove the sparkly patches of water on the right nearside of the river? There is no doubt that I shall be back once again to this lovely spot in the hope of improving my result…

Three aspiring photographers visit the mouth of the Cuckmere River to photograph a panoramic vista

THE COMPELLING POWER of water is an important factor in many a landscape image; it often draws a photographer to a scene in the first place. Whether a tumbling waterfall, crashing waves, or the meandering of a winding river, water can dramatically affect the mood of a photograph.

The hairpin turns of the Cuckmere River in East Sussex provided the perfect spot for our tripods. It is the kind of view which demands a high vantage point for photography. Here, the path leading up to the famous Seven Sisters rises from more or less sea level to a height of around 65 metres.

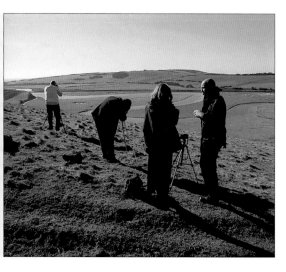

Far left Our three On Location participants choose their spots, setting up their tripods to do battle with the featureless sky

Left Charlie demonstrates to Rachel how using a polariser can deepen the blue of the sky and lessen the reflections in the meandering river below

"Unfortunately the sky was completely featureless – not a wisp of cloud punctuated the endless expanse of blue"

We arrived on a day bathed in sunshine, having had to decide whether to shoot during the morning or in the late afternoon, as this is one of those rare locations which succeeds at both times. The morning light creates raking shadows, modelling the landscape and revealing all its texture and shape, while later in the day you can shoot into the sun as it sets, backlighting the landscape and bouncing off the

RACHEL BURGESS

Occupation
Medical student
Photographic experience
Four years – mainly colour slide of travel and people subjects

Rachel says 'I had assumed we would all be sent off in various directions, so was surprised when Charlie suggested we all stop in one place. I thought all our photographs would turn out the same, so I turned my camera on its side. It wasn't until afterwards that I appreciated Charlie's methods, which are to find the best possible viewpoint and work with it. Normally I would just take a lot of pictures from a lot of different viewpoints, without really considering why. The Cuckmere River scene was a real challenge, as it certainly wasn't a ready-made picture and needed more exploration than that.'
Centon 300 with 28-70mm lens, Velvia, 1/125sec at f/11

CHARLIE'S VERDICT

'It was worth turning the camera on its side to see how the composition looked, but because the meandering river is essentially a horizontal shape, I feel unfortunately it does not lend itself naturally to the portrait format. The chunky nature of the foreground appeared to contradict slightly the graceful rhythm of the river. The near side of the bend closest to the camera appears to have been cropped slightly and perhaps if Rachel had moved forward by 10 metres or so, she would have been able to convey the full curvature. Also, in doing this she would have achieved greater separation between the tufty grass in the foreground and the more velvety grass surrounding the river. She was right, I feel, not to have allocated too much space to the sky as it was a very monotonous blue.'

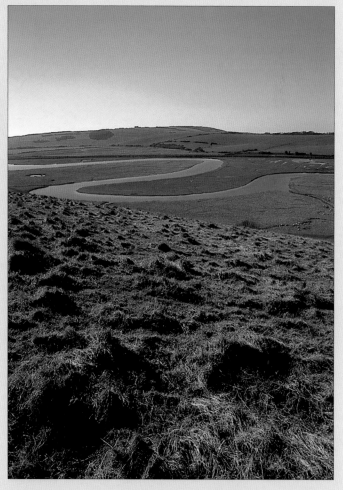

WATERWAYS AND LAKES

Right Accustomed to using an all-manual Canon AE-1, Mark suddenly discovers that loading a film isn't as straightforward as he thought it was. Out comes the instruction manual – again

Above A spotmeter reading can be taken from an area quite a distance from the camera, making sure the exposure is accurate. Mark has used a lens hood in order to avoid flare from the extremely bright sunlight

Planning

Vantage point Any point on the path (which is part of the South Downs Way) leading up towards the Seven Sisters. The lower viewpoints show the river as elongated lengths of water with the sea beyond, while higher up it appears more rounded.
Time of day Either mid morning or late afternoon.
What to shoot Try not to crop too tightly otherwise you lessen the impact of the oxbows. Only include a lot of sky if it has interesting cloud formations.
What to take A zoom lens will help cut out the rather wind battered grasses in the foreground. A tripod is an absolute must, and you will also benefit from a polarising filter (or yellow, orange or red if shooting black and white). Even on warm days the wind can be quite strong, so you will welcome a windproof jacket.
Watch out for If you are very lucky, you might catch sight of the pair of peregrine falcons nesting in the area, although waders are more common. Alternatively you could tackle the famous shot of the Seven Sisters, with the cottages in the foreground.
Ordnance Survey map Landranger 199
Recommended reading *South Downs Way National Trail Guide*, by Paul Millmore, £10.99, Aurum Press, ISBN 1-85410-407-1

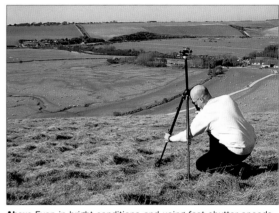

Above Even in bright conditions and using fast shutter speeds, a tripod makes you slow down and consider your composition

MARK BAKER

Occupation
Lumberjack
Photographic experience
One year – just product shots until this shoot, but is now photo mad, to the distress of his bank manager

Mark says 'This was the first time I used my brand new Nikon F90, so half the session was taken up with me referring to the handbook! But as I got to grips with it, I could begin to think about composition. Until now, I had never taken a landscape photograph before, and I found it difficult because there was no life in the sky. I chose this frame because I like the way the footpath leads you in and out of the corner of the picture. Next time I'll go a bit further round towards the estuary to see what that has to offer.'
Nikon F90, 28-70mm lens, Provia 100, 1/500sec at f/11

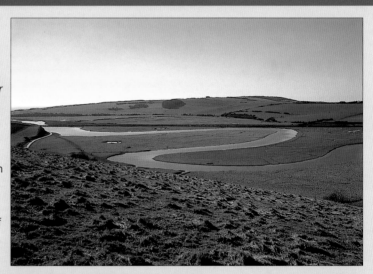

CHARLIE'S VERDICT

'Mark has allocated less of the clumpy grass to the image than Rachel, and has managed to separate the near grass from the far. The white path to the left is the brightest part of the photograph, and as a result is hauling the eye away from the river, diminishing its impact. However, unlike Liz, Mark was clearly keen to convey the river flowing toward the sea and therefore to include this distracting path was inevitable. In situations like this, when the viewpoint cannot be altered, a bit of electronic retouching would be the solution. Once again, there was nothing we could do about the sky and to have kept it to the minimum is best.

Perhaps in conclusion, the photograph of the River Cuckmere would be best treated as a panoramic. The poor sky was the least satisfactory part of the image in all cases and even Liz was not able to reduce its dreariness by choosing black and white. All landscape photographers consider themselves blessed when a wonderful sky is offered to them. On the day we photographed the lovely River Cuckmere, we may have had bright light but the price we had to pay was too high. I think, therefore, we all need to pay this location a second visit!'

LIZ McCLAIR

Occupation
Teacher
Photographic experience
One year – people and abstracts, always in black and white

Liz says 'I love taking pictures, but only ever on automatic. Charlie was very firm about changing to manual, saying if the camera is set to 'P', I don't take the picture, the picture takes me! I always shoot black and white, but I didn't get the picture I wanted – it isn't as abstract as I'd have liked. A better quality of light would have helped, mainly because it is quite a romantic scene. I also have a tuft of tree poking into the bottom, which is the one thing Charlie said to look out for!'
Olympus OM40 with 35-70mm lens and polariser, Agfa Scala 200, 1/250sec at f/16

CHARLIE'S VERDICT

'Black and white was definitely an appropriate choice for this scene, as it allowed the silvery ribbon of water to appear more pronounced, and the sense of an 'S' is very striking because Liz has chosen to crop at the point where the river meets the sea. As she used a polariser for this particular shot, the water has lost its reflection of the sky, although I think it could be lifted a little with a touch of ferricyanide bleach (and I believe it's possible to bleach and tone Agfa Scala film). The small patch of water reflecting brightly to the left could be knocked back with a black and white retouching dye, although ideally the river – with the aid of the ferricyanide – could be as bright as this patch.

I particularly like Liz's sidelit sheep at the bottom part of the frame. The smallest element in an image can sometimes play a key role in the viewer's understanding of the photograph. And, a small thing – but something I admit to being slightly obsessed about – Liz has managed not to cut any of them in half. Doing so would have suggested she was not aware of all the elements within the viewfinder as she took the photograph.'

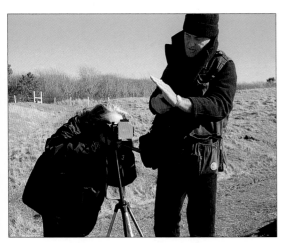

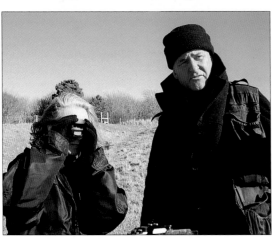

Cuckmere to reveal it as a winding silver strip. We decided the morning would be more favourable, as the afternoon would mean working against the clock to find the best spot and set up our cameras, while all the time the sun would be dropping out of the sky. During the winter, at no point is the sun directly overhead, so there is no need to battle with reduced contrast and harsh, overhead sunlight characteristic of the summer months.

A day as glorious as this can still be problematic. On this occasion, the perfectly clear conditions meant the sky was completely featureless – not a wisp of cloud punctuated the expanse of blue. There is only one solution at times like this: crop out the sky almost entirely, and concentrate on the foreground. Many photographers are seduced into thinking a clear sky is perfect for landscape photography, when all it provides is a plain wash of colour lacking any interest or depth.

Feeling sheepish

However, there was enough in the foreground to keep us happy, including a flock of sheep whose behaviour we believed – somewhat optimistically as it turned out – we could predict. While waiting patiently for them to form a photogenic clump by the river's edge, a couple instead would wander in one direction, while a few more would stray elsewhere, and still more headed for a different spot altogether. In the end, we could only concentrate on achieving the best sheepless composition possible.

Left In the absence of a lens hood, use your hand to shield the lens. A yellow filter with B&W film helps darken the sky

Below left Charlie's panoramic viewfinder demonstrates how well the composition would work in this format

Wondrous waterway

Perfect weather, a chocolate box scene, but can the photographs live up to the excellent conditions in which they are taken?

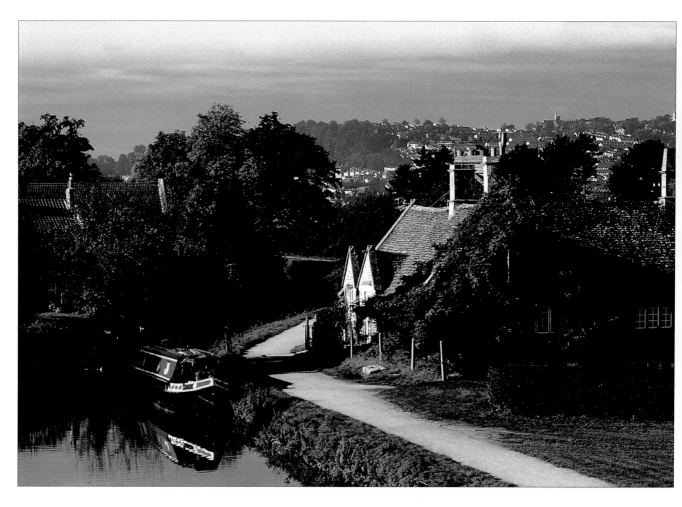

Above Taking the shot from higher up has allowed me to include the canal, The George Inn and the distant city of Bath, adding a real sense of depth to the scene
Nikon F5 with 80-200mm lens, Velvia, 1/2sec at f/32, polariser, tripod

LINKING THE River Thames at Reading to the River Avon at Bath, the Kennet & Avon canal is a waterway with a unique history. Stretching 57 miles, the canal passes through a varied urban and rural landscape, crossing chalk vales, navigating agricultural land and winding through villages, market towns and the city of Bath. The canal was first projected in 1796, and finally finished in 1810 by engineer and architect John Rennie. Parts of the canal gradually fell into disrepair until, in 1950, a stoppage at Burghfield near Reading finally made

the canal unpassable. Luckily, through the work of the Kennet & Avon Canal Trust, the canal was fully restored, and was re-opened in 1990 by HM the Queen.

For this shoot we travelled to Bathampton, a particularly picturesque village two miles east of Bath along the banks of the Kennet & Avon canal. Bathampton has a population of roughly 1,800, and is filled with impressive buildings made of Cotswold stone – a material that gains an attractive natural yellow/ gold tone when the sun hits it in the right places.

On Location shoots are notorious for bad weather, and on many occasions I have found myself sitting in a pub talking about the merits of filters and film, and willing the rain to move on and let us practise some real photography. However, this time – despite a particularly fierce deluge the night before – Kay, Gill, Bryan and I were blessed with some of the finest weather we have experienced in a long time – the perfect opportunity to drag out polarisers and graduated filters, and capture a quintessential

GILL HAMMOND

Occupation *Self employed*
Photographic experience *Six months. I have no preference as to what I like to shoot at the moment. I would like to try some portraits and close-ups before I decide on a subject to concentrate on*

'After the deluge of the previous day, the morning of the shoot was glorious. Charlie gave us some tips regarding how to approach our chosen subject in order to achieve the best results. 'Check the viewfinder for any distractions – twice,' he advised. A second useful point was to approach each shot as though it was a commission – this helps to focus attention on the subject.

This particular picture is my 'artistic' attempt. I tried to get a slightly unusual viewpoint, but maybe it was a little too ambitious for a complete novice like me, still getting to grips with f-stops and selective focusing. I like the composition, but the boat seems to be going uphill while the people remain upright – maybe it's the angle I took it from.'
Canon EOS 300 with 75-300mm Canon EF USM zoom lens, Velvia, 1/45sec at f/16, tripod

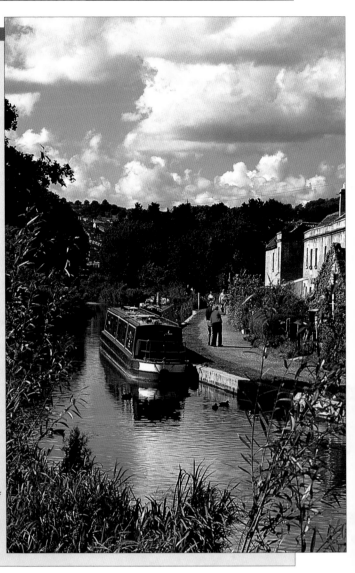

CHARLIE'S VERDICT

The tradition of including interest in the form of trees, or in this case reeds, either side of the main subject still appeals to many people, while I find it perhaps a little too old fashioned. Personally, I would have left the reeds out of the shot and concentrated on the sweep of water exiting the image to the left. Often when sky and water has no merit then concealment is the best answer, but here there appears to be a little soft reflection of the house which could have been brought out a little more.

The people in the image are obviously intentional, and it is true to say that there are two schools of thought with landscape photography when it comes to including people in the photograph: 'To have or to have not?'

Years ago, I was privileged enough to produce a book on Venice, and one of the comments was, 'Charlie, why do you omit people in your Venetian photographs?' My reasoning, while perhaps rather tenuous, was that if there had been people in the image, the observer would become the second visitor to the scene, not the first.

English scene at its best. Heading for a small bridge across the canal, Kay described the viewpoint out towards The George Inn as 'chocolate box' – a phrase all too often meant as a derogatory term. Personally, I feel that a scene such as this – with the bright primary colours of the barges and the idyllic towpath – has merits both in terms of stock photography, and for promotional purposes.

After handing the team some of my infamous framing masks – black mounts cut from card to aid composition – we began a thoughtful recce, taking into consideration the dramatic changes as we stepped mere metres to the left or right. As we moved further along the canal bank, new buildings emerged in the frame, the S-shape bend in the canal became more pronounced and rhythmic, and the distant city of Bath became more and more obscured by hills and shadow.

Standing on the bridge, we began to look at the elements.

The modern houses along the canal were rather displeasing – as were the cars, telegraph wires, tourist signs and modern advertisements, but the main focus of the scene was to be found in the

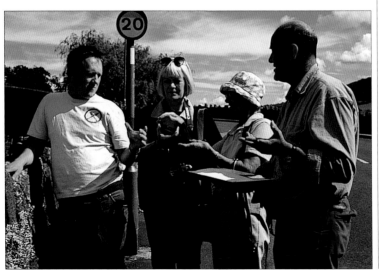

Left Charlie talks to the group about using warm-up filters to bring out the natural yellow/gold colour of the local Cotswold stone

WATERWAYS AND LAKES

relationship between the water, barges and the pub. The towpath led the eye into the composition, but it is crucial to consider just how such a feature will exit your picture before including it in the frame. A line of chimneys formed a neat pattern, settling nicely beneath the brow of a hill without

Planning

Location Bathampton is situated two miles east of Bath in Somerset.
How to get there Leave Bath by North Parade Road. At the traffic signals, turn on to the A36 (signposted Warminster). Continue to the junction with Bathwick Hill and, at the roundabout, take the second exit. Take the junction for Chippenham (A4) and at the roundabout take the second exit – keep left.
What to shoot The canal from the bridge looking both east and west. The River Avon, which cuts through the village.
The canal looking towards the swing bridge. Nearby Bathampton Meadow and Oxbow Wetland Nature Reserve. The Georgian architecture of nearby Bath and Bradford upon Avon.
Best time of day Early morning for atmospheric mist, and early evening for lit barges.
Other times of year The canal looks equally picturesque in both summer and winter.

What to take Tripod, warm-up or ND grad filters, polariser, zoom lenses, and macro lenses for close-up details of the barges and stonework.
Nearest pub The George Inn.
Nearest accommodation There are plenty of delightful B&Bs in nearby Bath and Bradford upon Avon.
Ordnance Survey map Landranger 172.
Further information Visit the Bath Tourist Information Centre in Abbey Churchyard, Bath (01225 477101). Try www.bathampton-village.org.uk/

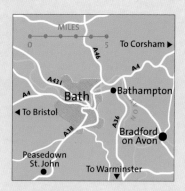

BRIAN ANGELINETTA

Occupation *Self-employed hairdresser*
Photographic experience *Four years seriously. One exhibition of Indian wildlife*

'Great weather, passionate photographers, a tranquil waterside location and a pub – you can't get better than that! We started the shoot from the bridge over the canal, discussing photographic possibilities, film and filters. After a few words of wisdom and encouragement from Charlie, we set about photographing our chosen viewpoints. I decided to return early the following day to try out some further ideas. With mist covering the hills in the background, and with the sun low enough to reflect along the side of the narrow boat, I hoped to capture a 'morning feel' to my photograph.

 I learnt a great deal from Charlie, not only from a technical viewpoint, but also about the way I 'think' about shooting my photographs.'

Canon EOS-1v with Sigma 70-200mm EX lens, Velvia, 1/20sec at f/11

CHARLIE'S VERDICT

Bryan's image could not be more different from Kay's. Capturing the atmosphere of morning, every hue has been subdued by the backlighting, affording the image an almost monochrome feel.

 The water has taken on the usual mercurial, semi-molten appearance common to backlighting and, despite

some apparent turbulence to the surface further toward the middle distance, there is a strong sense of stillness and calm.

 I see another narrow boat moored a little further along the canal. It's a small thing, but if it had been possible to reveal the starboard hull – please note naval folk – plus the smallest sliver of water to its

side, this would have given life and extension to the far end of the image. It would also have contributed toward a greater sense of depth – always one of the prime considerations with landscape photography. Who knows though, perhaps Bryan's arms were already stretched to the limit.

KAY BERRY

Occupation *Retired schoolteacher*
Photographic experience *Taken pictures, on and off, since childhood. Belong to a local camera club, which motivates me to produce photographs that will stand out in club competitions and exhibitions*

'Charlie's enthusiasm was inspirational. Starting the day off with some good general information and tips, we then looked at the scene to assess its possibilities. One of the tips Charlie gave was to watch the movement of the clouds and how they highlight different areas, affecting the light on the landscape. Reading the light in this way was something I hadn't thought about before.

I chose this shot of the boat moored outside The George Inn, as the pub is quite picturesque. I was pleased with the detail on the roof tiles, but the buildings to the left are too bright. The cloud detail could have been improved by using a filter, but I am happy with the general composition, and the progression along the canal to the countryside beyond.'
Canon Sureshot with 105mm zoom lens, Fuji Superia 100 [no exposure details recorded]

CHARLIE'S VERDICT

Many of us are drawn to water in our photography, and the image of this magical place seems to convey the quiet calm that life on the waterways offers.

The positioning of the two narrow boats is perfect with the strong blue-painted hull of the foreground boat making a bold statement informing us as to the nature of the boat beyond.

The small sapling, while clearly unavoidable, has been skilfully dropped into the space between the two boats. The construction of the image is pleasing. It is the subject brightness range that proves difficult to embrace.

The depth of the shadow on the building is compounded by the light absorbing creeper and, if a polarising filter were used, then the precious shadow detail carried toward the camera through reflection from the leaves would have been partially 'killed off'. Had the creeper been omitted, and the pale stone beneath revealed, then the subject brightness range of the building would have been extended. The hint of a car and people to the right were no doubt difficult to omit.

Perhaps a one-stop neutral density (ND) graduated filter would have helped: with some deft and judicious angle positioning the sky and the lit side of the building would have appeared darker, thereby providing a more balanced exposure. Despite the further darkening effect this would have had on the greenery beyond, the offending burnt-out face of the building would also have been somewhat lessened.

interfering with the skyline, but the foreground looked a bit bland. Perhaps it would be best to return in the morning for some atmospheric mist, or in the early evening when the barges are lit up – it's all trial and error.

While we were waiting for the harsh midday sun to pass, Kay and Gill headed over one side of the canal, while Bryan made his way closer to the water, choosing to home in on small details on one of the barges and the bright reflections on the water.

Left Charlie talks to Gill about using a monopod on the rough surface of the bridge

As the afternoon wore on, the play of light and shadow helped to convey a sense of drama to the scene – I often find that if you wait for some cloud shadow to arrive, you can paint the scene like a lighting director in a theatre. As the light became more interesting, the distant hills, and then the canal, dropped into shadow, changing the mood altogether. Kay and Gill laid in wait, watching the light dance across the water, until gaps arrived in the cloud. In order to make the most of the conditions, I talked to the team about the use of polarisers and graduated filters.

Polarisers are a little bit like alcohol: they can be your worst enemy or your best friend. As with any filter, a polariser should be used in moderation, and its employment should be unnoticeable.

Polarisers are ideal when there is some cloud in the sky, but, if it's all blue, the effect can be too insipid. If you do decide to use one, remember that they also take the brightness out of greens.

Warm-up filters can make stonework appear bolder, and much more handsome, but they also cut down the light by a stop and a half, and can often leave the sky looking quite grey. Using the 81 series of warm-up filters can locally warm up the stone, but remember that blue will be restricted and appear grey through an amber filter, and everything else in your shot will also be warmed up, unless you use a graduated filter.

Kay decided to give this a go, and discovered that using a graduated filter warmed up the stone, but left the sky well alone. Have a go, try one with a filter and one without.

Right As the clouds go scudding across the horizon, our participants have to work quickly in order to capture an image on film

Below David sees potential in including the lone fisherman in frame, using the reeds as a foreground element. To get just the shot he has in mind, he has to perch on the water's edge, with one of his tripod legs submerged in the lake itself. But if he gets the shot, it'll be worth it!

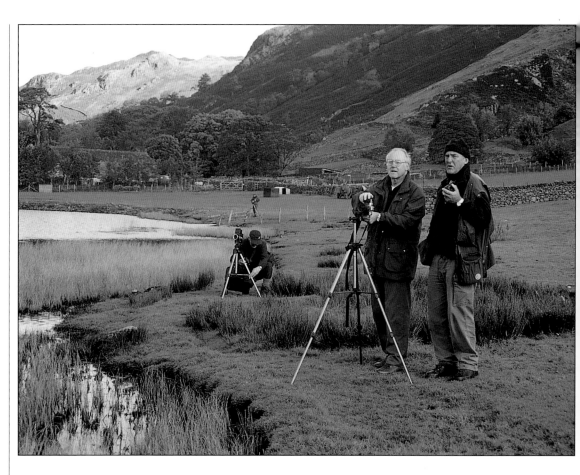

Light on the lakes

After weeks of gloomy, rainy weather, it was a relief and a delight for three amateur photographers to find their Lake District location bathed in sunlight

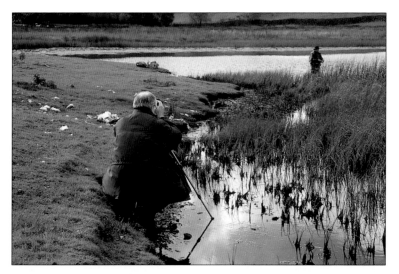

WHEN YOU VISIT an area like the Lake District for a photographic trip, the choice can be overwhelming. Where to start? With the brooding menace of Wast Water? The near-perfect compositional potential of Derwent Water? Or how about making for the stunning hills instead, photographing the never-ending views that can be afforded on, if you're lucky, a clear day? And don't forget Ashness Bridge, of course... You could spend so much time deciding, you might end up never taking your camera out of the bag, so when we arrived in this spectacular part of England for this shoot, we decided to keep things small and headed for the delightful location of Watendlath.

As the locals regularly like to remind those of us who are outsiders, there is only one lake in the Lake District National Park – Windermere. All the rest are

'waters', and Watendlath is a very small one. It's well known, however, because you have to pass over and alongside two of the lakes' most famous landmarks to get there – Ashness Bridge and Surprise View. But size isn't everything, as we all know. What Watendlath lacks in sheer volume, it more than makes up for in variety. Surrounded by rolling hills – which were just beginning to turn in colour when we were there – there are plenty of elements which prove suitable backdrops for any photograph. Wind-beaten trees,

shaggy sheep, and drystone walls all combine to create a picture that is unmistakably Cumbrian.

Below Terry has used the shoot as an opportunity to run a roll of film through his most recent purchase – a Rollei SLX 6x6cm format camera. He decides that a low viewpoint will do justice to the scene at Watendlath

Planning

Location Watendlath is in the heart of the Lake District National Park, within easy reach of Keswick.

How to get there From Keswick, take the B5289 south for about a mile, then take a left turn onto an un-named road. About four miles down this road, you will reach Watendlath, where there is a car park and, very conveniently for the cold photographer, a tea shop.

What to shoot Before you even arrive at Watendlath, you will be distracted by the classic image of Ashness Bridge, over which you must cross in order to reach Watendlath. One of the best times to photograph this view is around 6am on a June morning. At this time the light is perfect, and there are none of the hordes of tourists to impinge on your wonderful shot! Further up the road is one of the finest views in the whole of the Lake District – Surprise View. Don't get so distracted with shooting a series of pictures to stitch together as a panoramic, that you

forget where you are and step over the edge – it's steep! At Watendlath itself, work with the drystone walls, the warm greens and browns, and the small lake to bring together a good composition.

What to take Plenty of windproof and waterproof gear – especially footwear. A wideangle lens to capture the view of the river valley on one side, and a short telephoto to compress the perspective of the lake. Neutral density grads and a polarising filter will be invaluable.

Ordnance survey map Landranger 90

Further information www.cumbria-the-lake-district.co.uk; the Cumbria Tourist Board (01539 444444)

WATERWAYS AND LAKES

GARETH BROWNING

Occupation *Forester with the Forestry Commission in West Cumbria*
Photographic experience 10 years of photographing forest landscapes with the last two years producing a monthly photographic diary of Ennerdale Valley on the internet at www.forest-diary@freeserve.co.uk

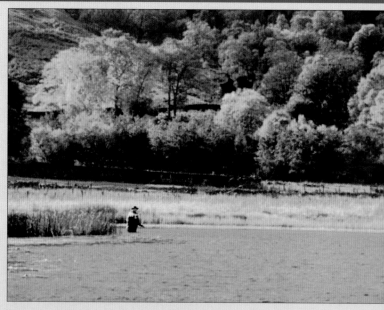

'After weeks of dull weather we arrived at Watendlath to see superb shafts of light playing across the hillside. Charlie gave us a card slide frame each to check out different compositions. He then encouraged us to think about and watch the changing light, which was fantastic, but trying to capture it was challenging. To reduce camera shake, I used a tripod and self-timer, but over the countdown the light often moved on. Time to invest in a cable release! The fisherman was difficult to capture without filling the frame with windswept grey water, or obscuring him with the beautiful reeds. I used a telephoto to reach him from across the lake, but still include the trees in their autumn colours. I like the light on his back and arm, and the rod and line as he cast, but his face is in shadow and there is still too much grey water.'
Canon EOS 50E with 80-200mm lens, Velvia, 1/180sec at f/5.6

CHARLIE'S VERDICT

Gareth has made a great job of separating the fisherman from the reeds. He has also captured a wonderful 'decisive moment', with the fishing line cutting a perfect curve through the air, before hitting the water. The light catches its silvery thread at just the right places. As for his face being in shadow, this doesn't affect the image in the slightest. We wouldn't want a pastoral photograph like this to be too literal, after all. It is slightly unfortunate the fisherman waded up to his waist, giving the impression of being cut off in his middle, but there was nothing we could do about that!

DAVID HALLEWELL

Occupation *Salesman*
Photographic experience *Years of casual photography, 18 months trying to improve*

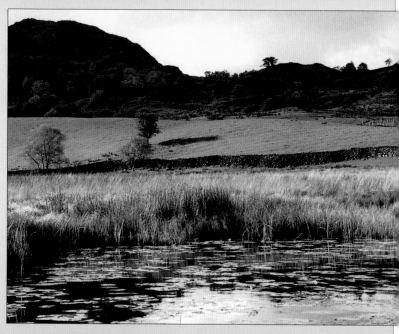

'Learning from Charlie's perception of the photographic opportunities, and the depth of thought and detail which should go into the composition was the most valuable lesson of the day to me. Even though we live within the Lake District, I needed a sense of purpose for my photography and Charlie may have provided that spark. I found the windy weather and rapidly changing light difficult to cope with. My photograph is an attempt to show something of the mixed images of early autumn. I selected this one because it had the only calm bit of the lake on it. I feel that the foreground conveys what I wanted to achieve but the sky is featureless and the shot may have been better without any of it.'
Pentax MZ-5N with 28-105mm lens, f/11, Fuji Superia 100 print film, tripod

CHARLIE'S VERDICT

The strong breeze certainly was a problem on the day, gusting across the water, and denying us any chance of getting reflections of those lovely reeds. However, David has done well to take a shot at a time when there was a lull. Yes, it's a shame the sky wasn't at its best, but photography is so often a compromise. However, the sky balances well with its reflection at the bottom of the frame, and to lose it entirely would have upset that balance somewhat. One thing I might suggest is a slightly raised viewpoint to separate the reeds in the distant left from the stone wall.

THE LAKE DISTRICT

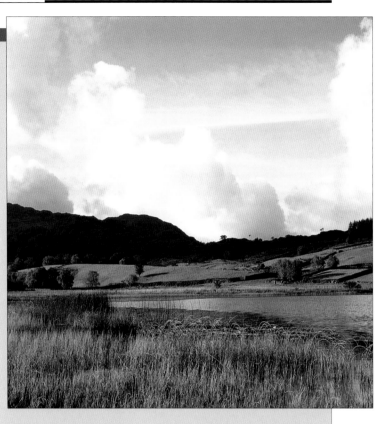

TERRY GOOD

Occupation *Glazier*
Photographic experience *Eight years of shooting landscapes*

'The photographic day out with Charlie at Watendlath proved to be extremely informative and useful for our picture-taking. After he talked to us about what elements to look for and how to include them in our photographs succesfully, I followed my instincts and captured this picture of the tarn, showing the different shades of light and dark contrasted against the lush lakeland farmland. I would have liked a more dramatic sky, and maybe to have cropped some of the reeds out of the lower part of the frame. It was only the third or fourth time I had taken out my new Rollei camera, so this was the ideal opportunity to get to grips with using it.'
Rollei SLX with 80mm lens, Velvia, 1/15sec at f/16, tripod

CHARLIE'S VERDICT

Considering Terry was still quite new to his Rollei when we visited Watendlath, he has come away with a photograph of which he should be very proud. It can sometimes be very easy to spend too long pondering over the technical aspects of our cameras, thus deflecting attention to the actual taking of the picture. It doesn't look as if Terry ran into this problem. There is just enough detail in the sky to justify allocating a lot of the frame to it, and to crop any of it would mean a loss of the blue patch at the top, which wouldn't do the picture any favours. Although he suggests cropping out some of the reeds, I would be inclined to leave them as they are, perhaps because I have a bias towards reeds anyway, but also because they give the picture a grounding and a reference for the rest of the scene. I like the way he has created an elongated triangle coming in from the right of the frame, with the wall on the hillside coming down to meet it towards the left of the picture.

And what we had on this occasion – oh miracle of miracles – was light! Sharp, fleeting, shifting, dramatic light. When we are given the gift of light like this, it is sometimes all too easy to rush to set up the camera, without giving due thought to bringing together a meaningful composition. So, as the light played across the distant hills, we made sure to take time setting up our shot, without panicking too much about missing its wonderful effects on the landscape!

Below Gareth decides on a viewpoint a little further round the lake, hoping that the curve will allow him to separate the fisherman from the reeds, compressing the perspective with a telephoto lens. He also has to decide upon a good height

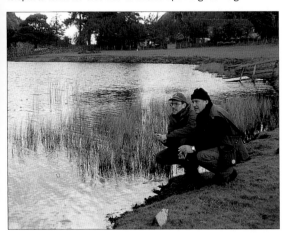

At Watendlath, some angles reveal just a wall of land, with no real focal point or compositional interest, while others are just too complicated, so there is nothing for the eye to settle upon. One of the most attractive angles, to my mind, had some sweeping reeds in the foreground, whose pale colour contrasted beautifully with the dark, peaty water. Best of all, they related to the golds and browns of the distant trees and hills, to hold the composition together.

When the sun broke through to light the trees from the side, it really was stunning. Just to complete our shot, if we chose to include him, was a fisherman, waist deep in the water. To make sure we didn't upset him, I asked him if he would give us permission to include him in our photographs, and he was fine about it, as long as we didn't scare his fish away!

Once my camera is in place, I always like to settle down and ask myself what I want to take place in the frame. It's almost as if I become a director of the image I want to make, with the light providing the theatre. Then you just have to wait. Of course, as it's nature we're dealing with here, the light will rarely do what you had hoped, but sometimes it might provide a quality even better than what you'd hoped for. It's just a question of being ready for the conditions when they happen. And when the Lake District is in the mood, it can give you the kind of light that dreams are made of.

Garden of the gods

With their ancient Roman themes, the gardens of Stourhead provide plenty of inspiration for the photographer and are a delightful backdrop to a very pleasent day

IF HENRY HOARE II, a forerunner of Capability Brown, was to pop back to 21st century Britain, I think he'd be pretty pleased with what he would find at Stourhead, a garden he started to lay out in 1741. This 2,650-acre estate, now owned and run by the National Trust, has a magnificent garden, whose vistas change with every curve and turn of the paths that wind their way through the rhododendrons, azaleas and magnolias. Every now and then the trees, shrubs and flowers are punctuated with views of beautiful structures – equally beautifully named – such as the Pantheon, Temple of Flora and Temple of Apollo. Many of them are at their best when viewed across the body of water which takes up a large part of the centre of the gardens.

And the beauty of this place really is in these features, with their references to ancient Rome, because they provide the photographer with a strong focal point to form the basis of a picture. It is then up to us, as photographers, to utilise the other elements – water, clouds, trees, light – to bring together a coherent image around this central point. It's hard to believe that photography wasn't invented in the early 1720s when the house and gardens were begun – such a delight it is for the camera-toting many who visit each year.

What a pleasure for us, then, when we met at the teashop on what really felt like the first day of spring. The sun was shining, and it was warm enough to remove the padded jackets which had practically welded themselves to our bodies over the previous few months. Big puffy white clouds were making their way across the sky, which meant that areas dropped in and out of shadow, as the pattern of light changed constantly. It was a day filled with photographic promise.

To make the most of it, we set off on the path that takes the visitor round, with the lake on their right and the Temple of Apollo on their left. For the time being we bypassed the bridge that forms the foreground of so many paintings and photographs, concerning ourselves instead with a closer view of the

KEITH BENDELL

Occupation
Electrical engineer
Photographic experience
20 years plus...

'Landscape is my favourite of all photographic subjects. We had good light, some interesting skies and, right from the beginning of the day, Charlie was enthusiastically providing us with valuable tips on seeing and composing the scenes. The day was informative and a real treat. At the time of taking this shot, I was concerned that it would not work well because of the Pantheon in the top right possibly appearing obtrusive. But on later looking at it I felt that the bushes to the left balanced this out. Some sunlight striking from the left has given a few nice highlights to the Pantheon, bushes and parts of the bridge. I would, however, have preferred to include more of the sky.'
Mamiya 645 with 80mm lens, Velvia, 1/15sec at f/22

CHARLIE'S VERDICT

Keith's photograph has a totally different feel to it compared with the other readers' pictures. He has taken a viewpoint just a few metres away from where they set up and this changes everything.

Here, the bridge plays a much more important role, almost eclipsing the Pantheon in weight. There is good tone in the sky and the balance seems about right – but like Angie's photograph *(see next page)* where the 'hemmed in' feel of the tree in blossom could be improved, more space might have been given to the right hand side of the Pantheon as it looks trappped here. It is good to see the pillars of the bridge and the eye travels happily in a sort of zig-zag from the bottom left, along the bridge to the Pantheon sitting in the distance on the top right of the frame. If the top of the tree was there in the transparency, it may improve the image if it were given back its crown!

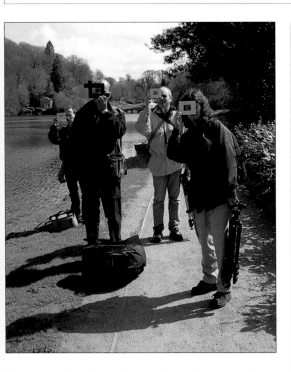

Above Using Charlie's infamous framing cards, our three readers decide whether to include or exclude the path from their compositions of the Pantheon

Planning

Location Stourhead is in Wiltshire, between Yeovil and Warminster.
How to get there From the M3, join the A303, turning off at the B3092 signposted Frome. Gillingham and Frome are the nearest train stations.
What to shoot Any of the features as well as glorious displays of rhododendron, azalea, and magnolia. Also, you could take the 1½ mile route to King Alfred's Tower, a 160ft red brick folly. Climb to the top and the views across the countryside are superb.
What to take Sturdy walking boots or shoes to negotiate the paths around the estate. Both wideangle and zoom lenses are essential – the former for including skies and reflections, the latter for compressing elements of distant images. Neutral density filters would be great for slowing down the movement of the water and clouds, creating a poetic feeling of movement.

Other times of year Autumn, when the trees change colour.
Nearest refreshments The Village Hall self-service café, and the Spread Eagle Inn (01747 840587) are both on site. The Spread Eagle has accommodation.
Ordnance Survey map Explorer 142
Further information Call the Stourhead infoline on 09001 335205 or see www.nationaltrust.org.uk for details on special events. Overnight parking for caravan club members is available between Easter and October. Reservations on 01747 840061.

WATERWAYS AND LAKES

Right The fascinating patina on the Pantheon's columns is just right for a close-up, and the diffuse light provides the perfect conditions, so Angie fits her macro lens

Far right Having dispensed with the macro lens for the time being, Angie opts for a telephoto, to compress the elements of the scene into a pleasing composition

Pantheon, which nestles among some trees on the northern edge of the lake.

Straight away we encountered a thought-provoking compositional issue. The path on which we stood was very brightly lit. To involve it in the composition would have been a distraction, as the eye would fall on it first, so the Pantheon wouldn't get the attention it deserved. The last thing a landscape photographer should do is set up conflict or competition between two areas in the frame. Once the path is out of the frame it begins to work because the scene is simplified – and simplicity is, more often than not, the key to a successful image.

Selecting the shot

The choice we were then faced with was whether to include all of the trees, or to 'trim' them at the top. I always feel that stunting the growth of trees by cutting them out is a great shame, as they can act as a backcloth, allowing the focal point to nestle comfortably in frame. There is also a question of how

ANGIE SHARP

Occupation *Computer analyst/programmer*
Photographic experience
Had first camera as a child, now serious amateur interested mainly in landscape

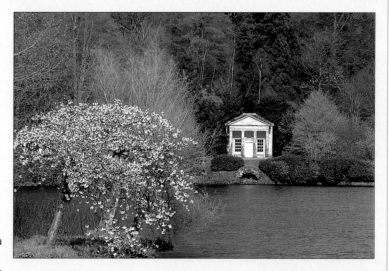

'Charlie's tips and guidance provided me with a wealth of ideas and inspiration, and I found his 'viewing frame' (a window cut in a small piece of card) particularly useful. Initially, I concentrated on close-ups of lichens, and by the time I'd decided to move on to some scenic shots, the sun had disappeared! After packing up for the day, a shaft of sunlight crept teasingly from behind the clouds onto the temple across the lake, so I quickly got my camera back out and loaded another roll of film to shoot several more frames before the sun vanished for good.
My favourite shot was one of the last I took. I think it might have been improved if there was less 'empty' water in the bottom right, but sadly the resident ducks were never in the right place at the right time!'
Canon EOS 3 with 70-200mm lens, Velvia, 1/2sec at f/32, polariser

CHARLIE'S VERDICT

This is a delightful image with an excellent relationship between the little building and the blossom tree.The Temple of Flora seems almost comic with its face looking out across the blue water. Relationships are always important in a photograph. They help to make the image more understandable, more cohesive and undemanding.

If I were to be hyper critical then I would say that perhaps there could have been a little more space to the left of the blossom and yet more beneath it. You would still achieve the same kind of impact – and the increased area may in fact show these features off to greater advantage! Don't get too tight if you don't need to.

CHRIS APLIN

Occupation *Systems support analyst*
Photographic experience *30 years, on and off*

'I was very surprised to get the call to accompany Charlie Waite on location. Charlie was great – he has an easy style and the three of us learned a lot from the day. Putting it into practice is something else. We were very fortunate with the weather – the forecast two days earlier had been for torrential rain. I tried to produce a picture that captured the spirit of Stourhead – one which included the turf bridge and the pantheon and was typically Stourhead. The quality of the light was best in the morning and although the three of us stayed for the afternoon, there was more cloud and the light was hazy. I found it very difficult to capture the classic Stourhead shot – a large bush obscured the bridge when the perspective between the bridge and the pantheon seemed correct. This picture was the last on the film and I thought the composition was the best I had got. However, it would have been much better had I taken it in the morning when the sky was more interesting.'
Minolta Dynax 9Ti with 24-105mm lens, Provia 100F, 1/180sec at f/6.7

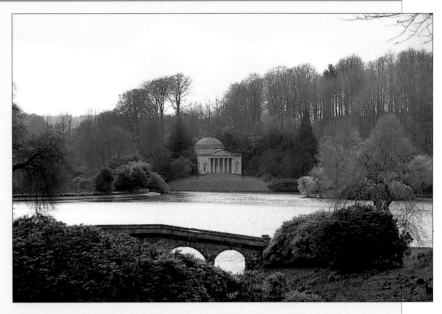

CHARLIE'S VERDICT

In this picture by Chris, the Palladian bridge appears to be at an angle that is not parallel to the front of the Pantheon, making the whole seem out of trim. The bridge seems to be struggling to make itself known and the large and rather uninteresting bush in the foreground overwhelms it.

I feel that more might have been made of the bridge although the one arch does sit comfortably beneath the dome of the Pantheon.

I like the smoky feel to this image, but the top-light that prevailed at the time did not do Chris any favours. Atmosphere and mood is more often than not created by light – providing a sense of dimension so important to a two-dimensional image. The photograph here appears to convey little depth and the weak sky above the line of trees lacks tonal value and harshly reflects itself in the lake below, serving to diminish the image.

much water to introduce in the bottom of the frame. If we wanted to include all of the Pantheon's reflection, a very deep image resulted, requiring a

wideangle lens and then we had come full circle, because a wider angle re-introduced the path! Moving up to the Pantheon itself, we see that the patina on the pillars and inside is really lovely.

It would certainly be a shame if it were ever to be cleaned. There is plenty of scope for close-ups of the patterns formed by the discoloration, views of the pillars from below, using an extreme wideangle to really distort the perspective, and views out the other way across the water towards the Temple of Flora.

Finally, it was back to where we started, looking at the classic image of the Turf Bridge in the foreground, with the Pantheon in the background. I've always had trouble with this scene, as there's something about the two that seems to be out of balance. And then it hit me. The angle of the bridge is running counter to the angle of the face of the Pantheon.

It strikes me as surprising that the two weren't placed so that they ran at the same angle, because no matter how you look at the bridge and the Pantheon together, there's always going to be that disharmony. It's an intriguing conundrum, and one that our group did our best to disentangle over sandwiches and cake at Stourhead's tea room. Well, I did say it was a delightful day!

Below left Chris and Charlie decide whether a low viewpoint will work

High water mark

On the border of Bolivia and Peru, the world's highest lake proves to be breathtaking in more ways than one

AS I WRITE THIS, I look up at the high cumulus clouds and find it hard to believe that some months ago, I was above the average cloud height in northern Europe and panting my way through the streets of La Paz, the highest capital city on the planet.

The aeroplane landing speed, I had been reliably informed, would be in excess of 350kph. And, the same person told me, I would probably succumb to acute altitude sickness. Some people seem to relish being the bearer of bad news...

The arrival was straightforward, but after 300 paces to the terminal building I was keeling over, and, as nausea swept over me, I recalled the doom merchant's words.

Like many South American countries, Bolivia has suffered both politically and economically, yet there has never been the degree of insurgency and terrorism that has afflicted countries like Peru and Colombia. It is hard to imagine that Bolivia is larger than France and Spain combined and, of its 10 million population, 55% are Indian. Proportionally, Bolivia has the highest Indian population of any Latin American country.

La Paz boasts one of the finest backdrops any city could wish for – the formidable Illimani, at a height of 6,322m, seems to stand silent guard over the city sunk into a great scoop some 3,000m below.

After a day or two in La Paz, we were away to Lake Titicaca,

arguably the finest lake in the world. This ravishing lake, the world's highest at a nauseating 3,856m, lies half in Bolivia and half in Peru, and within a few hours we were standing by her shores.

Before this point, I thought I had seen true azure in parts of the Adriatic, Aegean and Caribbean, but Lake Titicaca was like staring into the heart of a vast sapphire. It was breathtakingly, outrageously beautiful.

We had taken a boat to an island in the middle of the lake, and I had begged a local schoolteacher to let me have two desks to stand on. I had become obsessed with two pinnacles – the top of the sail and the apex of the thatched

Below *Fuji 6x17 panoramic camera with 300mm lens, Velvia, polarising filter, 50% polarised*

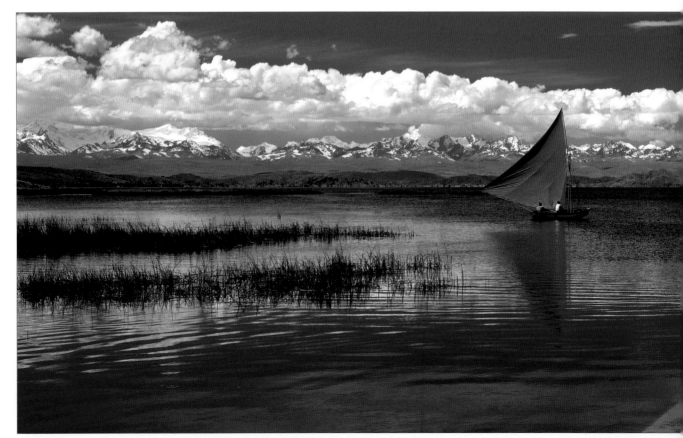

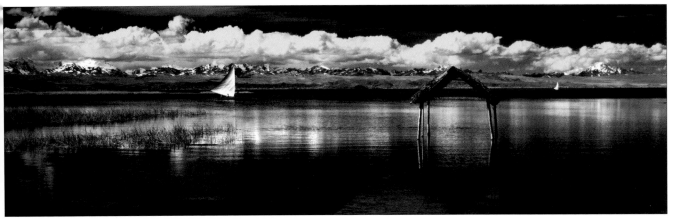

construction. As I stood before this image I was determined that it could only work if these two points fell under the distant mountain range. Two battered old school desks did the trick and I stood, albeit somewhat precariously and by a mere millimetre, triumphant!

At the far side of Lake Titicaca is the distant mountain range of the Cordilleras. The arrangement of cloud above their peaks was staggering and, although my first impulse was to use colour film, I felt that I could express the magnitude of the scene before me more effectively in black & white – or could I? What a pickle I was in.

Changing gear, as it were, from colour perception to black & white is always very peculiar and I rarely work with both mediums on the same day. However, it would have been perverse to deny myself the chance of doing some black & white, so I did.

Then came a further consideration. I often regard landscape photography as a gentle and sedate occupation, but here I was, panicking (well almost) about the position of this little boat, a small and yet crucial element. The boat across toward the distant horizon beckoned the eye as well, but my boat and its position was vital to the coherence of the image.

In the time allowed (the boat was not stationary), could I produce one image in colour and another in black & white? Perhaps I should abandon one or the other? Nothing else in the world should matter when standing behind the camera in eager and happy anticipation of everything coming together. I, however, was in a state of acute anxiety at the prospect of everything disappearing!

It was cold but I was on fire with excitement as the image took shape. The serenity that I hope is conveyed in this image was born within a climate of near frenzy. Who would have thought it?

Above *Fuji 6x17 panoramic camera with 300mm lens, Konica Infrared, 25A filter*

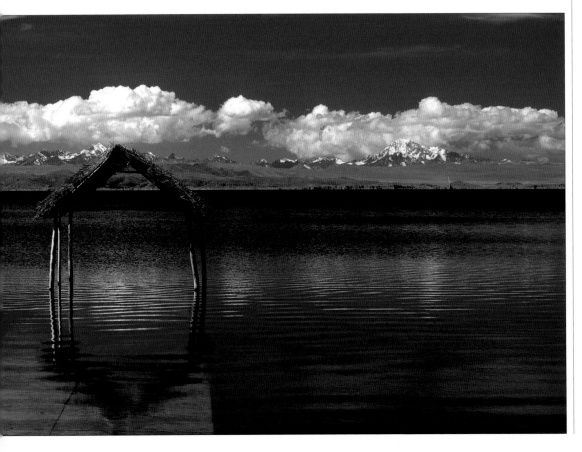

Viva Cuba!

Havana is the home of cigars, salsa and revolution and provides an inspiring setting for photographs with colour, character and originality

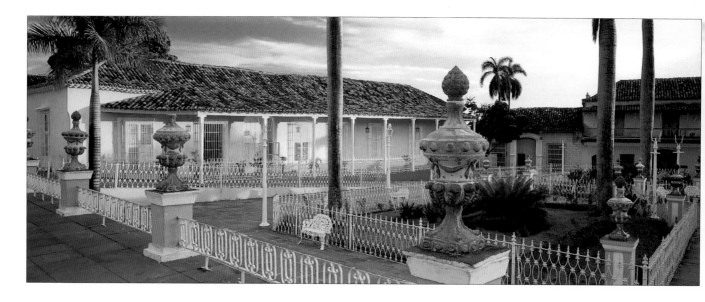

Above The small town of Trinidad is my favourite place in Cuba and I think this picture goes some way to explaining why. The soft lighting, colonial architecture and a distant palm tree combine to convey an ambience that is thoroughly laid back
Hasselblad X-Pan with 45mm lens, Velvia, 1/2sec at f/22, tripod and polariser

Right Like a stage set, these rocking chairs and partly open door, suggest the entrance of two actors who will sit down and talk away the day – act one, scene one...
Hasselblad X-Pan with 45mm lens, Fuji RMS100/1000, 1/15sec at f/22

IN AN ALMOST plaintiff operatic tone my Cuban friend, with arms outstretched, pleaded with me to understand the predicament of this remarkable island and its people. 'No money, no money!' he said, as we passed by one of the ration shops that appeared to me to be empty except for a few bars of soap stacked in plain wrappers on wooden shelves.

Cuba has no money, at least 95% of the Cuban people have no money. This island, full of contradictions seems to have one foot in its turbulent and tragic past and the other in a future that remains uncertain and yet is full of hope. The Cubans, with ancestors of slaves and nobles are generous, high spirited and astonishingly resourceful. Few of them have 'kept the faith' as laid down by Fidel Castro and Che Guevara in 1959 (over a million have turned their back on their country since the revolution and now reside in

Florida), but education is arguably the best in the region and literacy remains high.

Despite very considerable deprivation, Cubans have retained a very real sense of identity which remains strong. My guide was a printer by trade and I could not

understand why he appeared to have so much free time. 'The embargo,' he replied, 'No paper, nothing to print on!'

We discussed many topics as we strolled around some of the less visited streets. Of course, the architecture is of great interest to

JAN BOON

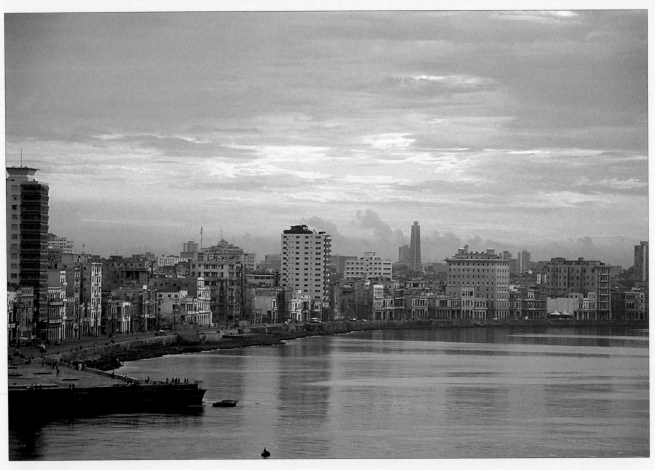

Occupation
Co-ordinator
Photographic experience
Very little! Prior to this trip I tended to keep the camera in program mode

Charlie had taken the troupe to one of Havana's forts across the bay so that we could get a view looking back at the city. The rain had finally stopped and the mist was rising, so eager to take my first ever shot using a tripod I set up the camera and scanned the horizon looking for a view that reflected the diverse Havana skyline. I liked the sweep of this part of the bay with the reflections and felt the tall buildings on either side of the bay held the photograph together.

Had the light not been fading so rapidly I would have waited for the small rowing boat in the foreground to move. Since taking this picture I have learned more about using filters and grads, so probably would have used an 81A to enhance the evening warmth.
Nikon F70 with 24-120mm zoom, Provia 100F, 1/60sec at f/16, tripod, but no filters

CHARLIE'S VERDICT

Firstly, the composition of the great sweep of the Malecon (the sea front) is very good. I like the way Jan has used a part of the least attractive building to act as a block for the left of the image.

Over to the far right she has ensured that the distant tower block does the same job despite being far away. Sadly, the light was not so favourable that day and my feelings are that the steely grey late afternoon light does not have the right feel for the exotic and colourful reputation of Havana.

Here would be a perfect opportunity to use quite an extreme warm-up either upside down perhaps to romanticise the buildings, and possibly a very mild warm graduated (of a different nature to the upside down one used for the buildings) for the sky. An overall warm-up would show no distinction between the land and the sky, this is one of the poverties of placing a warm-up over the entire lens... everything gets warmed.

The great key to skilled filtration is modest and careful use. Ultimately there should not appear to be too artificial a feel. I am convinced that while not altering the excellent composition, a little warmth (maintaining some differential between sky and buildings) introduced by some image manipulation software could help make this a very effective image indeed. I urge Jan to try.

Finally, congratulations for keeping an eye out on the little boat... an important touch.

visitors. Predominantly Spanish colonial, the great houses and civic buildings, many of them wonderfully eccentric, remain decrepit. Few of them are intact. Passing what looked like a building site my Cuban friend with both arms outstretched as if he had wished to have been there to save it, said with a resigned tone, 'It fell down last week'. The once splendid classical mansion with Moorish characteristics had just quietly slumped into itself during one rainy September evening. 'One raindrop too many', said my friend, resigned to such fates.

We walked through Vedado where many of the fine post colonial buildings are now used as museums and municipal offices. Everything is here from baroque, rococo and classical, each boasting unique features and yet all blending into a fascinating jumble of styles that any student of architecture and photography would find wonderfully rewarding. The once opulent Havana is now desperately in need of restoration. Work is being done but progress is painfully slow. One wonders, as

DAVID WILLIAMSON

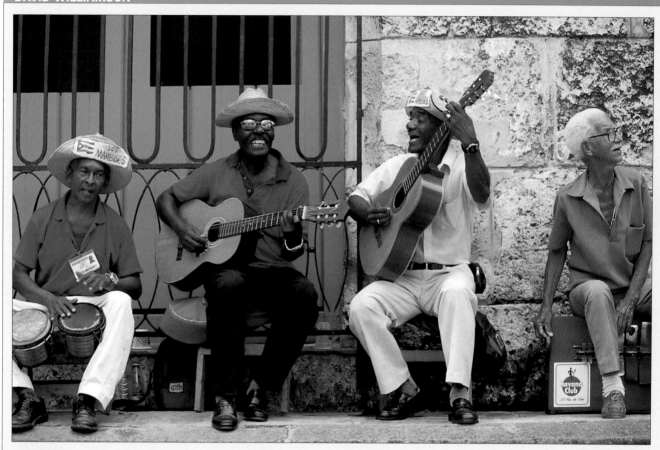

Occupation *McDonald's franchisee*
Photographic experience *Seven years, plus four Light & Land trips with Charlie!*

Despite having travelled to a number of war zones while an officer with the RAF, nothing had prepared me for Cuba, particularly Havana. Destruction is never easy to come to terms with, but decay on the grand scale of Havana is quite something else.

Cuba is in a time warp with many contradictions: decaying through communist neglect but breathtakingly beautiful; unimaginably poor but unquestionably happy. As a landscape photographer I felt uncomfortable without my tripod, cable release and slow film. I'm not used to holding cameras and shooting with fast film, my joy is in the composition and the time to acquire it. Therefore, Havana was a real challenge for me, as I had to think quickly, move fast and hide in the shadows. I chose this image not

necessarily for its technical competence, but for the joy of music that it portrays, which is the personification of Cuba. You cannot go more than 50 yards without hearing another band; music is Cuba's lifeblood, its soul and its salsa.

Rum is its elixir and I'm glad that its most popular brand, Havana Club, features so prominently in this photo. It's just a shame that the old boy doesn't have a great fat Romeo & Juliet cigar in his mouth!
Canon EOS-5 with 75-300mm IS telephoto zoom, Provia 400

CHARLIE'S VERDICT

This is an image that undoubtedly captures the flavour of the place. I can hear the music when looking at this image. The two central characters are wonderfully centre stage and looking at these two alone for the moment, the image is terrific, full of zest and song.

I very much like the background with the textured wall and the blue doors with bars. I would

imagine that this has been carefully thought out as it works very well. Good too that the shutter was released at a moment when the guitar did not mask the face of the musician in white. It could so easily have done so.

Always wishing to be constructive, I do wonder if the main thrust of the image is in fact to be found in these two central

musicians. I feel that the man in beige on the right is simply not part of the ensemble. He has no instrument and appears detached from the proceedings.

Across to the left, we have the man on the bongos. He does not seem to have the vigour of the two guitarists and perhaps having his right leg and part of the drum cropped diminishes the image? I

have tried cropping both the bongo player and the man far right leaving just the two 'stars' and I find the image in my humble opinion considerably more evocative.

Cropping is often frowned on with folk talking of 'destroying the aspect ratio'. My feeling is that if you think it will improve the image then crop!

DENNIS CLARKE

Occupation *Retired engineer*
Photographic experience
Fluctuating interest for many years. Interest rekindled five years ago by joining Chelmsford Camera Club

On the morning of our visit to Trinidad, Charlie suggested that we take plenty of fast films with us. My first thoughts were: 'the sun is bright, the houses and streets are colourful - why is fast film necessary?' But as the day progressed I realised the advantages. The streets were full of life and activity, every archway, courtyard and alley reveals a mini drama.

We first saw this old man silhouetted in a doorway talking to someone inside the building. For some reason these shots did not work, but Charlie exercised his charm and persuaded our 'model' to sit on the steps. I took many different shots and selected this one because, for me, it encapsulates the flavour of Cuba and that face has seen a million years.
Nikon F100 with 28-105mm zoom, Sensia 400, f/11

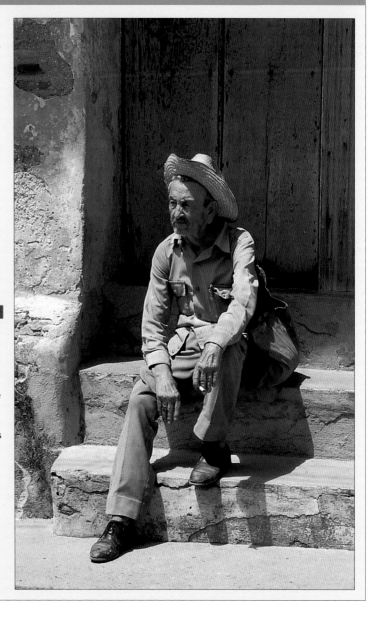

CHARLIE'S VERDICT

There is a resigned expression on the face of this old gentleman that looks fitting and congratulations to Dennis for managing to produce an entirely natural portrait. Its all too easy to make a portrait of a local but still fail to make the subject look unconcerned and unaware of the camera.

I like the angle of his head and the highlighting of the top of the hat, setting it off nicely against the dark grey/blue door works well. It appears to be quite a contrasty photograph, with the darkish skin and the bright areas between the steps. The shadows work well and the exposure is good. Half a stop more and the steps may have burned out, half a stop less and possibly the shadowed side of his face would have gone too dark.

I often think that squinting is a good way of determining the subject brightness range. If it is too great for the capacity of the film to record then adjustments have to be made.

The harmonious colouring seems perfectly right for this image and his tired looking expression tells a story, and a story being told by a still image is very much the key to effective portraiture of this nature.

with Venice, if these worn out and faded buildings were to be restored, which in time they surely will be, would Havana still retain the atmosphere of today?

As photographers, many of us are attracted to decay and dilapidation. When Havana is spruced up, I doubt very much that we will care for it as we do now. No doubt, the 1950's Pontiacs and Chevrolets will still be seen growling through the streets, continuing to defy the scrap yards.

We went on to speak of the difficulty that the visitor has in reconciling the discrepancy between salaries paid to the various professions: the taxi driver earning more than the doctor, the waiter more than the teacher. Then there are the restrictions on free speech, the law forbidding nationals to stay in tourist hotels, even if they could afford it. Much of the old Soviet bloc mentality is still very much operative in the administration of the country.

Cuba's jewel

Away to the southeast of Havana is one of Cuba's jewels - Trinidad. Settled within sugar plantations and pastures, this small town stretching across no more than three square kilometres is perhaps my favourite place on the island.

Here, the townspeople seem to just quietly go about their business seemingly unconcerned with visitors. This delightful town, settled in between the Escamgray Mountains is now declared a World Heritage Site, but despite its acclaim, the town has not become a tourist trap. Horses and mules are still used and this humble town is, arguably, the finest preserved in Cuba. For the photographer there will be a surprise around every corner and the evening light that graces the flaking and crusty ochre masonry is utterly lovely.

Cuba is opening up to tourists, there can be no denying that. While the United States still irrationally continues with the embargo, foreign currency is Cuba's salvation. We can be sure of one thing however, while Fidel is still very much in evidence, his departure will herald a further transformation in Cuba's history. McDonalds and KFC are already eyeing up the real estate!

White and shade

The play of light on the white painted towns of Andalucia requires an imaginative approach to exposure and filtration

SOUTHERN SPAIN is perhaps best known for the thousands of visitors each year who swarm down to the giant condominiums of Malaga, Marbella and Torremolinos. While these high spots offer certain things to many, I prefer to be high up in the hills some 80 or so kilometres inland from the tumult at the coast.

From the breathtaking Sierra Nevada in southern central Andalucia across to Arcos de La Frontera in the east, there is scenery that any lover of landscape photography can feast on. The ubiquitous olive groves provide some stunning patterns as they stretch out across the hills in impeccable order that could match the ranks of any infantry brigade.

All across this part of Spain, the Moorish influence is seen in every town, providing numerous arches and many a labyrinth of alleyways. At any time of day and providing the sun is shining, the photographer will find sharply defined strips of shadow, perhaps running across some church steps or up a doorway, all reminiscent of a Cartier-Bresson photograph – now there is a man who knew about shadow!

Andalucia is also known for its astonishing white towns. There are a few in particular that I am very fond of. Setenil, just a few kilometres north of Ronda, is remarkable for the way in which its small white houses seem to tumble down the hillside in a terraced fashion. A little further on

from Setenil is Torre Alhaquime, a small almost entirely circular village that looks from a distance like a giant deposit made from a passing seagull. It has no suburbs and sits quite perfectly in the landscape as if it has always done so. Torre Alhaquime represents classic Andalucia.

One of my favourite of the white towns has to be Olvera, a little further north from Setenil. I have been there many times and always wonder if a giant pot of white emulsion has been spilt across the hillside. Seen from the road to El Bosque, Olvera is a shining white beacon and, with late afternoon light raking across the landscape, the entire town is thrown into marvellous relief.

Below Evening view of Antequera, a perfect shape for the panoramic format
Fuji 6x17 with 300mm lens, Velvia, polariser and 81C warm-up filters, one second at f/45, tripod

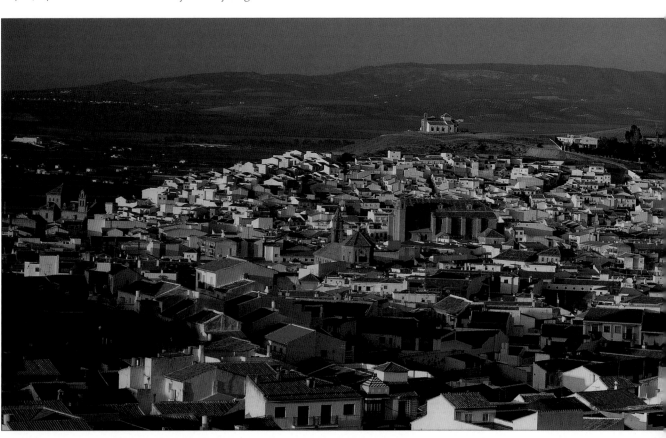

The great bonus from photographing the white towns is, of course, the low contrast. Each white building, which throws its white neighbour into shadow, is perfectly filled in by reflection. The whole town is comprised of reflectors.

On a recent Light and Land trip to Andalucia, I was often asked whether to open up the exposure to compensate for the extreme brightness of the white villages and towns. It occurred to me that to compare an overall snowy alpine scene with the brightness of the white towns would be incorrect. Snow is 'blindingly' bright and the camera meter is always determined to peg it to an 18% reflectance – we have all known and despaired at our grey snow!

However, the white towns of Andalucia, often broken up by light absorbing matt terracotta roofs are different. They will be nowhere near as bright as snow and therefore if any increase in exposure is necessary, it will be just a half to two thirds of a stop at the most, and certainly no underexposure.

Some years ago, I spent a happy hour or so waiting for evening

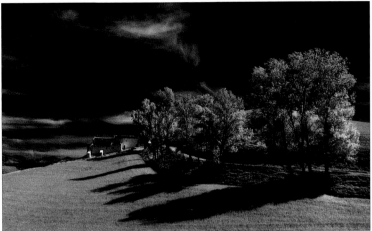

Left White house and trees west of Ronda, tailor-made for monochrome, especially on infrared film
Konica Infra Red ISO 25, with red filter, 1/15sec at f/16, printed on Ilford Multigrade 4

light to fall on a large town called Antequera. It has an elongated shape, lending itself to panoramic treatment with a peculiar face shaped hill to the right behind. As we know, film does not see the colour quality of light as we do, and with this in mind, I remember not being sure whether the prevailing light at that time of day would be warm enough. Consequently, I chose to warm the entire town and sky but felt an 81C would be too much. The sky would be unsatisfactory as whatever blue light radiation there was would have been eaten up by the amber filter. It was in this

situation that I subsequently learned to warm from beneath and leave the sky unaffected.

Andalucia has its fair share of hilltop dwellings. Unlike Tuscany there are few cypress trees here punctuating the landscape, but in the springtime the pale and translucent leaves of the gum trees lend themselves beautifully to black and white photography. If a good sky is on offer with high cirrus then much enjoyment can be had.

I have one regret from this most recent photographic workshop in Andalucia: I saw no Flamenco. Ah well, maybe next year!

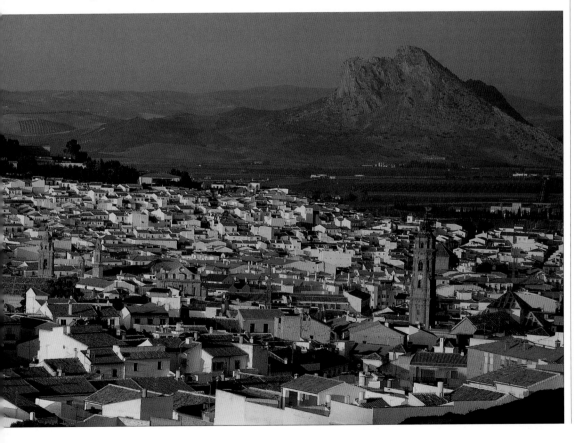

Cypress avenue

A classic winding road in rural Tuscany is an inspirational setting on a beautiful late spring day

Right The dynamic sweep of the bends in the 'wiggly road' near Monticchiello gain added emphasis when cropped to an upright format from the original 6x4.5cm format landscape *Hasselblad with 250mm lens, Provia, 1/15sec at f/16, polariser and 81A warm-up filter*

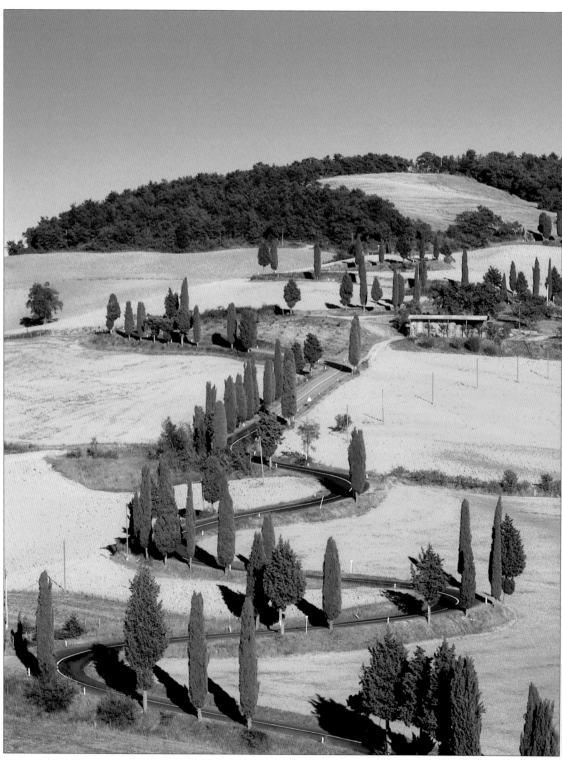

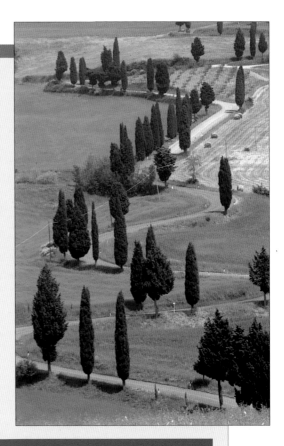

LYNN TAIT

Occupation
Publisher and retailer
Photographic experience
Serious interest for nearly five years, helped by City & Guilds courses

'My instinct on the view of the wiggly road was that it was a portrait, tightly cropped composition, rhythmical, graphic and an obvious triangular shape. It would be a challenge. Having decided on this interpretation, I then began to look at it as an abstract pattern, so out went the barns, cars, sky and any other distraction, such as stray grasses close to the front.

The success of the image would be decided by how I could lay out the pattern without cropping parts of the trees. As the trees were the strongest feature and held the pattern together as full stops, I had no problem with cropping the road because this was just giving the impression of the movement of the curves. It was important to get as high a viewpoint as possible so a ladder gave me the extra height to allow the road in the bottom right hand corner to sweep into the photograph and then the eye would follow up the curves like a helter skelter.

Having finished on the exact position a check was made for wires, light patches and making sure the horizon was straight, also allowing for 97% of the slide being visible as the composition was critical. Other components that added to the aesthetics were the diagonal shadows of the trees at each junction. Of particular concern was the base on the left hand side which filled the frame. Obviously, the base of the triangle was the widest part and the denseness of the shadow helped to hold that corner in. The bales also added a contrast in colour, texture and shape, neatly in the top one third of the picture'.
Canon EOS 5 with 300mm lens, Velvia, 1/4sec at f/32, tripod

CHARLIE'S VERDICT

The rhythm of this image is very well conveyed through the trees sweeping up to the top of the frame. The first two curves of the road have been cropped I know intentionally and unless a wider lens had been used allowing more judicious cropping, this was possibly the only way of handling the composition. I have no idea why curves and zig zags have always appealed to me especially when they occur naturally in the landscape. Here of course the road is man made but the graceful shapes are none the less appealing. Only a small issue, but perhaps it would have been nice to have held the tops of the trees at the top of the frame although the loss of them in no way diminishes the impact of this strong image.

THIS WAS AN *On Location* with a difference. As I was to be in Tuscany, leading a trip with Light and Land, it was impossible for me to get to a location in the UK. Why not, then, pull names out of a hat so that three participants could join me On Location, Italian style! In truly civilised fashion, the photographs were made just before a picnic lunch on the outskirts of the hilltop village of Monticchiellio.

The back road from Montipulciano to Monticchiellio is uneventful until you descend a series of sinuous bends delineated by the ubiquitous cypress which stand proudly along the entire distance. It is quite probable that if you were to innocently drive along this road, you would have no idea of its fame and reputation. It takes no more than four minutes to travel along and is no longer than 500 metres. As you twist and turn your way down, there is also a strong possibility that someone is taking your picture, for this is arguably the most photographed road in Tuscany.

I first came across the 'wiggly road' of Monticchiellio along with a good few others some time in the very early 1980s. I was by no means first, as a few Italian landscape photographers had produced postcards carrying this image. I think I can say with some confidence that pretty well every professional stock photographer on a shoot in Tuscany will have

Left Lynn uses a step ladder to gain extra height and keep the field of oats from intruding into the foreground of her picture

'I would be the first to say that this image is not handed to the photographer on a plate'

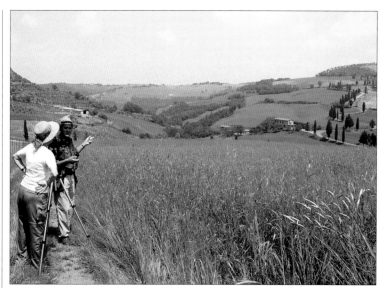

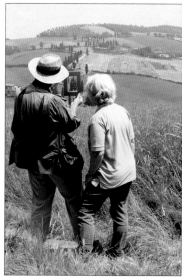

Right This shot of Charlie and Desiree shows the proximity of the road to the viewpoint that Charlie and the readers chose for their pictures

Far right Charlie and Sandy check the view as it looks cropped by Charlie's masking frames

photographed this road. It has been photographed in every season, with every conceivable crop in the foreground. In wideangle, tight close up, in snow, in forbidding light and with the wonderful creams, yellows and beiges of winter soil. This little scene is to many minds an image of quintessential Tuscany.

I have seen countless car commercials of this humble little road, often showing only a two second sequence and frequently drenched with an 85B filter. This serves to romanticise the notion of our driving the same car, lover by our side and all bathed in a warm, Mediterranean light that resides more in our imagination than in reality. Two seconds is not long enough to detect the crass use of filtration. A day earlier I had seen the new Mini Minor twirling down this road and yes, there was the photographer crouching amidst the crop on the hillside.

This image is not handed to the photographer on a plate. There are numerous 'contaminants' that prevent the image from being as perfect as one would like. A non-Tuscan looking barn sits at the bottom left and is, annoyingly, too near the first bend. There is a charmless open barn up near

DESIREE JACKSON

Occupation *Social worker*
Photographic experience *Interest in landscape since the late 1980s, in particular the Kinloch and Rannoch areas. Member of local camera club*

'When I first saw this location I was impressed by the sinuous coil of the road and the cypress trees standing sentinel alongside. The photograph was taken at midday when the sun was overhead and the light was vertical and white. To redress this I decided to cut out the sky altogether as it was too bland.

Based on my reading of Charlie's books, I decided to use a 81B warm up filter to romanticise the picture and give some colour and texture to the surrounding landscape. I also decided to use a 180mm lens from a high viewpoint which, while not flattening the persepective too much, helped to bring out some definition in the trees and emphasised the coil of the road.

I feel that the finished result was a strong image, given the conditions and timing of the photograph, and goes some way to giving an indication of the shapes, textures and recessions in the scene. However, I would love to take this photograph in the evening when the low light would have created the sculptural shadows that were needed to dramatise the trees in the relationship to the road.'
Nikon F4 with Nikkor 180mm f/2.8 lens, Velvia, f/22 plus 81B warm-up filter, tripod

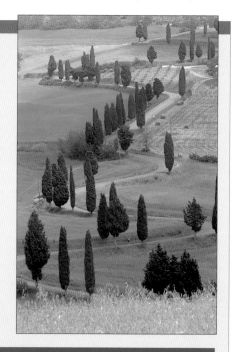

CHARLIE'S VERDICT

Again, the fist two curves have been cropped but I am aware that the barn top right and another bottom left would have appeared if this radical crop had not been made. The tall cypress tree standing on the edge of the first right hand curve might have been nice (if it were possible) to keep as it would have then helped to have delineated this part of the image better. A little space the other side though may well have revealed the unwanted barn. We were all frustrated by the crop in the immediate foreground which was hard to make harmonise with the remaining body of the image. We could have marched into the crop but I am a firm believer that unless permission has been granted, landscape photographers should have great respect for things growing. I like to think my colleagues would agree.

SANDY WOOD

Occupation *Retired GP Practice/Fund manager*
Photographic experience
I always wanted to paint but was useless so four years ago I decided to take up photography and let the camera paint for me. Learning through evening City & Guild courses

'I decided to shoot in black & white because the cypress trees in Tuscany seem to be exclamation marks in the countryside. I hoped that these would appear black to help define and accentuate the bends. There were two distinct problems. One was that the whole road would not fit a 35mm format. Either the sky came into the top of the picture or some of the bends would be cut off – everyone knows Charlie hates anything being cut in half!

My second problem was that I am not tall and the oats in the field were too high for me to avoid in my viewfinder. I decided to use the foliage as a base for the picture and tried to disguise the start of the road. Unfortunately the farmer would not allow trespass in and 'weeding' of his crop. A rather long, straggly stem of wild oats is annoying in the foreground but it has partly hidden a clump of round trees which detract from the cypresses lining the road.

I know the foreground is quite dominant but I quite like the road not being too evident and disappearing into the distance. The hayfield on the right is very distracting and the telegraph posts and cable stretching across the picture are an unavoidable fact. I would love to go back and have another try, but this time with a long pair of secateurs to weed the field!'
Minolta Dynax 700si with 70-300mm Sigma zoom lens, Ilford Delta 400, f/22, green filter

CHARLIE'S VERDICT

I think this image lends itself very well to Black and White and I am so pleased to see that we have one here. There was very little contrast on the day and this print has been made to try and compensate for that. We all had wished for longer shadows but in late spring and of course at lunch time, these were not to be. There seems to be a very bright patch of newly cropped grass at the top right and this seems to distract a fair bit from the strength of the tree pattern. I like the way in which the line of the trees continues on giving the image good depth. The foreground, whilst being of a different nature to the remainder of the photograph, seems to blend well with the remainder although I wonder whether there may be a square image to be made here. I am not sure whether the bit of 'rogue' grass enhances the overall feel though.

Below Wine, women and Charlie... the On Location team pose in a vineyard on the day of the shoot
ALL PICTURES, UNLESS OTHERWISE CREDITED, BY JULIE HULSE

the top right corner, when I would rather have continuous flat ground going up and over and beyond. Many a time, also, I have seen the scene with a poor sky, reducing the choices and forcing it to be cropped out of the image altogether.

From the higher viewpoint, the pleasing rhythm of the road often conflicts with the hard horizontal line of the foreground crop, which denies us a clear view down to the first bend on the right.

I shall always be drawn back to this spot, though, in the hope that perhaps I can time my visit for the shadows to be longer and perhaps with an unknown photographic surprise lying in wait for me.

Many more car commercials will be made here and no doubt countless more stills, ensuring that the wiggly switch back road of Monticchiellio remains as much in vogue as it ever was.

Two of a kind

A photograph's ability to tell a tale is shown to great effect in these two images taken from Charlie Waite's book *In My Mind's Eye*

'I waited while a micro moment of live theatre unfolded in front of me'

Some time ago, a good friend of mine invited me to Pennsylvania to visit Amish country. I had no idea what to expect and, while I had seen the excellent film *Witness* a few years earlier, I was on the whole unfamiliar with these people.

While I have photographed many people with their permission, I am always reluctant to photograph people without it – it seems invasive and somewhat intimidating for the individual concerned.

Within a few hours, I had set up my tripod and was soon witness to a wonderful sight. Not one hundred yards away I saw six muscular shire horses pulling a plough, with the Amish farmer standing firmly on the back controlling the procedure. On seeing me, he snarled and bellowed across the rutted field: 'Don't you have anything better to do than photograph me?' In an instant, I felt like throwing my camera away. I had brutally intruded upon this man's way of life, and I felt quite guilty. However, the contrition, while sincere, could not have lasted, as later that day I went back and did it again!

The second time I was further away, and there was a group of Amish people walking towards a barn where they were about to participate in a Sunday gathering. The light was poor, but for once – I never thought I would say this – light had no relevance. I cared that there was enough for simple illumination, but, on this occasion, the quality of light was of little significance. The way in which the 'buggies' had been seemingly marooned was pure heaven. I remember praying that the owners would leave at least two of them set off against the white barn. The carriage far left, with its lopsided tilt, was perfect, and when the owners walked away, leaving this wonderful composition, I could have hugged them.

Then it was the turn of the congregation. I hoped that they would remain separate – if they bunched up they would create a black mass that would be distracting to the viewer. As they marched towards the building, I had perhaps 30 seconds to act, but it was still long enough to enjoy the decisive strides they were making. From the man at the head of the line, with his right heel up indicating natural motion back towards the two in conversation, to the stragglers – it all seemed right. Even the small black window above the first man left me feeling content.

Were they aware of me? Of course they were, but the resentment they felt was perhaps dissipated among them.

Nevertheless, I enjoyed what I had learnt making this image. All the components of triangles, rectangles and circles offset one another perfectly and set the stage for the arrival of the human form. As I watched, a micro moment of live theatre unfolded, and prevailed for a fleeting moment. That moment quite delighted

Right Amish men walking to a Sunday gathering, 1999
Ricoh GR1S compact with fixed 28mm lens, Kodak T400CN

Left Siena Italy, stone steps, 1982 Hasselblad 500C with 40mm lens, Kodak Tri-X, eight seconds at f/22

me, and I thank my friend for inviting me to Pennsylvania. I have always been the type of person to sneak a look through a door, or follow an avenue of trees to see where it might lead. About a year or so ago, my curious nature led me to chase a pair of nuns around Siena in Italy! On another occasion in this glorious city, I found myself wandering around the streets. From a distance, I spied the small entrance to the mathematics department of Siena University.

I hoped that this austere tableau would lend itself to black and white, but unfortunately my arrival coincided with the students returning to class.

One of the things I like most about the photographs I admire is the mystery of what took place before or after the shutter fired.

My stone stairs, still shining from the wet, were being leapt up two at a time by perhaps 50 students as I waited in the hope of achieving a long exposure. Finally, the moment arrived when the staircase was empty, and I made my exposures.

Having spent a long time at the scene, I became intrigued by the giant central pillar. To be awarded such prominence it was clearly of great structural importance, and yet it seemed to disrupt the continuity of the staircase. It related to the smaller perpendicular plinth on which the slightly grumpy lion sat, and of course the stone balustrades. However, my main pleasure was to be found in the stairs themselves.

I was thankful for the artificial light spilling through the lattice grill at the top of the staircase. It seemed to prevent an 'end' to the ascent, and provided a welcoming light.

As I collected myself together, the cloud gave way to sun, and contrast swept through the setting, leaving deep blacks and bright whites.

I have since been back to the staircase, and found it all under scaffolding. The walls were being restored, the large dominant pillar was being rendered and the lion, while not dislodged, seemed to be just a little grumpier.

Venetian blind

Venice triggers a flurry of superlatives from visitors as they struggle to describe it, but sometimes it is more effective to let photographs do the talking

Right It was before 9am in the cool light of a January morning when I composed this scene of calm, a composition that many others would miss in their eagerness to make the Bridge of Sighs – just above and out of frame – the subject of their attention

Nikon F5 with 80-400mm Nikkor zoom at 150mm, Velvia, 1/2sec at f/22, tripod

VENICE COULD ALMOST be a city dreamed up in one's imagination, a celestial city that might be described in some fictional fantasy tale.

For visitors today, it is inconceivable how the magnificent and formidable palaces and mansions that flank the Grand Canal were constructed. Every stone, whether it abuts its neighbour to form the graceful arch of one of Venice's four hundred bridges, or sits high above as part of an elaborate facade, rests upon a vast network of wooden piles driven down to a base of clay and sand.

The architecture seems at first sight to blend into a homogeneous whole but any specialist of Venice would know that the styles are based on a remarkable mixture of influences that have shaped the city over hundreds of years.

Anyone who has been to Venice remembers their first impressions of the delicately balanced gondelieri, with his single oar and his expert twist of the wrist as he drives his familiar shaped craft through the labyrinth of waterways. Or of a fog so dense that an approaching figure materialises like a spectre from its midst, only to vanish in a moment.

The key to photography in Venice is to attempt to enter into the imagination of the person who has never been to Venice, to make an image that corresponds to that person's imagined idea of this astonishing and unique city. Surprisingly, it seems to become necessary to romanticise the image of Venice despite it being

already outrageously romantic. Slow exposures suggest the ethereal nature of the place and a wisp of colour set against some of the monochromatic stonework can be effective.

The network of canals that weaves through the city provides much photographic contentment. An hour spent leaning against an arch, camera in hand, will often yield reward. It occurs to me that with

AUDREY MCGEOGH

Occupation *Retired school teacher*
Photographic experience *Always been interested in photography, but soon after becoming a member of a photographic club began searching for more subtle images rather than record shots*

'When I first visited Venice many years ago I loved it and thought it was a unique, magical place. Since then I have returned several times, the last visit being four years ago. On that occasion it was so overcrowded I decided, 'never again!' All this changed when I saw that Charlie was taking a Light & Land

group to Venice in January when it would be so much quieter. From previous holidays with Charlie, I knew how well organised things would be. Being one of only two people walking through St Mark's Square at 7am on a misty Sunday morning was an experience I shall never forget.

In order to take this picture of gondolas I set up my tripod and camera while it was still dark and waited for dawn to break. Thereafter, it was a race against time to take atmospheric images before it was broad daylight. Waves from passing boats meant that the gondolas were constantly on the move.'
Canon EOS 500N with Sigma 28-200mm zoom lens, Velvia, exposure not recorded, 81B warm-up filter, tripod

CHARLIE'S VERDICT

Many of those who visit Venice find the rocking motion of the gondolas moored along the Riva degli Schiavoni completely irresistible. End on and fanned out, each with their pointed shadows rushing toward the lens, they offer the photographer some wonderful opportunities for long and multiple exposures. Perhaps Audrey might have been a little more daring and allowed a longer shutter speed. She was dedicated enough to get up early and has positioned her camera perfectly. The

lamp, with its accompanying subtle reflection, prevents the image from appearing too flat and the distant lights in the background immediately lend depth to the work. Although some people may find the overall magenta cast unappealing, this does not diminish the image one bit for me. Reciprocity law failure is often the reason for this and is not filtered out intentionally by some. Again though, we are not looking for a record of what the gondolas looked like, that could result in

something sterile and uninteresting. Venice is an impossibly difficult city to photograph. There appears at first to be so much choice but in time one realises that it is not enough to just point the camera at the Bridge of Sighs or a grouping of gondolas in the hope of making something magical. Being selective is the key and a good rule is to keep the image simple. The image here has that simplicity and consistency of shape that contributes toward its success.

photography of any kind anobjective has to be defined before application begins. The potential image must, to a degree, reside as clearly as possible in the photographer's imagination so that

when that idea as to how the image may materialise becomes reality, the shutter can be confidently released. In short, what the mighty Ansel Adams termed 'previsualisation'.

Away from the bustle of Venice lies a number of islands and, passing the famous cemetery, the 'vaporetto' (the people's water public transport) eventually arrives at Burano. The Venetians like to

joke with visitors when they ask to be taken to Burano. 'Don't you mean Murano, for the glass?' One letter exchanged to satisfy their lighthearted jesting.

Burano is a child's toy town. Perhaps no more than a few hundred small two up, two down houses closely lining the edges of canals. If they were of uniform colour, then they would look perhaps quite drab. But the houses of Burano are far from drab. The residents are proud to paint their fairly humble dwellings in every conceivable colour. Flaming

Left David's customised cable release used with his tripod-mounted Contax 167

DAVID JACKMAN

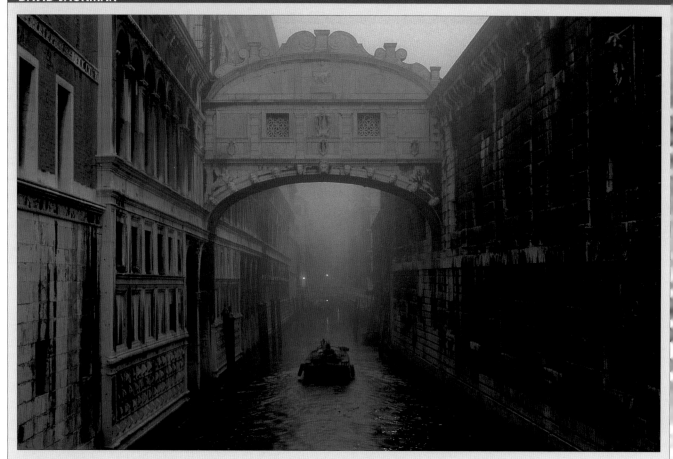

Occupation *Retired electrical engineer*
Photographic experience *Several years, seriously since 1998. Member of Taunton Camera Club*

'I've photographed the great outdoors during many walking trips in the past but always needed more kit than was sensible to carry. Therefore, dedicated photo trips have been the answer for me, especially landscape work. Venice was my sixth trip with the Light and Land team – all have been great. I use secondhand Zeiss and Tamron lenses with my old Contax

167 and 139 cameras. I've made a brace for the 139 and telephoto zoom to balance the outfit better on the tripod. A cable release is another cheap innovation.

Venice was cold and foggy – maybe one day I'll see it in a different light. I chose this morning shot of the Bridge of Sighs as it sums up my first impressions of this city with its inherent water transport system.

Long exposures, warm-ups, etc were necessary for these conditions — polarisers and wideangle lenses were unusually redundant for me on this occasion.'
Contax 167MT with Tamron 28-70mm zoom lens, Velvia, 1/4sec at f/11, 81B warm-up filter, tripod

CHARLIE'S VERDICT

Thick mist with only a few yards visibility would defeat most photographers but in Venice, the mist lends a sense of mystery and can often be more interesting than harsh light with dense shadows. In most photography, there should be something that awakens the imagination. Pure record photography does not activate this part of the human consciousness. There is a good story told here in David's image. Even the hint of light from a distant street lamp helps to conjure up a mood. The vague shape of the barge leaving the viewer is quite enough to bring the image to life. It's a dark image but full of meaning. There is a very good monochrome feel as well, which is entirely appropriate. In terms of light and shade, there is just enough to resolve the shapes and all in all, I think the image works very well.

LIS LONG

Occupation *Management consultant* **Photographic experience** *Interested in photography since about 10. Started taking it more seriously about three years ago and now spends much more time on it*

'Venice was wonderful and particularly so for being almost without tourists. It was completely freezing, however. Our hotel was both very central and well centrally heated, which meant I fell out of bed in the early morning thinking it was warm and put on far too few clothes before going out at dawn. An hour or two later I came back chilled to the bone and with no feeling in fingers or feet!

This photograph was taken around 7.15am, looking east under the bridge over the Rio delle Procuratie, just north of St Mark's Square. I loved the perfect reflection with its soft cream and terracotta and yellow tones, and it got better when the water became a little disturbed as the occasional early morning commuters came up the canal. I first took several photographs of the whole bridge with its reflection, but I couldn't fit the complete circle in – and there was also a gondola moored at the right of the picture with a very bright green tarpaulin, which was distracting. So I concentrated on the reflection only and used a longer lens which got rid of the green tarpaulin but left the reflection of one gondola in for a bit of identifiable local colour. Ideally, I would have moved a bit to the left, but I couldn't do that without falling into the canal!'

Mamiya 645 with 300mm lens, Velvia, 4sec at f/22, tripod

CHARLIE'S VERDICT

This is a radical departure from all the images that I have seen of Venice over the years and one that is bold and wonderfully impressionistic. It clearly is a reflection and brings with it a lot of the fantasy feel of Venice. At first, it reminded me of a cathedral with gothic arches to the right. Then I investigated it in depth and saw a negative shape reminiscent of the prow of a gondola and what appears to be the intricate design of a wrought iron bridge. The square of bright light lifts the entire image and the whole scene has become impressionistic and in my view dramatic with all the verticals stretched and distorted. The point is that it does not matter if we are unable to identify certain features. That was not the intention of the artist. She meant this image to represent her own visual response and the fact that her work seems far away from reality is entirely fitting. After all, Venice herself seems barely real.

crimson next to canary yellow. Deeply saturated lilac in one adjacent to a dark maroon, and gorgeous blues of every description make Burano a true delight.

It is a perfect location to check various chrome films to see how they compare with the rendering of colour. Each of these colour blazing houses carries its own reflection down to the water beneath where the colours mingle and mix together. This is where the photographer can have much fun.

To a degree it is all trial and error. The unpredictability of this sort of photography can be something of a departure from the measured, almost sedate nature of landscape work but it's good to try.

On our Light and Land visit to Venice earlier this year, we returned with memories and images, not of streaming sunshine, but of mist and muted colours. Nonetheless, they were evocative of the place, and perhaps offering another view of this truly unbelievable, astonishing, and almost mythical city.

Below David holds up the ubiquitous viewing card to assess a composition in Burano

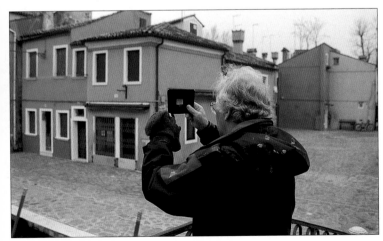

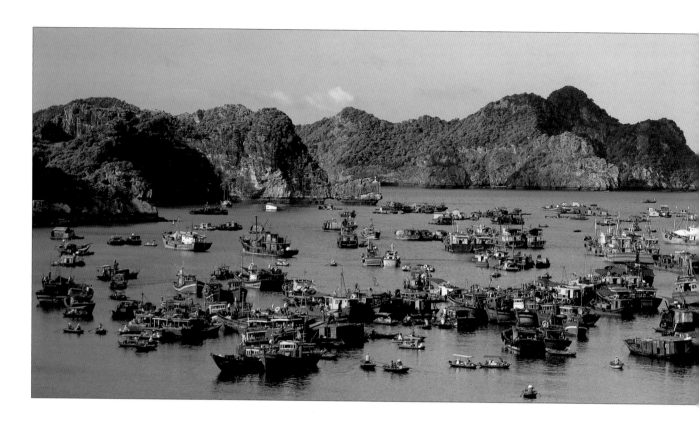

Above Cat Ba Harbour, a tangle of boats and activity, where hundreds of people live afloat on the north east coast of Vietnam

Peace mission

A visit to Vietnam provides diversity, dramatic weather and an insight into a country now at peace with itself

A FEW MONTHS AGO, I was given a commission to photograph in Vietnam. The photographs would be used to mark the 25th anniversary of the ending of the Vietnam War. It was not until I had read more of the agonising history of the country and its people that I realised that war (not just 1965 to '75) was something that they had become used to over many years in their quest for sovereignty and independence.

First impressions always linger in the mind and I remember thinking that the roar of the thousand strong mass of 250cc motorcycles, waiting at the lights in Ho Chi Minh City (Saigon as was), made a grand prix grid look as if there had been a mass retirement. The driving was more about bluff and counter bluff rather than the familiar formal arrangement of each side of the road being designated for traffic going in a separate direction. Pedestrians took their chances.

The dusty city air is kept at bay by makeshift handkerchiefs stretched triangularly across the faces of the straight-back, elegant lady bicyclists, their dark glasses giving them a sinister appearance of masked bandits. Within a few hours we were away from this frenzy and standing on the edge of the mythical Mekong Delta. This vast delta with its ribbons of waterways has not a single hump within it, no rise or fall. All flat paddy fields to the horizon, presenting a real challenge to a landscape photographer!

We had gone intentionally during the rainy season in the hope of seeing some majestic, forbidding cloud

Right A timeless scene – women mending nets in the Mekong Delta

Arriving in Cat Ba, was akin to greeting a family I had never met. An entire aquatic community exists on the surface of the water and feeds from its depths. Unlike a scene in Cowes of moored inert £100,000 yachts, Cat Ba harbour, safely tucked into the southern coast of Cat Ba Island, was a tangle of boats and activity. Oval reed and bitumen tub-like coracles were ferrying these water people to and from the quay to their boats. The essentials of tobacco, soap and vegetables being supplied by a couple of fully laden grocery boats skilfully weaving through this water city to sell to the residents.

The famous limestone peaks of Guilin in southern China are rightly challenged by the immense towering peaks that punctuate the South China Sea around Halong Bay and the waters to the north west of Cat Ba. Japanese-owned pearl beds lie awaiting harvest and locals from Cat Ba can be seen casting nets by hand for a catch in this almost theatrical setting.

Our guide, inappropriately called James, pointed to a slim channel through the rocks and casually told us that it was from here in 1989 that he set off in a small boat with his family of five for Hong Kong – rowing! The journey took 23 days. After two hurricanes James and his emaciated family arrived, only to join a further 56,000 fellow Vietnamese languishing in camps. Here, James explained, 'I learned English. We were given three meals a day and one orange. I paid for my English lessons with my oranges!' James remained with his family in the camps for five years.

formations. The weather did not disappoint. When it rained, it rained so hard that it stung as it made contact with my head. Then there were the electrical storms, strangely unaccompanied by thunder. That absolute whiteness of the lightning was constant with perhaps a hundred flashes a minute as they flared across the sky.

Here, we photographed the people who knew nothing of city life, living as they do among the dense reeds and coconuts palms that flank the waterways. The country, once so unnaturally split, was to have six images taken from the south and six from the north. After a week in the Mekong, we flew north to Hanoi, a name that would have resonance with anyone born post 1950. Hanoi is a very different city to the tumult of the southern Ho Chi Minh City. Here was the elegance of French colonial buildings and the broad tree-lined boulevards that could only have come from French architects and engineers.

As I left Cat Ba behind me, sweeping away on an ancient Russian-built hydrofoil, the rude shrill of the mobile reminded me that I was soon to return to the questionable affluence of my north European mother ship. A few kilometres from the airport I saw a couple of water buffaloes and their owner strolling sedately into a petrol station. This was my last and abiding image of a country slowly emerging from the hideous ravages of many years of war and foreign occupation.

Approaching the airport, I saw dozens of high flying kites floating against a background of pink cumulus cloud. Children's hands were grasping the strings and the scene seemed to speak of a freedom which the Vietnamese people may now be allowed to enjoy.

Below Time for a breather, cycling with these loads is such hard work! South of Ben Tre, Mekong Delta

ABOUT THE AUTHOR

Charlie Waite began his prolific career in photography when he turned his hand to making images of his fellow thespians during his early days as an actor.

He took up photography as his full-time occupation when he was commissioned to provide images for the *National Trust Book of Long Walks*. Many successful books have since followed, featuring the landscapes of Britain, France, Italy and Spain. He has also worked with a variety of bestselling authors, including Jan Morris, Adam Nicholson, A.N. Wilson and John Julius Norwich.

Charlie travels all over the world leading photographers on dedicated holidays and workshops with his company Light and Land.

INDEX

GMC TITLES

WOODCARVING

Beginning Woodcarving	*GMC Publications*
Carving Architectural Detail in Wood: The Classical Tradition	
	Frederick Wilbur
Carving Birds & Beasts	*GMC Publications*
Carving the Human Figure: Studies in Wood and Stone	
	Dick Onians
Carving Nature: Wildlife Studies in Wood	*Frank Fox-Wilson*
Carving on Turning	*Chris Pye*
Celtic Carved Lovespoons: 30 Patterns	
	Sharon Littley & Clive Griffin
Decorative Woodcarving (New Edition)	*Jeremy Williams*
Elements of Woodcarving	*Chris Pye*
Essential Woodcarving Techniques	*Dick Onians*
Lettercarving in Wood: A Practical Course	*Chris Pye*
Relief Carving in Wood: A Practical Introduction	*Chris Pye*
Woodcarving for Beginners	*GMC Publications*
Woodcarving Tools, Materials & Equipment (New Edition in 2 vols.)	*Chris Pye*

WOODTURNING

Bowl Turning Techniques Masterclass	*Tony Boase*
Chris Child's Projects for Woodturners	*Chris Child*
Contemporary Turned Wood: New Perspectives in a Rich Tradition	*Ray Leier, Jan Peters & Kevin Wallace*
Decorating Turned Wood: The Maker's Eye	*Liz & Michael O'Donnell*
Green Woodwork	*Mike Abbott*
Intermediate Woodturning Projects	*GMC Publications*
Keith Rowley's Woodturning Projects	*Keith Rowley*
Making Screw Threads in Wood	*Fred Holder*
Turned Boxes: 50 Designs	*Chris Stott*
Turning Green Wood	*Michael O'Donnell*
Turning Pens and Pencils	*Kip Christensen & Rex Burningham*
Woodturning: A Foundation Course (New Edition)	*Keith Rowley*
Woodturning: A Fresh Approach	*Robert Chapman*
Woodturning: An Individual Approach	*Dave Regester*
Woodturning: A Source Book of Shapes	*John Hunnex*
Woodturning Masterclass	*Tony Boase*
Woodturning Techniques	*GMC Publications*

WOODWORKING

Beginning Picture Marquetry	*Lawrence Threadgold*
Celtic Carved Lovespoons: 30 Patterns	
	Sharon Littley & Clive Griffin
Celtic Woodcraft	*Glenda Bennett*
Complete Woodfinishing (Revised Edition)	*Ian Hosker*
David Charlesworth's Furniture-Making Techniques	
	David Charlesworth
David Charlesworth's Furniture-Making Techniques – Volume 2	
	David Charlesworth

Furniture-Making Projects for the Wood Craftsman	
	GMC Publications
Furniture-Making Techniques for the Wood Craftsman	
	GMC Publications
Furniture Projects with the Router	*Kevin Ley*
Furniture Restoration (Practical Crafts)	*Kevin Jan Bonner*
Furniture Restoration: A Professional at Work	*John Lloyd*
Furniture Restoration and Repair for Beginners	
	Kevin Jan Bonner
Furniture Restoration Workshop	*Kevin Jan Bonner*
Green Woodwork	*Mike Abbott*
Intarsia: 30 Patterns for the Scrollsaw	*John Everett*
Kevin Ley's Furniture Projects	*Kevin Ley*
Making Chairs and Tables – Volume 2	*GMC Publications*
Making Classic English Furniture	*Paul Richardson*
Making Heirloom Boxes	*Peter Lloyd*
Making Screw Threads in Wood	*Fred Holder*
Making Woodwork Aids and Devices	*Robert Wearing*
Mastering the Router	*Ron Fox*
Pine Furniture Projects for the Home	*Dave Mackenzie*
Router Magic: Jigs, Fixtures and Tricks to Unleash your Router's Full Potential	*Bill Hylton*
Router Projects for the Home	*GMC Publications*
Router Tips & Techniques	*Robert Wearing*
Routing: A Workshop Handbook	*Anthony Bailey*
Routing for Beginners	*Anthony Bailey*
Sharpening: The Complete Guide	*Jim Kingshott*
Space-Saving Furniture Projects	*Dave Mackenzie*
Stickmaking: A Complete Course	*Andrew Jones & Clive George*
Stickmaking Handbook	*Andrew Jones & Clive George*
Storage Projects for the Router	*GMC Publications*
Veneering: A Complete Course	*Ian Hosker*
Veneering Handbook	*Ian Hosker*
Woodworking Techniques and Projects	*Anthony Bailey*
Woodworking with the Router: Professional Router Techniques any Woodworker can Use	*Bill Hylton & Fred Matlack*

UPHOLSTERY

Upholstery: A Complete Course (Revised Edition)	*David James*
Upholstery Restoration	*David James*
Upholstery Techniques & Projects	*David James*
Upholstery Tips and Hints	*David James*

TOYMAKING

Scrollsaw Toy Projects	*Ivor Carlyle*
Scrollsaw Toys for All Ages	*Ivor Carlyle*

DOLLS' HOUSES AND MINIATURES

1/12 Scale Character Figures for the Dolls' House	
	James Carrington

Gardening with Wild Plants *Julian Slatcher*
Growing Cacti and Other Succulents in the Conservatory and
 Indoors *Shirley-Anne Bell*
Growing Cacti and Other Succulents in the Garden
 Shirley-Anne Bell
Growing Successful Orchids in the Greenhouse and Conservatory
 Mark Isaac-Williams
Hardy Palms and Palm-Like Plants *Martyn Graham*
Hardy Perennials: A Beginner's Guide *Eric Sawford*
Hedges: Creating Screens and Edges *Averil Bedrich*
Marginal Plants *Bernard Sleeman*
Orchids are Easy: A Beginner's Guide to their Care and Cultivation
 Tom Gilland
Plant Alert: A Garden Guide for Parents *Catherine Collins*
Planting Plans for Your Garden *Jenny Shukman*
Sink and Container Gardening Using Dwarf Hardy Plants
 Chris & Valerie Wheeler
The Successful Conservatory and Growing Exotic Plants
 Joan Phelan
Tropical Garden Style with Hardy Plants *Alan Hemsley*
Water Garden Projects: From Groundwork to Planting
 Roger Sweetinburgh

PHOTOGRAPHY

Close-Up on Insects *Robert Thompson*
Double Vision *Chris Weston & Nigel Hicks*
An Essential Guide to Bird Photography *Steve Young*
Field Guide to Bird Photography *Steve Young*
Field Guide to Landscape Photography *Peter Watson*
How to Photograph Pets *Nick Ridley*
In my Mind's Eye: Seeing in Black and White *Charlie Waite*
Life in the Wild: A Photographer's Year *Andy Rouse*
Light in the Landscape: A Photographer's Year *Peter Watson*
Outdoor Photography Portfolio *GMC Publications*
Photographing Fungi in the Field *George McCarthy*
Photography for the Naturalist *Mark Lucock*
Professional Landscape and Environmental Photography:
 From 35mm to Large Format *Mark Lucock*
Rangefinder *Roger Hicks & Frances Schultz*
Viewpoints from *Outdoor Photography* *GMC Publications*
Where and How to Photograph Wildlife *Peter Evans*

ART TECHNIQUES

Oil Paintings from your Garden: A Guide for Beginners
 Rachel Shirley

VIDEOS

Drop-in and Pinstuffed Seats *David James*
Stuffover Upholstery *David James*
Elliptical Turning *David Springett*
Woodturning Wizardry *David Springett*
Turning Between Centres: The Basics *Dennis White*
Turning Bowls *Dennis White*
Boxes, Goblets and Screw Threads *Dennis White*
Novelties and Projects *Dennis White*
Classic Profiles *Dennis White*
Twists and Advanced Turning *Dennis White*
Sharpening the Professional Way *Jim Kingshott*
Sharpening Turning & Carving Tools *Jim Kingshott*
Bowl Turning *John Jordan*
Hollow Turning *John Jordan*
Woodturning: A Foundation Course *Keith Rowley*
Carving a Figure: The Female Form *Ray Gonzalez*
The Router: A Beginner's Guide *Alan Goodsell*
The Scroll Saw: A Beginner's Guide *John Burke*

MAGAZINES

WOODTURNING • WOODCARVING
FURNITURE & CABINETMAKING
THE ROUTER • NEW WOODWORKING
THE DOLLS' HOUSE MAGAZINE • OUTDOOR PHOTOGRAPHY
BLACK & WHITE PHOTOGRAPHY • TRAVEL PHOTOGRAPHY
MACHINE KNITTING NEWS
GUILD OF MASTER CRAFTSMEN NEWS

The above represents a full list of all titles currently published
or scheduled to be published.
All are available direct from the Publishers or through
bookshops, newsagents and specialist retailers.
To place an order, or to obtain a complete catalogue, contact:

GMC Publications,
Castle Place, 166 High Street, Lewes,
East Sussex BN7 1XU, United Kingdom
Tel: 01273 488005 Fax: 01273 402866
E-mail: pubs@thegmcgroup.com

Orders by credit card are accepted